KANSAS

MURALS
A TRAVELER'S GUIDE

Lora Jost and Dave Loewenstein

FOREWORD BY SARALYN REECE HARDY

UNIVERSITY PRESS OF KANSAS

Published by the University Press of Kansas (Lawrence, Kansas 66045), which was organized by the Kansas Board of Regents and is operated and funded by Emporia State University, Fort Hays State University, Kansas State University, Pittsburg State University, the University of Kansas, and Wichita State University

Library of Congress Cataloging-in-Publication Data

Jost, Lora.
 Kansas murals : a traveler's guide / Lora Jost and Dave Loewenstein ; foreword by Saralyn Reece Hardy.
 p. cm.
 Includes bibliographical references.
 ISBN 0-7006-1468-0 (cloth : alk. paper) — ISBN 0-7006-1469-9 (pbk. : alk. paper) 1. Mural painting and decoration, American—Kansas—Guidebooks.
2. Mural painting and decoration—Conservation and restoration—Kansas.
3. Kansas—Guidebooks. I. Loewenstein, Dave, 1966- II. Title.
 ND2635.K36J67 2006
 751.7'3'09781—dc22 2006010982

British Library Cataloguing-in-Publication Data is available.

Printed in China

10 9 8 7 6 5 4 3 2

The paper used in this publication meets the minimum requirements of the American National Standard for Permanence of Paper for Printed Library Materials Z39.48-1992.

Photographs on pages 5, 9, 33, 39, 43, 53, 61, 63, 65, 67, 75, 83, 91, 99, 113, 129, 163, 173, 183, 187, 189, and 191 are by Dave Loewenstein; 7, courtesy of Kansas Wesleyan University; 8, 161, and 167, Scott Jost; 35, © Douglas Kahn Photography; 59, Daniel Donnert; 89, Melanie Bingham; 95, Teresa Gawrych; 101, James J. Switlik; 103, © 2000 Gary Pollmiller; 111, courtesy of Brown Grand Theatre; 141, courtesy of Kansas Cosmosphere and Space Center; 175, © Rock Island Studios, Inc. 2005; 185, Doyle Saddler; 203, Stephen L. Harvey (The Photo Place); 205, Dennis Burghart; 218, courtesy of St. Benedict's Abbey; 226, Federal Works Agency photo, courtesy of Seneca Post Office; 249, courtesy of Kapaun–Mt. Carmel Catholic High School; 254, High Plains Journal photo, courtesy of Ted Carlson. All others are by Edward C. Robison III.

For our friends and families

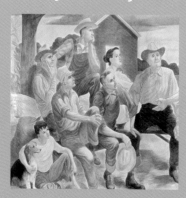

CONTENTS

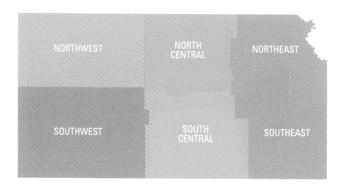

FOREWORD

This indispensable Traveler's Guide gathers for our collective consideration Kansas murals from widely scattered locales. More than painted surfaces on blank walls, decorated thresholds, or solutions for vacant windows, these murals are public events, daring to share the common spaces of our everyday lives. Some are socially compelling or formally beautiful, and others possess quirky local color, but all are inescapably available and vulnerable to quick public critique and response. They remind, inspire, locate, intrigue, charm, challenge, refresh, and sometimes simply amuse their audiences. Most of them provoke a question; many of them cause a stir. It is this public presence, the sometimes intrusive and unexpected quality of these murals, that marks them as a uniquely democratic art form. They can often be found readily at hand in everyday space but at other times require careful search. These murals do not reside in the focused and hushed spaces of the art gallery; rather, they cohabit with the hustle of an urban landscape, may be stained by the vagaries of the weather, or may be forced to tolerate the daydreaming glance of a preoccupied observer.

Muralists risk, and trust, the public forum as a frame for their work. This is true public art, out there for anyone to embrace or ignore. The artist who creates for public life is working in a studio without boundaries. In a way, we all claim the work, although none of us can ever finally own it. Dave Loewenstein calls this assembly of murals a great living Kansas museum, while Lora Jost describes it as a picture book. As a truly public art collection, these murals might equally be described as a series of in-place postcards transmitting our shared experiences of a place—recalling where we have been, where we are, and even suggesting where we might be going.

Common themes reflect the root issues of Kansas: the Civil War, agriculture, the landscape, diverse peoples, and native cultures. Artistic style is usually representational; specific content often refers to freedoms of thought, action, and expression. Many of the artists seem to know that a public picture makes a public statement and that the language of choice in Kansas murals leans toward "realistic." In practice, many of these murals are communal projects with artists acting as coordinators,

creating with, and not merely for, the community. These community-involved murals stir a collective visual identity shaped by shared situations, beliefs, and feelings then fixed in collaborative image. The "barn-raising" mural style is the very practice often employed by the authors of this book. This tangible experience creates the crucial authenticity at the heart of this project. The authors as muralists live their values of community, participation, and belief in the public view. They are both full of passion for the local, desiring to create statewide support for the mural form while advocating for the artists who risk working in plain view. Beyond that, I admire the years of work and many miles traveled throughout this project. Both artists have driven, talked, researched, written, painted, collected, photographed, interviewed, and edited to make this book of Kansas murals a reality. Only two artists who understand that murals are utterly vulnerable in many ways would attempt (and succeed at) a task of this magnitude. These artist/authors have themselves made work in public space with public critics close at hand. They are both missionaries, believing in art as a way to build community and create understanding about this place.

How might you use this traveler's guide to Kansas murals?

* * *

Mail a letter to a friend in one of the many post offices mentioned in this book. Perhaps my first experience with Kansas murals was in the Belleville post office, where Birger Sandzén's painting continues to enliven this ordinary social space. This post office, like so many others in Kansas, registers as a very particular post office, like no other in my memory because of the presence of its distinguishing mural. Above the postmaster's door the line of blue and golden horses hesitate by a Kansas stream flowing into trees and landforms—a painted, scenic view hovering over a threshold of utility. Below the picture, announcements, sealed condolences, greetings, gossip, and bills go from hand to box and disappear as people come and go.

A post office persists as an important social space for many small Kansas towns. Woven into the pattern of communal gathering, it is a place to greet friends, to connect with the outside world, or to discuss the news. Although the U.S. Postal Service is no longer thought of as the most efficient or speediest means of communication, the Belleville post office still functions as a communal parlor colored by its oversized pastoral postcard from the 1930s installed above the door. The mural insists upon a presence for collective memory—though many might not recall how it came to be there. "It has been there as long as I can remem-

ber," says one resident. My native Kansas mother reports that the mural reminds her of a typical scene of Kansas in the fall.

Mailing a letter in Belleville, Lindsborg, or Horton may mean speculating about the weather while considering the conventions of painting in the 1930s, the attraction of a season for its color, or the significance of a regional icon like Sandzén. Glancing up in the company of others may prompt a conversation about meaning, the history of the site, and the skill of the artist. Before long, a story unfolds, and the location of Scandia as a point of inspiration may surface for debate. Someone insists that horses do not stand that way. The painting in its location stimulates interactions among place and art, historic document and expressive gesture, community lore and that ever-elusive component—creative license.

* * *

Explore the exteriors and interiors of Kansas churches while searching for symbols of belief in place. A pilgrimage to Sacred Heart Cathedral poses contemporary questions about the future of the Salina community. How long will the grain elevators signal a strong farming economy and way of life for the people of central Kansas? A stone relief procession of devout figures marks the entrance. Replete with regional motifs of sunflowers and wheat, the frieze in front of this building embodies the agricultural metaphors for religion and piety common in Kansas' past. Wheatland, as place, is God's acre; the rural farmer as a tiller of soil represents a Kansas equivalent to the keeper of the vineyard; and the church inspired by grain elevators suggests the gathering, holding, and dispersal of spiritual plenty.

The architectural form with its echoes of grain elevators reflects Salina's community position in the 1950s as the fourth-largest wheat-processing center in the United States, while recording a vernacular correspondence between the Catholic Church and people of the region. The building's monumental forms provide an imposing backdrop for the humble line of parishioners carved into the stone on site. The farm family, reflecting economic and spiritual importance, leads the processional panel of life-sized carved figures. The artist, Bruce Haswell and his collaborators, Bishop Frank Thill and architect Edward Schulte, acknowledged the community's images and values, permanently binding them in stone on the façade of the building.

It is significant that the authors of this volume include not only painted surfaces, but also mosaics and friezes, such as the one at Sacred Heart Cathedral. A frieze inserts itself into the space of a community with permanence and architectural au-

thority. Attached to a building with the frame of an architectural setting and plan, the frieze is less vulnerable to erasure than a painted wall.

Loewenstein's definition of murals as links to a building and therefore a community expresses not merely a defining category but also a desire and process that bonds murals with community building. One of the strengths of this book is that the authors are linking the dissimilar, including us, in their enthusiasm for the varied uses, subjects, creators, and roles of Kansas murals. They insist upon an ecumenical look at Kansas murals. This book is itself a link, creating a map for fresh understanding of the shared pleasures of differences—ignoring hierarchies of artistic consensus or public opinion. Rather than relying only upon the artist's reputation, or the approval rates of communities, they ask us to have our own look. As a traveler in Kansas, what do you see, think, say?

* * *

Wander onto a campus and experience a surrealist master unexpectedly residing within the imaginative power in Kansas. Playful floating bird forms with eyes at angles greet visitors to the Ulrich Museum of Art on the campus of Wichita State University. These fugitive shapes of the imagination created by Joan Miró bring an international artistic movement to an accessible space in Wichita. Surreal, more than real, beyond the real, vivid primary colors and whimsical shapes usher phantoms of fantastic dream creatures into public view. An enlivening departure from the plethora of representational mural art in Kansas, the mosaic invites a look within a landscape of consciousness. Miró's forms represent a concern with transformation and flight that relates to his series of smaller, intimate paintings created during the 1940s. At this large mural scale they link the journeys into the self to the experience of the shared collective unconscious. The Miró mural has become a destination for art enthusiasts, expanding visual culture and symbolizing the desire and capacity for Kansas to embrace artists whose signatures and sources lie beyond the state, or any specific locale, but rather in the boundless imagination. The artistic authority and prominence of the Wichita mural at the threshold of a university art museum contrast with collaborative and consensual processes of some of the other work represented in this guide. (It lands in mythic fashion, delighting and surprising with abstraction and expressive freedom.) Miró's mural suggests this freedom and latitude as it loosens the borders of the tangible, expands the real, challenges the rational, honors fantasy, and sends regional stereotypes flying like so many surreal birds.

* * *

Debate history and politics as you visit our State Capitol Building in Topeka. No mural in the state has generated more words, attention, or debate over time than the Capitol murals by John Steuart Curry. The initial project and controversy erupted between 1937 and 1941, but its echoes continue to describe a certain aspect of public art in Kansas. If you visit the portrait of John Brown today, its visual power expresses those same high emotions evident in current debates over evolution, or a legislative standoff about education, or other hotly contested issues. Curry's depiction of his experience of Kansas and his representational style still resonate with Kansas people and sometimes painfully express a certain public identity. His tornado and religious zealot occupy the same public space as quiet nights on the prairie.

Curry's political convictions and his desire to paint the extremes in Kansas embody the tradition of artist as commentator and activist. Describing the legendary portrait of Brown, Curry says, "I portray John Brown as a bloodthirsty, god-fearing fanatic, a dangerous do-gooder who, with those like him represented on both sides, brought on the Civil War." Curry's portrayal confronts historically sensitive subjects and perspectives, suggests a strategy still used by mural makers in Kansas who hope to affect public policy and opinion by re-presenting his-

tory. Curry relayed his stories with conviction and some degree of melodrama by painting the interactions of people and nature at a grand scale. As an active form of remembrance, the mural demands attention by visualizing history and re-creating its questions in the public domain.

Curry's oil studies for the Capitol murals are in the Spencer Museum of Art at the University of Kansas, where educators, students, and schoolchildren compare them to the imposing murals at the Statehouse. The studies provide an opportunity for discussion about the creative process necessary for making large-scale murals, and the role of sketches and preliminary proposals necessary for a politicized arena like the Statehouse. The studies challenge the assumption that "real" art lives only in museums. In this case, the real art and the most ambitious project resides in the Statehouse, and visitors must leave the museum to see it.

* * *

Visit a tribal community or a historically important site to understand native culture and heritage. Driving to see Kansas murals fosters an understanding of overlooked places and peoples crucial to sustaining our vitality and diversity as a state. A trip to the Early Childhood Center on the Potawatomi Prairie Band Reservation rewards visitors with a look at a joyful mu-

ral painted by Laurie H. White Hawk. White Hawk says that her hope is to "dispel misunderstanding, believing that an image will speak louder than words."

Brightly painted in a flat graphic style, four native dancers greet children, parents, and visitors who come and go from Head Start. Everyone passes between the receptionist (who knows three of the four models) and the mural to find a classroom or pick up a child. White Hawk's dancing subjects float among shadows and repeating shapes of clouds, fields, and trees, and the suggestion of human footprints under each dancer makes them seem weightless, as if they are moving in a mystical landscape beyond a specific time or place.

This book is an open invitation to visit the open-air museum of Kansas murals. It will bring you closer to them: not closeness in the sense of shortening distance; rather, a closeness that comes from intimate understanding, deep knowledge, and a committed caring. Taking this book with you assures that you travel in good company. So take it with you on walks, give it to a friend, construct thoughtful tours, or merely keep it close at hand so when that rare sighting occurs, you can confirm and identify what has unexpectedly caught your eye and imagination.

I am deeply grateful to Dave and Lora for this gift of art in place.

Saralyn Reece Hardy
Director, Spencer Museum of Art
November 2005

Acknowledgments

This book is an outgrowth of the Surface Art Conference of 2000, a regional conference about murals and mural making sponsored by KanArts, the Kansas Arts Commission (KAC), the Nebraska Arts Council, and the National Endowment for the Arts (NEA). The book began as a research project aimed at satisfying the need, as expressed by conference participants, for more information about murals—and the process of making them—in rural and urban communities in the Midwest. Conchita Reyes of the KAC was instrumental in the early days of this project, along with Amy Carr of KanArts, David Cade of the Pélathé Center, and grant writer Joan Wingerson.

We extend our heartfelt thanks to the Kansas cultural organizations that gave generously of their time, energy, and finances to support this project. Storytellers Inc., and the Hutchinson/Reno County Arts and Humanities Council were lead organizations on project grants, assisted by the Barton County Arts Council, City Arts (of Wichita), KanArts, the Kansas Sampler Foundation, and the Pélathé Center. We also wish to thank Dave Wilson of the Kansas Arts Commission, Todd Kitchen and Eric Hansen for technical assistance, Dave Kendall for a spot on *Sunflower Journeys*, Pam Loewenstein for accounting services, and Susan Whitfield-Lungren for legal assistance.

We are deeply grateful to the many artists, artist family members, and mural sponsors for their time and assistance in researching the murals of Kansas. In addition, we are thankful for the people working in city governments, Chambers of Commerce, libraries, museums, cultural organizations, and historical societies who patiently answered our questions and provided information and contacts for our research. We are especially appreciative for the help of Jerry Bernard, Chet Cale, Lois Crane, Melanie Dill, Laura Donnelly, Robin Dunitz, Dena Friesen, Terra Houska, Don Lambert, Kim Lister, Karen Neuforth, Marci Penner, Mark Rassette, Father Blaine Schultz, O.S.B., Michael Toombs, Tom Young, and the extended family of artist Franklin Gritts.

We are indebted to many people who helped bring the manuscript and photography to completion. We're especially grateful to Saralyn Reece Hardy for writing the foreword. In addition, we thank William Tsutsui and John Pitman Weber for their helpful reviews of our book proposal and William Tsutsui for his insightful comments on our manuscript; Leslie vonHolten for editing

the manuscript prior to submission to the press; Karl Janssen for designing the maps; Paula Schumacher, Kirsten Bosnak, and Chuck Epp for reading and commenting on project proposals and selected narratives; a number of artists for providing photographs for the book or contacts with photographers; and Edward C. Robison III for his amazing photography work and digital mastery. Last, but certainly not least, we extend a very sincere thanks to Fred Woodward and the staff at the University Press of Kansas for all their patience and guidance through the entire process.

Finally, we extend our warmest thanks to our friends and families—for their boundless support during the four years it took to research and write this book, including Katherine Dessert and Elan McCabe, Chuck Epp and Nicholai Jost-Epp, Walter and Mary Ann Jost, Scott Jost, Pamela Loewenstein, and Alyson Matkin.

Principal Funders

The National Endowment for the Arts

The Kansas Arts Commission

Elaine Amacker Bridges

Walter and Mary Ann Jost

Marilyn Klaus

Michael Loewenstein

Grant Partners

Hutchinson/Reno County Arts and Humanities Council
 (lead organization)

Storytellers Inc. (lead organization)

Barton County Arts Council

City Arts (of Wichita)

KanArts

Kansas Sampler Foundation

Pélathé Center

Contributors

Peter Amberg and Suzanne Trine, Bill Balcziak and Nancy Loewen, Marc Becker, Sandy Broughton and Linda Niedbalski, Amelia and Robert Epp, Timothy Epp and Heidi Schmidt, Becky Fast, Sandra Gartler, Jean Grant, Doug and Shirley Hitt, Hutchinson/Reno County Arts and Humanities Council, Reinhild Janzen, Jerry Jost, Kelly Kindscher and Maggie Riggs, Ann Kowalsky, Roxanne La Maina, Kate Leonard, Joan LeTendre, Diane and Tim Loewenstein, Pamela Loewenstein, Gail Lutsch, Andrew Martin, Jeanne Martin, Bobbie and Shirley McKibbin, Louisa McPharlin, Anne Miller and Roberto Rey, Michael Miller and Nancy Oswald, Kristi Neufeld, Karla Niehus, Joan Nothern, Oswego Historical Society, David and Debbie Owen, Plains State Bank and Jerald Stinson, Dwight and LaVonne Platt, Al Pounders, Karen Prindle, Gail and Mark Rassette, Kyrill Schabert, Peter Schabert, Marie Snider, Kathy and Jeff Steely, Swedish American State Bank, Kay Westhues, Charles A. Westin.

INTRODUCTION

The highest, most logical, purest and most powerful type of painting is mural painting. It is also the most disinterested, as it cannot be converted into an object of personal gain nor can it be concealed for the benefit of a few privileged people. It is for the people. It is for everybody.

—Mexican Muralist Jose Clemente Orozco (1883–1949)

HOISINGTON, KANSAS—24 JANUARY 2002

Sprawled over the dashboard, our Kansas map was dotted with yellow highlights to guide us to the towns known to have murals. We drove into Hoisington, which had been devastated by an F4 tornado a year earlier, in the hopes of seeing a 1937 mural by Dorothea Tomlinson in the post office. Finding the post office undamaged, we went inside and discovered to our pleasure not one mural, but two.

Tomlinson's mural *Wheat Center* was installed above the postmaster's gold-trimmed door. Showing the influence of Regionalist painter Grant Wood, the mural is an aerial view of a family farm during wheat harvest. Lora took notes while I shot photos. When we were done, we turned to leave and caught sight of the second mural.

This mural looked remarkably like *Wheat Center*. It was divided into three panels and followed the life of a farmer born on the farm that Tomlinson had created in her mural. On closer inspection we discovered that the mural, titled *The Generation*, had been painted by Bob Booth fifty years after Tomlinson's. What a thrill to see this dialogue between artists across the decades, each of them using murals to illustrate the continuing importance of the family farm in Kansas. After this discovery and eager to see what we would find in the next town, we gathered our notes and cameras and headed west.

A DEMOCRATIC ART FORM

Murals, because they are usually public and immobile, are perceived differently than paintings displayed in galleries or museums. People often discuss the latest auction price of a van Gogh or Picasso, but not the ceiling of the Sistine Chapel or a mural by Diego Rivera. Murals are not objects to be bought by

the highest bidder. They relate closely to the performance of a free band concert in the park, where an audience comes to experience the art unencumbered by the thought of how much the band and its music are worth in dollars. Unlike a band that can travel, however, murals can play only to audiences who come to them.

Murals are a democratic art form. They tell our collective stories and encourage collaboration by bringing people together to become co-designers and painters as well as audience. Distinguished from more portable paintings, murals are literally linked to the building, and therefore the community, where they are created. This permanence influences how they can become part of the identity of a neighborhood or town and vulnerable to its changing economy. Murals also can inspire the rejuvenation of civic pride and the love that residents have for where they live, as seen in towns like Great Bend and Winfield, where mural tours are marketed as attractions for visitors.

The Ninety Murals Highlighted in This Book

We define a mural as a large, roughly two-dimensional artwork executed on a wall surface or installed as a permanent part of a building or space. Media that we include in this defini-tion are paint, mosaic, ceramic tile, and low-relief. Because this book is also a travel guide, we focused on murals that are pub-licly accessible. To steer clear of overt product placement, we chose murals that were not explicitly commercial in nature.

This book brings attention to the great diversity in the mu-rals created in Kansas during the last 115 years, and not only the greatest hits by the best-known artists. The ninety murals featured in the book include examples of murals from all re-gions of the state, including both rural and urban areas; from all decades reaching back to the 1890s; murals made by profes-sional and amateur artists, students, and community groups; and murals that explore a wide variety of subjects and employ different media and techniques.

These ninety murals just scratch the surface of the great wealth of murals in the state. In fact, more than 600 additional murals are out there (see Appendix B). We listed as many mu-rals as we were able to locate based on information from city clerks, Chambers of Commerce, historical groups, arts organiza-tions, librarians, and many others. We missed many, of course, because of the limits of our resources and the continuing work of artists creating new murals.

MURAL GENRES

The subject matter of most murals is a compromise. The artist brings his or her interests together with those of the institution or community that is sponsoring the project. Over the years these relationships between artists and sponsors have changed and expanded, spawning new types or genres of murals.

In the mid 1930s, the federal government under Franklin D. Roosevelt transformed the Kansas mural landscape with a series of nationwide programs that employed artists to decorate new post offices and other federal buildings. These programs, funded by the Treasury Department, including the Section of Fine Arts (or "the Section," described in detail in No. 27), were not relief programs like the ones under the Works Progress Administration (WPA), which also sponsored several programs that commissioned murals. The Section held regional and national competitions for established, professional artists and made provisions for local people to have a say in the subject matter of the murals they created. The Section, which sponsored projects in more than 1,000 towns nationwide (including twenty-six in Kansas, mapped on page 217), ended abruptly in 1943 with the onset of U.S. involvement in World War II.

In the 1950s, Kansas communities began sponsoring their own murals. Funding and organizing their own projects gave towns more control over the selection of the mural artist, location, and subject. The murals that followed, which were painted mainly by local artists such as Sue Jean Covacevich in *The Story of Winfield* (1951, No. 79), showed a passion for town pride and a recounting of local history from settlement to the present.

Beginning in the late 1960s in Chicago, the Community Mural Movement furthered the notion of local sponsorship by encouraging the grassroots development of murals in neighborhoods and schools. Many of these murals focused on ethnic identity and up-to-date issues that were on the minds of residents. The first mural we found in Kansas that shows the influence of this movement is *We Are the Dream* by Travis Mosely, Willie McDonald, and Harold Carter (1980, No. 20). This distinctly multicultural mural at Kansas State University celebrates the histories of Native Americans, African Americans, and Hispanics.

Beginning in the late 1980s, "painting the town" was taken almost literally as a way of infusing a renewed sense of meaning and pride in places struggling with declining populations and Main Streets lined with empty storefronts. There is a real

effort in these places to revitalize the visual environment and regain control of the town's public image. This is true in downtown Coffeyville, where one artist, Don Sprague, painted fourteen murals in just four years, and in Oswego, a town of less than 2,000 residents in the southeast part of the state, that has eleven murals.

Today, many of these genres continue while new ones are emerging. Most noticeably perhaps is the recent wave of murals created after the terrorist attacks of September 11 that revolve around depictions of the American flag. Many of these patriotic murals, like Marilyn Dailey's *Our Flag Was Still There* (2003, No. 38), do not directly reference the September 11 tragedy, yet they are historically significant because they mark time by capturing what was important to a community and an artist when they were created.

1980: THE KANSAS MURAL RENAISSANCE

Artists have been painting murals in Kansas for more than a century. During the first ninety years, styles and media changed, artists were favored and then forgotten, and subject matter was hotly debated. Some of these early murals faded away, and others were lost to the wrecking ball. Then around 1980 a dramatic shift began. The practice and frequency of mural making changed so significantly that it could be called a Kansas mural renaissance.

More than 80 percent of the murals we discovered were created after 1980. This resurgence is due, in part, to the fact that over time many murals have been lost. But even accounting for these losses, it is clear that there has been a large increase in mural production. In addition to increased production, placement changed as well. The majority of murals created before 1980 were made for interior spaces. After 1980, more than half were created outdoors. Paralleling this trend to paint outdoors has been the broadening of the group of artists doing this work. Based on the murals we found, the number of amateur artists, students, and community groups making murals quadrupled after 1980.

This dramatic shift was not happening only in Kansas: it was actually part of a much larger phenomenon that had been working its way across the country since the late 1960s. Some of the early factors that spurred these changes were improvements in low-cost acrylic paint and the influence of the Community Mural Movement coming from urban centers like Chicago and Los Angeles. Later, the Internet, Kansas Arts Com-

mission funding, Percent for Art programs, and revitalization efforts based on mural tourism in towns like Chemainus, British Columbia, helped communities and artists realize "painting the town" mural projects.

Across the state, in big cities and small towns, this mural-making boom does not appear to be slowing. Quite the opposite. The Kansas mural renaissance is actually gaining momentum, as evidenced by the abundance of murals—more than 100—that have appeared in the state in just the last five years.

SEE FOR YOURSELF

Quietly, out of the spotlight of the "high art" world, a wave of murals has spread across Kansas in the last twenty-five years, adding to the state's rich 115-year tradition of mural painting. This vast collection of more than 700 murals spread over more than 150 cities and towns, from Liberal to Atchison, Baxter Springs to Atwood, is like a great living Kansas museum of art. We hope that this book inspires you to go to see some of these great artworks for yourself, because like theater and music, murals are best experienced live and at full scale.

—Dave Loewenstein

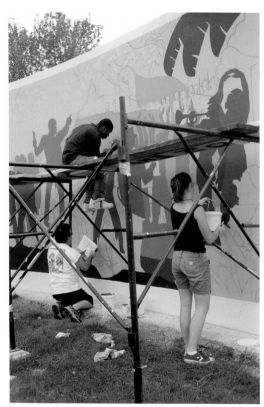

Two students and their art teacher are at work on *Aspects of Negro Life: Slavery through Reconstruction* (2005, No. 30).

Imagery and Identity in Kansas Murals

The colorful contemporary depiction of a children's pow-wow in Laurie H. White Hawk's *Potawatomi Children* on the Potawatomi Prairie Band Reservation (1997, No. 25) and the whimsical collage of interconnected people among a stars-and-stripes landscape in Jane Beatrice Wegscheider's *What Do You Love about This Place* in Salina (1999, No. 51) seem to reflect two very different worlds. Yet both are based on the identity of two characteristically Kansas communities. Although Kansas murals are diverse in subject matter, technique, style, and location, a closer look at the state's murals reveals many common themes about our state's history, culture, communities, and identity.

Several significant Kansas murals reflect the state's turbulent origins in the clash over slavery and the buildup to the Civil War, a period when the state was known as "Bleeding Kansas." Some of the most notable of these murals play on the "Free State" identity forged in that controversy. The most famous is a scene from *The Tragic Prelude* by John Steuart Curry (1938, No. 32). This powerful mural depicts the fiery abolitionist John Brown standing over dead Union and Confederate soldiers, arms outstretched as if on a cross, a Bible in one hand and a rifle in the other.

Curry's depiction of Brown, as art historian M. Sue Kendall observes, captures the artist's ambivalence about Brown, and by extension about themes at the heart of Kansas (and even American) identity. Curry strongly favored equality for African Americans and made art for the antilynching movement. He firmly supported Brown's commitment to the abolition of slavery. Yet the artist also feared Brown's "missionary zeal," which for him was a trait deeply embedded in the Kansas character and one that the artist worried was held more widely by Americans and was leading the country down the path to war.

Thus Brown, hero to many and villain to others, is central to this most famous of Kansas murals, depicted as a moral leader of American history, but with a wild fanaticism in his eyes. The depiction initially won Curry few friends in Kansas and provoked a raging controversy, gaining mainstream acceptance only decades later, reflected in a 1992 state legislative resolution belatedly expressing appreciation for the mural. Curry's image of Brown has become something of a folk icon, appear-

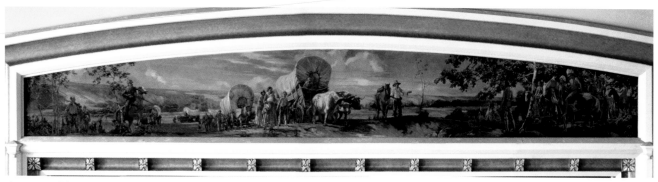

The Coming of the Pioneers, Robert W. Grafton, 1928.

ing on everything from T-shirts advertising John Brown Ale to a whimsical incorporation of Brown's outstretched arms into a sculpture of the KU Jayhawk (by Jim Brothers, part of the 2003 "Jayhawks on Parade" promotion in Lawrence).

Dave Loewenstein's *A Thousand Miles Away* (2001, No. 12), which commemorates an escaped slave's journey through Kansas' underground railroad, and Edmund Ness's *Quantrill's Raid on Baxter Springs* (1968, not pictured), which portrays the grisly massacre of Ft. Blair troops by proslavery guerrillas, also reflect Free State identity and heritage.

Kansas' prominent western identity is seen in both seri-ous and playful portrayals of cowboys, stagecoaches, saloons, and pioneers in covered wagons often depicted on the Santa Fe Trail or Oregon Trail. These murals celebrate settlement and the conquering of the mythic frontier. Robert W. Grafton's *The Coming of the Pioneers* (1928) at Kansas Wesleyan University provides an example of the resonance of the pioneer as a met-aphor. The mural celebrates the pioneer spirit that inspired the Methodists who, in 1883, founded the school in the middle of the prairie. The pioneer spirit continues in the perseverance of the university and the students' entrance into the uncharted landscape of adult life. The university still, in part, defines its

identity in these terms, pursuing a fund-raising program called "The Society of the Pioneers," which features the mural in its literature.

Many such pioneer murals depict Native Americans on the periphery watching, hunting, or retreating, with white settlers forming the central image. These murals, often depicting Native Americans as passive, almost welcoming, onlookers to white settlement, underplay the extent to which Kansas' Indian populations struggled to retain their land in the face of official policy aimed at removing them.

By contrast, a number of Kansas murals by Native American artists and others place Native American cultural identity and historical experience at center stage. Among them is Blackbear Bosin's *From Whence All Life* (1972) about the Native American philosophy of reverence for the universe as expressed by the Great Plains and Southwest Indians. A small area in the mural, peripheral to the Great Plains scene, is described in a mural-related pamphlet: "The buffalo are gone now, purposely killed off by the white man. The burial platform, with the corpse shrouded in a sacred white buffalo robe" is also a reminder of what happened. "But the poles of the scaffold have roots, indicating that there is still great depth to the culture of the Ameri-

Detail of *From Whence All Life*, Blackbear Bosin, 1972.

can Indian, and that it is not really going to die completely." Other examples include Laurie H. White Hawk's *Potawatomi Children* (1997, No. 25); Rick Regan's *Medicine Songs* (1986, No. 74); Travis Mosely, Willie McDonald, and Harold Carter's *We Are the Dream* (1980, No. 20); and Richard Haas's *Justice* and *The Prairie* (1993, No. 10).

Many Kansas murals focus on agricultural themes, and their

changing depictions of Kansas' agricultural identity is revealing. Agricultural murals of the 1930s and 1940s, supported by the Section (see No. 27), depict family farming as a way of life embedded in thriving rural communities, with scenes of communal work, harvest, picnics, and rodeos. By the late 1950s, rapid changes in farming inspired Ted Carlson's *Harvest through the Twentieth Century* (1957, No. 87), Ron Allerton's *History of Brown County* (1961, No. 6), and Bob Booth's *The Generation* (1990, No. 59). In addition, Frederic James's *Farmland Mural* (1956, No. 5) depicts the origins of farmer cooperatives. More recent murals depict large-scale combines or grain elevators as the ever-present symbol of Kansas' agricultural economy, as in Allan Lindfors's *Civic Mural of Marquette* (1983, No. 64) or Dave Loewenstein's *Ad Astra* in Hutchinson (2002, not pictured). Murals are even painted on agricultural structures. Seeing Stan Herd's historical mural in Wilmore painted on the side of a grain elevator was, for us, a quintessential Kansas moment.

Stan Herd's mural in Wilmore, 1987.

This shift in agricultural identity—from the ideal of the independent family farmer to corporate "agribusiness"—contributed to the consistent loss of farms beginning in the 1920s, with larger losses occurring from the 1940s through the 1980s. During the 1980s, rural Kansas experienced the decimating effects of the "farm crisis," and the population in rural Kansas communities declined 7 percent. As community leaders sought to retain energy and vitality in their communities, mural making increased dramatically in the 1980s. From the 1980s to the present, community advocates have been using murals to bol-

ster community involvement, community dialogue, civic pride, and tourism, often reflecting bittersweet themes.

Artist JoAnn Dannels and community volunteers, for example, painted several murals in Vermillion (1981, No. 34) as part of a town beautification effort. Among them are murals representing former businesses painted in the windows of empty buildings, now relics of a once thriving community. The murals intrigue viewers with the details of a bygone era, and also produce a sense of longing for what is no longer there. Similarly, as part of a project called *Conversation and Community* coordinated by Joan Nothern in Glasco, I painted, with the help of residents, silhouette murals on buildings in Glasco, by first tracing around participants and then painting with bright colors inside the figures (1998, not pictured). The project enlivened the town with colorful "people," evoking the character of the people I traced (one figure still remains). Yet as shadows, the figures were a reminder of those who were gone—who had died or moved away. Ultimately, the project contributed to a broader community discussion about the town, its history, its people, and their hopes for the future.

Community advocates and residents in rural communities are justifiably proud of their murals and are often intentional about their economic use. Some of these murals are also nostalgic reminders of an idealized past. Cristi McCaffrey-Jackson painted a mural in downtown Argonia to promote the town's history and boost community pride (2001, No. 52). The mural was one of a number of community-based projects aimed at improving the town, among them the establishment of a local grocery store and the creation of a housing development. Similarly, it has become common for communities to commemorate their heritage in murals, with the intention of promoting tourism as part of rural economic development. Stan Herd's murals, beginning in the 1970s, were surely a catalyst in this regard. Many communities have chosen to portray thriving downtown scenes of a bygone era, such as Stan Herd's *Inman's Mural* (1986, not pictured). The city of Anthony has recently painted several heritage murals, hiding within them a small character called "Art" for viewers to find, a marketing gimmick to get tourists to "linger longer."

Only a few rural murals reflect contemporary life. Dave Loewenstein with community volunteers painted a mural in Garden City reflecting diverse cultural influences (among them European, Hispanic, and Vietnamese), referencing the new wave of immigrants working in the rural Kansas meatpacking indus-

try (2005, not pictured). Images by and about children are also among the few representations of contemporary life in rural community murals. Child-centered murals are un-self-conscious in the joy they represent and genuine in the hope they provide for the future. Among them are *Grow with Us* by junior high students in Harper (1999, No. 57) and *Summer* by Chad Haas in Hays (2001, No. 84).

In addition to wrestling with changing rural identity, Kansas murals also reflect the heritage and identity of specific regions, towns, communities, and neighborhoods. Among the many examples are Wayne Wildcat's *Solidarity . . .* (2000, No. 43), which reflects the southeast region's mining and organized-labor heritage; murals about the Cherokee Strip Land Grab, reflecting the south central region's heritage; Kenneth Evett's *Changing Horses for the Pony Express* (1939, No. 7), which reflects the northeast region's heritage; monumental murals by Jesus Ortiz, Joe Faus, and Alisha Gambino, reflecting cultural identities in various Kansas City neighborhoods (1998, No. 8); Lewis W. Clapp's *Lindbergh Panel*, reflecting Wichita's identity as "the air capital of the world" (1935, No. 73); and Edward Curiel, Fred Henze, and Migdonio Seidler's *Our Lady of Guadalupe Shrine*, which reflects Catholic identity (1982, No. 62).

Depictions of steam engines, depots, and even contemporary passenger trains mark railroad town identity. Railroads were central to the settling of Kansas, bringing goods and businesses throughout the state. Many towns were founded because of the railroad, as seen in H. Louis Freund's mural in Herington (1937, No. 48). The railroad is a symbol of Mexican American immigrants' work heritage in Patrice and Ray Olais's mural in Newton (1978, No. 65). The railroad supported Kansas industries, and these are also depicted in many murals—among them the cattle, mining, and gypsum industries. The railroad runs through the entire length of Jesus Ortiz, Joe Faus, and Alisha Gambino's historical mural of the Argentine neighborhood in Kansas City (1998, No. 8). And the railroad is a symbol for the journey of immigrant groups, among them the German Mennonites in Peter H. Friesen's mural in Goessel (1974, not pictured).

Kansas murals evoke landscape—as the main subject or to provide context—by portraying the big sky, storms, sunsets, tornadoes, open prairie, agricultural land, and the Flint Hills. Among the many examples are Sabetha's bank murals (1965, No. 26), and murals by Louis Copt and Stan Herd (2003, Emporia, not pictured); Phil Epp and Terry Corbett (1998, No. 55); Joe

Jones (1940, No. 27); Dennis Burghart (1991, No. 90); and Birger Sandzén (1939, No. 45).

Although Kansas murals often look to the past for inspiration, mural project facilitators such as Amy Carlson; Joe Faus and Alisha Gambino; Cathy Ledeker of Van Go Mobile Arts; Dave Loewenstein; Michael Toombs of Storytellers Inc.; Jane Wegscheider; and many others find inspiration in a mural-making process rooted in the present. Their work brings community members together—from schools, youth programs, or neighborhoods—to design and paint murals. These murals are often intentionally multicultural and encourage communication between people of different backgrounds and identities. They are often based on contemporary themes and are steadfastly hopeful and forward-looking. Among the many examples are *Crossroads* (1995, No. 9), *Hmong Cultural Mural* (2005, Kansas City, not pictured), and *What Do You Love about This Place* (1999, No. 51).

As you can see, while finding our way across the state, we soon found that depictions of the people of Kansas are everywhere in murals. In Liberal, a mural by Stan Herd commemorates the town's unusual Pancake Day. On this day, an uproarious race is held against the clock, where contestants compete with the women of Olney, England, in a quarter-mile race—with skillets in hand—flipping pancakes as they run (1983, not pictured). In Hutchinson, delightful murals by Larry Caldwell and AvNell Mayfield portray senior citizens enjoying activities at a community center (2001, No. 61). In Salina, a wheat farmer and his family lead a Catholic procession in a beautifully carved mural on Sacred Heart Cathedral (1953, No. 50). We traveled the state looking for murals and found in Kansas an open picture book of the state's history, culture, and identity. We hope you will enjoy visiting these murals, too.

—Lora Jost

Kansas Murals

Northeast

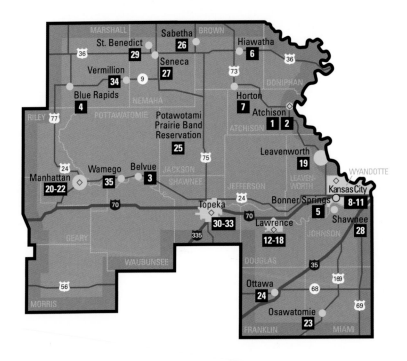

◇ Cities and towns highlighted with this symbol are home to ten or more murals. Consult the appendix for a complete listing.

1 Abbot's Chapel Mural 1938
Brother Bernard (Wilhelm) Wagner

ATCHISON

St. Benedict's Abbey, 1020 N. 2nd St. (inside, by appointment only)

In the spring of 1935, twenty-year-old Wilhelm Wagner was studying at the Maria Laach School of Liturgical Art in Germany. He had hoped to complete his studies and hone his skills there when world events forced an abrupt change in his plans. Wagner was listed for the first conscription into the military as Hitler's Germany readied for war: "There was no choice but to get out of the country or to be drafted into the Nazi army," he said. That summer, with the support of Abbot Martin Veth, he fled Germany. Professed as a lay brother while still in Germany, Wilhelm arrived in Atchison as Brother Bernard, and he quickly went to work on plans for murals in the Abbot's Chapel.

In Wagner's mural, the Abbot's Chapel, which was traditionally used by the abbot to say Mass privately, is populated by figures from the Old Testament and saints from the New Testament in a procession toward a now-lost figure of Christ above the altar. For either side of the altar, Wagner designed angels in brilliantly colored stained glass windows. Symbolically guarding the chapel's entrance are the figures of the twin Saints Benedict and Scholastica with accompanying texts from sacred scriptures.

As the viewer enters the chapel after walking through the relatively somber abbey, Wagner's murals are striking in the way they illuminate and enliven the space with pastel colors and decorative patterning. Wagner painted the mural's figures in a precise, simplified realism, which was influenced by his studies at Maria Laach and were, as he described them, "moderately contemporary." Their presence on all four walls transforms a room meant for one into a spiritual gathering place for meditation and prayer.

Brother Bernard continued his work in Atchison, creating several fine murals for the abbey and its counterpart St. Scholastica Monastery before leaving his monastic vows to pursue a career in liturgical art and become Wilhelm once again.

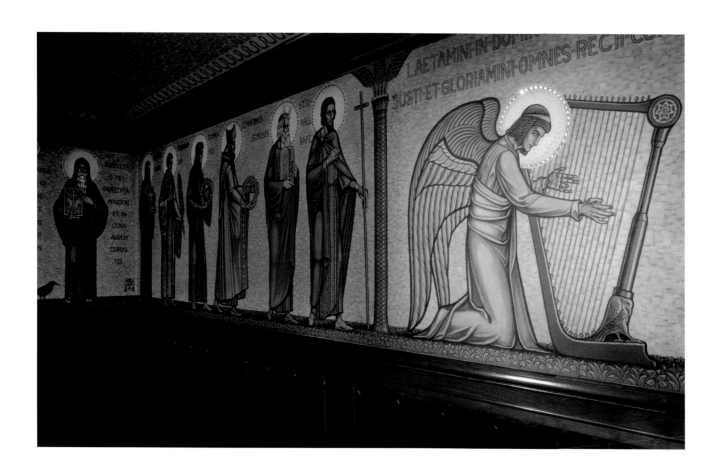

2 *Trinity and Episodes of Benedictine Life* 1959
Jean Charlot

ATCHISON
Abbey Church, 1020 N. 2nd St. (inside)

From a high bluff overlooking the broad expanse of the Missouri River valley, the Abbey Church, on the campus of Benedictine College, stands out as one of the most beautiful examples of the integration of art and architecture in Kansas. Throughout this impressive building, designed by architect Barry Byrne (a student of Frank Lloyd Wright), limestone, marble, and wood have been expertly crafted to enhance the experience of solemn reflection and collective voice.

Completing this awe-inspiring space is the luminous fresco by Jean Charlot that rises above the choir on the east wall of the upper church. Charlot is one of the twentieth century's most highly esteemed muralists (see page 218). He painted this mural, along with two smaller frescoes for chapels in the crypt, in the summer of 1959 with the help of those who came to observe, including Brother Martin Burkhard and Benedictine College art professor Dennis McCarthy. In recalling Charlot's openness, McCarthy said, "If you were around the painting site more than half an hour, he'd give you a brush and say, 'Now go and do this.'"

The fresco is dominated by a square cross framed in aluminum and raised in relief from the mural's background. Within the cross are depicted God the Son, God the Father, and God the Holy Spirit, which is symbolized by a dove. Beneath Christ are St. Benedict and his twin sister, St. Scholastica. To the right and left of Christ are angels shown with symbols of Christ's passion. Outside the cross in the corners of the mural are two scenes from the life of St. Benedict (left side) and two scenes from the early history of Benedictine monks in Atchison (right side).

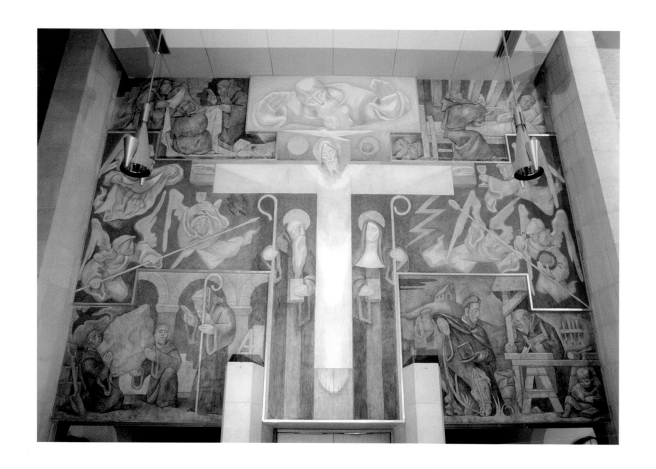

3 *Oregon Bound, Fall Hunt,* and *Kansas Wildlife* 1996
Cynthia Martin

BELVUE
Oregon Trail Rd. (one quarter mile west of the Schoeman Rd. intersection)

Artist Cynthia Martin may have thought her immersion in the history of the Oregon Trail was getting the better of her when, while working on this mural, she saw two people with a packhorse ride into the Oregon Trail Nature Park like pioneers from the 1850s. But it was no daydream. The couple from New Zealand had set out to retrace the entire 2,000-mile route of the trail, which borders the park on the south, but were having trouble with their horses at the time of their fortuitous meeting with Martin. Fortunately for the trekkers, Martin was a horse expert and was able to help the couple with their animals before wishing them well on their journey west, the same journey that more than 300,000 emigrants took between 1843 and 1866 in their search for a new life in the Pacific Northwest.

Set along a hillside below the reservoir for Kansas' largest power plant, the Oregon Trail Nature Park was developed by Westar Energy on sixty acres that had previously been used as a farm, of which only the grain silo remained. Although the silo did not appear at first to fit into the park's historical theme, Belvue resident William Ledeboer had a vision for how it could become a landmark commemorating the area's history and landscape: he imagined a mural.

Westar agreed and selected Cynthia Martin's proposal, which divided the silo into three scenes painted with exceptional detail and fluid brushwork. The scenes are *Oregon Bound* on the south side, complete with a detailed map of the entire trail; *Fall Hunt* on the east side, depicting the Kansa Indians engaged in a buffalo hunt; and *Kansas Wildlife* on the west and north sides, filled with the area's flora and fauna, many of which were hidden by the artist to make them more fun to find.

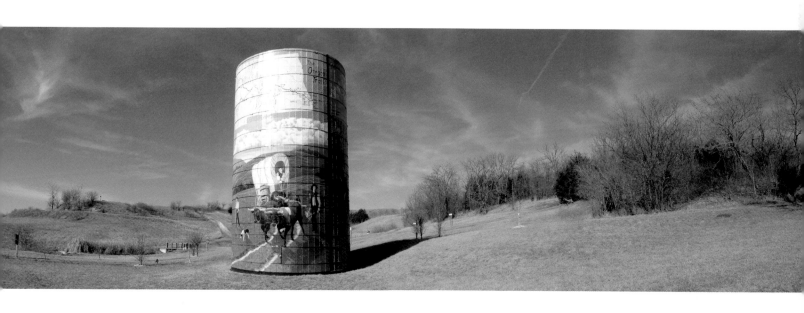

4 *Gypsum on the Blue* 1997
Kenny Winkenwader

BLUE RAPIDS
Public Square, just south of Main St. on 5th St.

They were really good days," recalled artist Kenny Winkenwader of his boyhood, spent fishing and swimming with his cousins in the Little Blue River. "Mom made Sunday dinners, then we would end up on the river." Located on the town square, this mural, "a self-portrait in spirit," recalls those times and the area's gypsum industry with a gypsum mill shown in the distance. In a second mural to the left, Winkenwader portrays Alcove Spring, an important stop on the Oregon-California Trail.

Gypsum on the Blue is an apt title, for the mural's Blue River is painted in a particularly vivid shade of blue, a color that is characteristic in more than a dozen of Winkenwader's area murals. As a self-taught artist who has farmed in the area all his life, Winkenwader often depicts local history in his murals. He recalled that his brother once worked in one of Blue Rapids' gypsum mills. Gypsum was first discovered near present-day Blue Rapids in 1858 and eventually became a major area industry. The first small-scale mine opened in 1871, with four in operation by the early 1900s; one remains in operation today. Two early-day companies used steamboats to shuttle the gypsum from mine to mill. "There have been so many mills," commented Winkenwader. One of the earliest, powered by the water of the Blue River, "had a waterwheel turned horizontal, which drove a shaft through the water into the gears that powered the plant."

The accompanying mural *Arrival at Alcove* portrays travelers at Alcove Spring, which flows from rock directly below Naomi Pike Falls, located just north of Blue Rapids. The spring was named in 1846 by Edwin Bryant, a member of the ill-fated Donner-Reed party that endured freezing and starvation while crossing the Sierra Nevada. The countryside around Blue Rapids was well known to travelers, immigrants, gold seekers, and explorers. The springs, now a popular tourist destination, were reopened to the public in 1993.

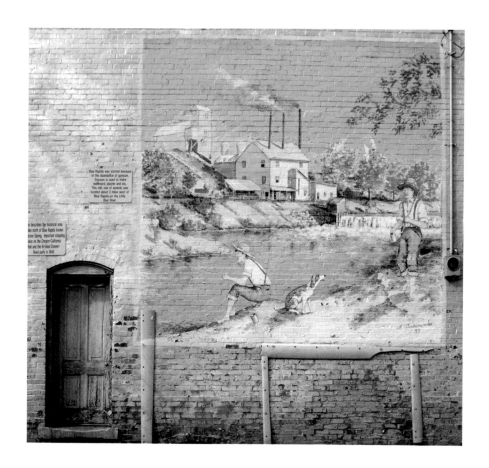

5 **Farmland Mural** 1956
Frederic James

BONNER SPRINGS
National Agriculture Center and Hall of Fame, 630 Hall of Fame Dr. (N 160) (inside)

This mural hails the founding of farmer cooperatives, the mechanism by which farmers come together to increase their buying and selling power. The mural, painted in 1956 by the prominent Kansas City artist Frederic James, was displayed at Farmland Industries International Headquarters in Kansas City, Missouri, for many years and has been moved several times; it was restored in 1981, late 1990s, and 2004.

Farmland Industries was founded by Howard Cowden, who worked to improve the economic situation of farmers and ranchers in 1929 by pooling petroleum orders through his single-pump gas station. His small company became Consumers Cooperative Association, then Farmland Industries in 1967. A Farmland Industries statement describing the mural begins with a quote about Cowden: "You will see the Midwest pioneer clearing the wilderness. He is alone but he is looking to the future." The second scene depicts a farm family, with a farmer "passing on the heritage of the soil to his son." The third scene is a group of farmers forming a cooperative and includes portraits of specific cooperative leaders. The last scene portrays modern agriculture and includes a rainbow, the sign of international cooperatives. The mural was fittingly donated to the National Agriculture Center and Hall of Fame in 2004; Cowden, the "pioneer prairie cooperator," was one of the museum's founders.

Artist Frederic James was an instructor at the Kansas City Art Institute and is best known as a watercolorist inspired by the Flint Hills and Martha's Vineyard. He rarely depicts figures in his work, as are included in this mural, yet the mural's use of "scenes" on a freestanding curved wall seems almost to reflect his interest in theater set design. The mural also reflects his teaching philosophy: "We want our students to regard art as a function of life as well as an esthetic exercise," he once told a journalist. For some, the mural suggests the influence of the regionalist painter Thomas Hart Benton, a friend of James's for twenty years.

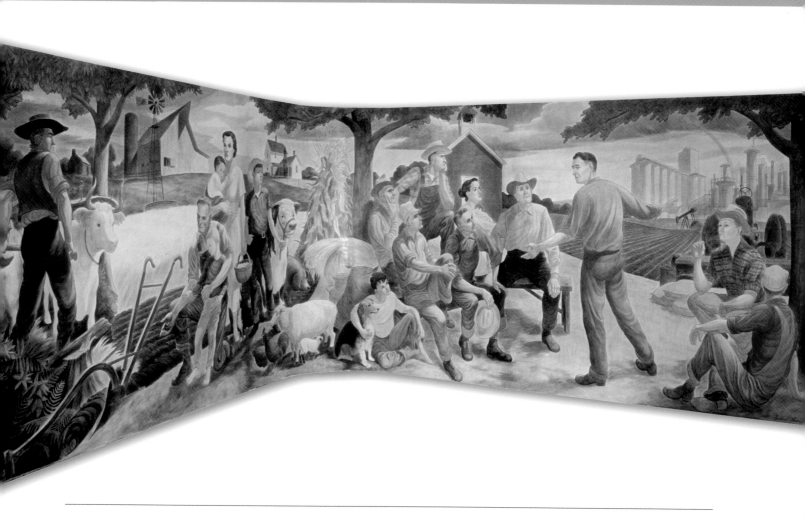

6 *History of Brown County* 1961
Ron Allerton

HIAWATHA
Brown County Historical Museum, 611 Utah St. (inside)

In artist Ron Allerton's commemorative mural for the Kansas centennial, he foresaw Hiawatha's residents working in a highly automated agricultural industry of the future. This idea is illustrated in the scene on the far right side of the mural where a lone figure dressed in what appears to be a space suit operates a red combine while harvesting a wheat field. Behind the combine, in the background, a futuristic agricultural or chemical plant emits waves of magenta-colored gas into the air.

This scene of imagined agricultural progress contrasts sharply with the rest of the mural, where a condensed time-line of Brown County's agricultural history is laid out. Familiar scenes of Native Americans hunting buffalo, a pioneer breaking sod with a horse-drawn plow, corn, sunflowers, a church revival, and a group of men loading hay bales onto a flatbed trailer overlap in a montage similar to many Kansas murals. Allerton's vision of the future is where this mural differs.

Absent in the mural's agricultural future are animals, manual labor, or any signs of domestic life, which are present in earlier scenes. Stylistically, the mural feels modern as well. Allerton's faceted, cubist-like technique gives forms a hard-edged geometric appearance that suits the modern architecture and high-tech combine in the mural's last scene, but belies perhaps the rolling hills and farm animals portrayed in Hiawatha's past. Whether or not Hiawatha residents embraced this vision of the future, the twenty-six-year-old Allerton's predictions look more accurate as time passes and large industrial farms replace family farms. Since 1961 when the mural was painted, Kansas has lost more than 40,000 farms, whereas the average size of a Kansas farm has increased by one-third.

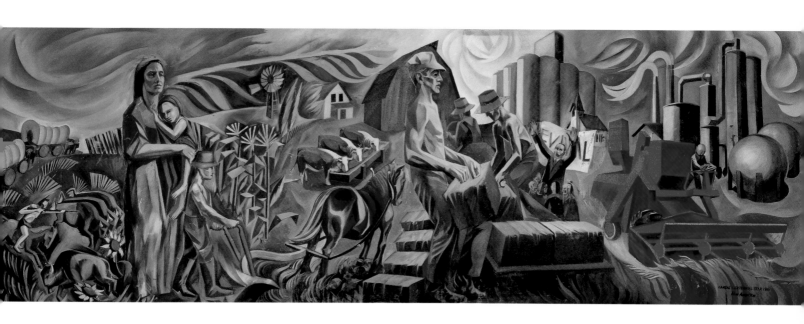

7 *Changing Horses for the Pony Express* 1939
Picnic in Kansas 1938
Kenneth Evett

HORTON
Post Office, 825 1st Ave. East (inside)

"This is the first mural I painted," Kenneth Evett recalled in 1957. "I was still a student at the time, very much influenced by Thomas Benton, and the mural reflects both these facts. Criticism that the people represented look like Middle Europeans, Latins, Creoles, or what-not, seems to me beside the point. Artists have the right and responsibility to use the images, forms, and colors which seem suitable. However, the mural could certainly be criticized as immature and provincial."

In 1938 Kenneth Evett, a twenty-five-year-old art student, was selected by the Federal Art Project's Section program (see No. 27), which commissioned qualified artists to paint murals in new post offices and other federal buildings, to paint a mural for the Horton post office. One year after *Picnic in Kansas* was installed above the postmaster's door, Evett returned to Horton with a second mural to be installed on the west wall above the post office boxes. This time he chose a subject with a clear connection to local history: the Pony Express.

From 1860 to 1861 (when it was outrun by the newly completed transcontinental telegraph), the Pony Express route had a station in Kennekuk, just south of Horton, where riders would change their mounts. In his mural, Evett shows family and station workers gathered around the station, waving goodbye to the rider on a white horse as he departs. In the year that passed between these two murals, Evett had honed his style and focused his intent considerably. Comparing his *Changing Horses for the Pony Express* mural to *Picnic in Kansas*, Evett said, "*Changing Horses for the Pony Express* was more successful in design and color, and although I would not work in that style now, I feel that the mural, seen in the context of its time and place, is a respectable piece of work."

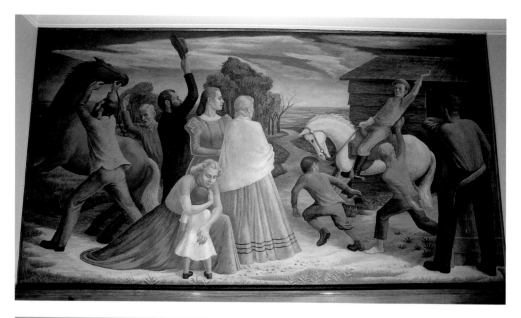

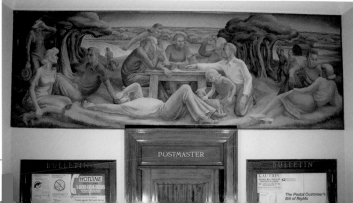

8 *Anthology of Argentine* 1998
Jesus Ortiz, Joe Faus, and Alisha Gambino

KANSAS CITY
Metropolitan Ave. between 30th and Woodland Sts.

"To the Prevailing Spirit of Argentine and Its People—Past, Present, and Future" reads the dedication on the plaque for this mural, epic in both its scale and subject. At 660 feet long and 20 feet high, *Anthology of Argentine* is easily the largest mural in Kansas. This ambitious project, directed by a team of artists from Kansas City and Mexico, traces the historical roots of the Argentine neighborhood from its earliest inhabitants, through its difficult economic and class struggles, to its present-day cultural diversity. In overlapping panels painted in vibrant colors, the human history of Argentine unfolds. The mural begins with the first people to live in the area, the Hopewell, who are followed by other Native Americans including the Osage, Kansa, and Wyandot (see left detail). Joining them is the French trader Chouteau who marks the start of European settlement.

In the panels that follow, the industrial age takes hold and the neighborhood grows. New prosperity at the end of the nineteenth century is good for Argentine, but there is also inequality and racism as illustrated in the yellow diamond panel pictured in the right detail. Here is shown the stratification of the classes, with the wealthy at the top and the poor at the bottom.

As the railroad developed, employing new immigrants from Mexico, Argentine grew into the thriving multicultural neighborhood it is today. The mural shows the joy of families celebrating their new country, interrupted by the devastating flood of 1951, which nearly wiped out the neighborhood. Argentine prevailed with the help of Senator Bob Dole, who secured funding to rebuild. Commenting on his neighborhood's resilience, artist Jesus Ortiz said, "The floods come and go, the other things, but it is the people who have made this area." Argentine shines in the mural's final scenes, which highlight its architecture, the Silver City Days parade, and a hopeful vision of the future inspired by the Kansas Muse.

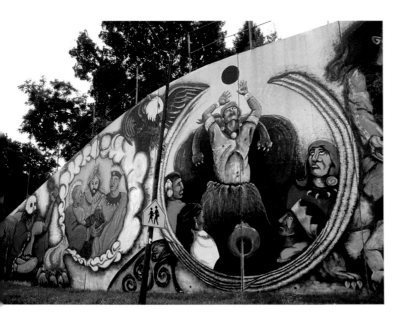
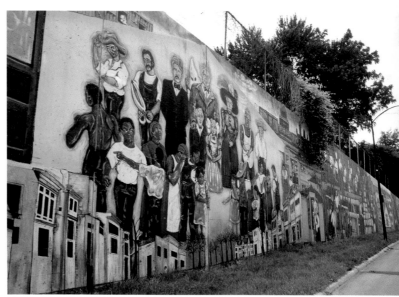

9 *Crossroads* 1995
Michael Toombs with students, community members, and artists from the Kansas City area

KANSAS CITY
Donnelly College, 608 N. 18th St. (inside)

W hen you create the opportunity for people to express themselves in a positive way, in the way of art, the art resonates for a long time," said Michael Toombs, coordinator of the *Crossroads* mural project. Toombs, a graduate of Donnelly's Entrepreneurial Development Program, brought Donnelly students—who come from around the globe—together with college administrators and faculty, as well as local artists and students from Stony Point North Elementary School, Kennedy White Church, and Bishop Ward High School to get to know each other by working on a mural.

At least thirty cultures are represented in the mural's 400 individually painted scenes that are jigsawed together to spell "Donnelly College" with a sunrise-to-midnight landscape appearing through the words. The mural, collaboratively made to depict diverse cultural symbols and experiences, resonates with Donnelly's mission of preparing students for living in an intercultural society. The mural also resonates with the mem-ory of hundreds of individuals sharing their heritage, music, food, creativity, imagination, and learning (see detail).

Working with the college's Multicultural Committee, Toombs invited participation through press releases and by talking with student and community groups. Participants sub-mitted small drawings for the mural showing cultural imagery relating to personal heritage. The drawings were then refined and transferred to the mural. Hundreds of people painted on the mural, whether they submitted a drawing or not.

Through the warmth of his spirit and a little food and mu-sic, Toombs created a safe place for people to talk and make art. The mural helped spawn Storytellers Inc., a multicultural performing and visual arts organization founded by Toombs. The community art process used in the mural, which Toombs dubbed Interactive Arts Education, is integral to the work of Storytellers Inc. Upon seeing *Crossroads* again after many years, Toombs noted, "It feels like a hug, coming into the room."

10 *Justice* and *The Prairie* 1993
Richard Haas

KANSAS CITY
Robert J. Dole United States Courthouse, 500 State Ave. (inside lobby)

Look and listen for the welfare of the whole people and have always in view not only the present but coming generations.

—**Constitution of the Five (Indian) Nations**

This statement is one of six quotes extolling the virtues of the Kansas landscape and the role of the justice system that appear chiseled into the wall of these exceptional trompe l'oeil (painted illusion of three-dimensional objects or space) murals by one of the foremost muralists working today.

The two facing murals, *Justice* and *The Prairie* look, in their solidity and muted palette, as though they could have been created during the New Deal era. *The Prairie* features a family of freed slaves in Nicodemus Town, which was the first settlement in the Midwest established by African Americans, and a family of Native Americans behind a group of trees watching carefully the passing of a wagon train. These scenes are painted in monochromatic blue tones to simulate Portuguese ceramic pictorial murals known as *azulejos*. They are framed by trompe l'oeil architectural relief, and at the center is the figure of Tens-Qta-Ta-Wa, a Native American shaman and brother of Tecumseh.

On the opposite side of the courthouse lobby, *Justice* (shown here) depicts contemporary downtown Kansas City also painted to simulate *azulejos*. Flanking the view of the city, on the right is the family of freed slaves and on the left the family of Native Americans elevated out of their historical contexts from *The Prairie* into the present in full color. In the center, acting as a counterpart to the shaman in *The Prairie*, is the symbolic figure of Justice with children at her side. Haas's masterful technique, combined with incisive quotes, draws viewers into the mural to reflect on the relationship of our justice system to those who historically have been most vulnerable to its laws.

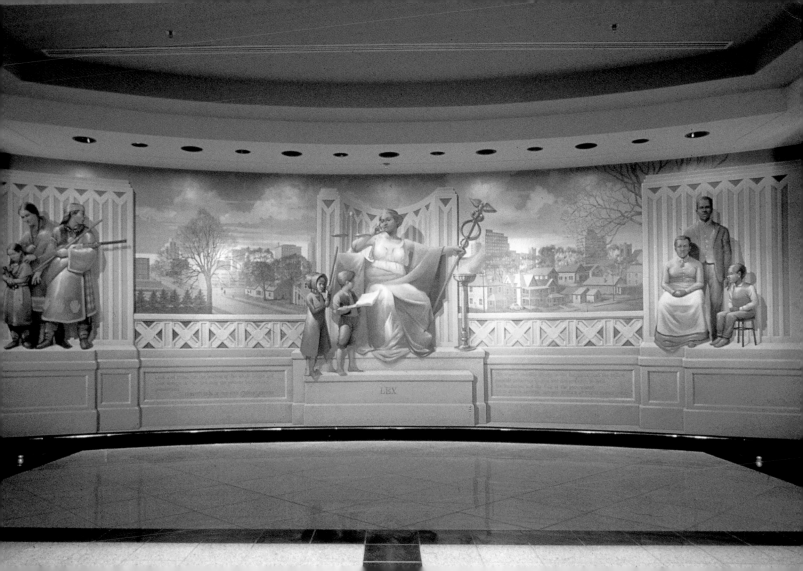

11 *Pillars of Hope and Struggle* 2002
Students at West Middle School with facilitators Christal Clevenger and Dave Loewenstein

KANSAS CITY
West Middle School, 2600 N. 44th St. (inside front entrance)

I can't tell you how impressed I was with their work and how excited I was about what the mural would look like," said artist Dave Loewenstein about the ten student muralists he worked with to produce *Pillars of Hope and Struggle*. "It was exciting to see kids take on such weighty issues in art with such purpose." The mural depicts the hopes and struggles of these sixth-, seventh-, and eighth-grade students, based on their experiences of school and broader issues, atop decorative pillars.

Loewenstein and the school's art teacher, Christal Clevenger, facilitated the project through Young Audiences, an organization that integrates community art resources into school curricula. Loewenstein, who had previously facilitated another mural at the school, helped the students work together to discover the mural-making process of brainstorming ideas, designing the mural, and painting it on the wall.

"I remember at the time, February 2002, all that was in the news was the lead-up to the war in Iraq and the kids were talking about it," said Loewenstein, who encouraged students to make sketches about their concerns and desires. "It became apparent the kids were very passionate and interested in issues of equality and fairness," he said. The design breakthrough came when students talked about studying Greek architecture, including columns, in another class. Thus, each student created a pair of visually linked columns (or pillars) representing a hope and a struggle (see detail).

The mural portrays the students' perseverance regarding education, homework, tests, sports, friendship, racial harmony, and peace. One portrayal of racial inequality elicited strong feelings and misunderstanding from some parents, teachers, and administrators. The school community worked through these concerns and creatively used the mural as a springboard for discussion. To help viewers understand the mural imagery better, students described their ideas in a short video, which is available at the school.

12 *A Thousand Miles Away* 2001
Dave Loewenstein

LAWRENCE
Cordley Elementary School, 1837 Vermont St. (overlooks playground in back)

"It is easy to be brave a thousand miles away, but now I must face the question at short range," wrote the Reverend Richard Cordley, a prominent intellectual and abolitionist in pre–Civil War Kansas, for whom Cordley Elementary School is named. The mural portrays Cordley's account of helping Lizzie, a runaway slave, through Lawrence's underground railroad in 1859 with the help of Mrs. Cordley and Mr. Monteith.

In the mural, Mr. Cordley is shown recording his thoughts. "When he was a student in college, he and many peers supported the abolitionists and were against slavery but didn't have to deal with the reality of it," explained muralist Dave Loewenstein. "The heroic part for the Cordleys, Monteiths, and Lizzie was that they were afraid, but they did it anyway because they felt it was right. To me that was very compelling."

Although the school's Parent Teacher Organization hired Loewenstein to design and paint the mural, students, teachers, and the local National Association for the Advancement of Colored People (NAACP) were also involved in the planning process. Students brainstormed ways to capture the story through writing and drawing workshops led by Loewenstein. "They were really interested in the sense of time counting down," said Loewenstein, because in the story the race between the underground railroad and the federal marshals is intense. Thus, Loewenstein arranged the mural's elements around a clock face, with Lizzie and Mrs. Cordley at the center.

Among the mural's depictions are U.S. marshals enforcing the Fugitive Slave Act; Mrs. Cordley's plan to hide Lizzie, if pursued, between a mattress and featherbed; Lizzie and Mr. Monteith disguised for travel; and Lizzie's escape to Canada in a covered wagon. History comes full circle in the contemporary classroom scene where students, taught by an African American teacher, see the real impact of this story on where we are today.

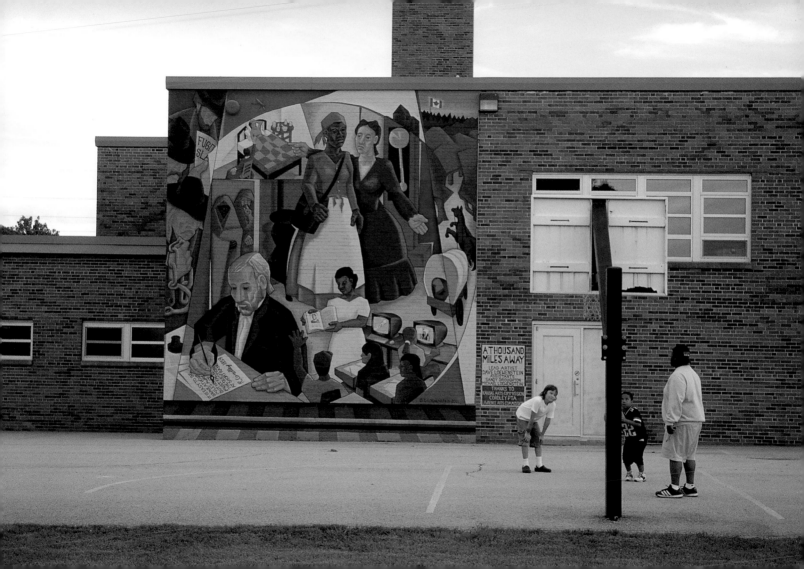

A THOUSAND
MILES AWAY

LEAD ARTIST
DAVE LOEWENSTEIN
ASSISTS
SANDY GROGOUTON
MICHAEL LOEWENSTEIN

THANKS TO
KANSAS ARTS COMMISSION
CORDLEY PTA
LAWRENCE ARTS COMMISSION

FUGITIVE
SLAVE

13 Auditorium Mural 1941
Franklin Gritts (Oou-nah-ju-sah)

LAWRENCE
Haskell Indian Nations University, Auditorium, 155 Indian Ave. (inside foyer)

The name of the artist who painted this 1941 mural, in the style of an important school of Indian painting, was nearly lost: the signature had been painted over. The artist's family, however, noticed the missing signature and informed Haskell Indian Nations University about it, a revelation that coincided with research on the muralist during a 1990 renovation of the auditorium. In 1994, for his eightieth birthday, Cherokee artist Franklin Gritts (his Cherokee name means They Have Returned) returned to Haskell for an honorary reception, and he then re-signed the mural.

This mural is the only one of several he painted at Haskell that still remains. Among the mural's romantic scenes of early plains Indians, described in a 1941 Haskell newspaper, are "an old-time home scene," "returning from an expedition," "the work of putting up camp," and "a semi-modern Indian pow wow" (the detail that is shown here).

Gritts grew up in rural Vian, Oklahoma, and spoke only Cherokee until grade school. In the 1930s he studied art at Bacone College under acclaimed Creek-Pawnee artist Acee Blue Eagle and at the University of Oklahoma under Oscar B. Jacobson. Jacobson, of European ancestry, said his Indian students painted from "a different racial point of view," and he encouraged them to depict cultural themes from memory without using models or photos. These students influenced an emerging style emphasizing flat forms, design, and color.

During college, Gritts sold a painting to Eleanor Roosevelt. He became the university's second Indian student to receive a Bachelor of Fine Arts degree. After college, Gritts received additional training and became a teacher, professional painter, and muralist. Yet Gritts was not comfortable with the expectation, popular then, that Indian artists should paint "Indian" themes, noted his son Galen. After learning photography in World War II (where he was injured on the ill-fated USS *Franklin*), he eventually left teaching for commercial art, becoming the art director for *Sporting News* magazine for many years.

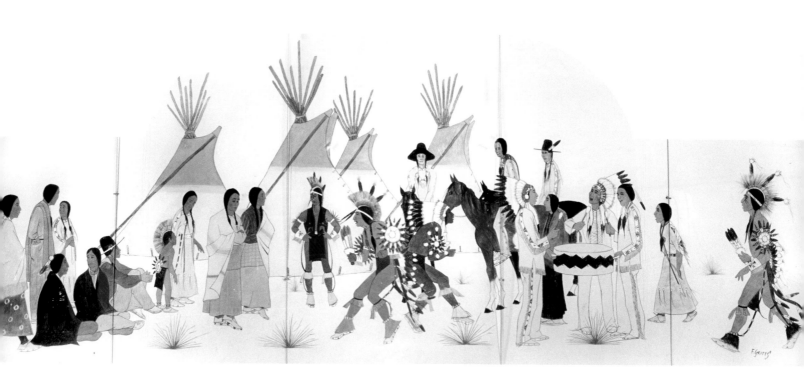

14 *Berkosaurus* and *Out Standing in His Field* 1998-2004
Missy McCoy

LAWRENCE
Footprints, 1339 Massachusetts St. (inside)

What do the paintings of John Steuart Curry and dinosaurs have in common? The answer lies in the imagination of Footprints owner and local art patron Mick Ranney, who commissioned muralist Missy McCoy to bring his varied interests to the walls of this popular Lawrence shoe store. Beginning in 1998 in the front room, McCoy transformed the interior by weaving together some of Curry's best known paintings, *The Line Storm*, *Our Good Earth*, and *Kansas Cornfield*, into a larger-than-life homage to the famous artist.

In the adjoining room, entered by walking through a doorway in *Out Standing in His Field*, Ranney envisioned and McCoy painted a landscape very different from that of Curry's agrarian idealism. Set in a tropical landscape, a pair of beautifully rendered dinosaurs frolic, their long necks and tails arching over shoe and sandal displays. Most striking is the brightly colored red and blue dinosaur that resembles a duckbill hadrosaur except for its unusual head crest, which looks a lot like a Birkenstock sandal. This, it turns out, is the mythological "Berkosaurus" (shown here) that first appeared to the store owner in a dream about an archaeological dig of his front yard.

On other walls in the store, McCoy painted a traditional gypsy wagon, a view looking through the store's north wall down Massachusetts Street, and a fanciful interior in the store's one-of-a-kind restroom. In recalling how customers reacted to her as a kind of living display while she was painting, McCoy said, "Essentially you are painting for other people. That scaffolding is almost like a stage sometimes, and you are the performer."

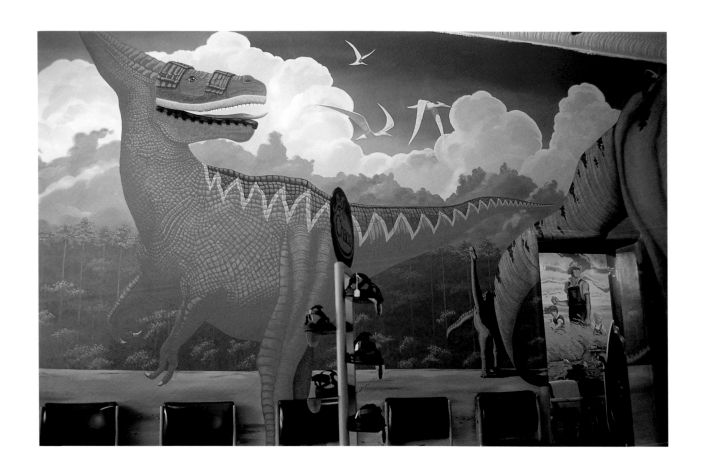

15 *Cranes* 2001
Lora Jost

LAWRENCE
Reed and Dillon Associates, 1213 E. 24th St. (inside)

Jack Hope wanted to call attention to the creative approach to interior design that set his company apart from many in the field. A mural on the twenty-two-foot-high wall inside the company's showroom was just the place to do it. Hope foresaw showing customers the unexpected juxtaposition of kitchen cabinets with the dynamic and brightly colored artwork of artist Lora Jost. He thought this would inspire them to think "outside the box" when considering new designs for their homes. Clean lines and rich simplicity are what Hope gravitates toward when it comes to interior design. This is an aesthetic that he also admires in the art of Japan, and that was the prime inspiration for the design of the mural.

When they began the mural project, Hope showed Jost examples from art history that related to the sensibility he liked in Japanese art. He also asked Jost to include five elements that he felt symbolized his vision: a pine tree, moon, crane, bamboo, and water. Initially Jost, whose work often is characterized by subtle shifts in value achieved through the manipulation of mosaic-like shapes of color, struggled with combining these elements in a Japanese style. So she and Hope agreed that she would try interpreting his vision in her own style. It worked.

Jost's final design, a detail of which is shown here, brings together the five elements in an animated artwork filled with intersecting branches and the overlapping visualized voices of birds. The effect of the mural, interesting for a static medium like painting, is one of sound and motion that activates the space and brings nature indoors. This mural is especially brilliant when viewed at night through the building's large windows.

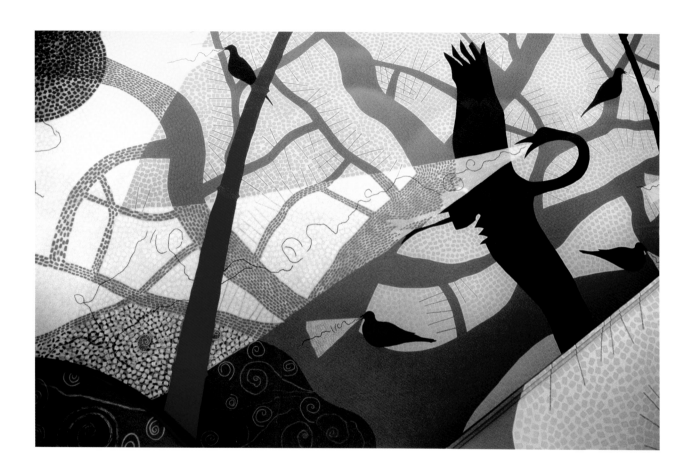

16 *Make Your Life in Harmony* 1997
Amy Carlson with elementary school children

LAWRENCE
East Lawrence Center, 1245 E. 15th St. (outside bench)

The mosaic murals on this bench, "dedicated to kids in honor of their imaginations," comprise delightful neighborhood scenes designed by artist Amy Carlson (detail shown here). Carlson worked with children from neighborhood schools near the recreation center where the benches are installed. Commissioned by the Lawrence Percent for Art program, the mural is made of Venetian glass integrated with four-inch ceramic tiles decorated by the children.

With "neighborhood" presented to the children as a central theme, Carlson was struck by their drawings in the ceramic tiles of nearby houses, train tracks, a cemetery, a trampoline, a weightlifter, a bicycle, a windmill, and a dam and bridge. Their playful artwork informed her own focal image, a child walking through the neighborhood "conducting" a road, street signs, a bicycle, and cars in a swirl of leaves and air.

"When you have an artist work with kids and they make art to put with an artist's, it validates them," said Carlson, "It says you have just as much to say as I do." Some children who worked with Carlson embellished their tiles with textures and imprints made with beads, shoes, leaves, and tools. Others carved their tiles with area scenes and activities. Still others responded to the question, "What would the world be like if art ruled the world?" with phrases such as "houses would be made of glass," "my dad would be blue," "animals would be silent," "hair would be like licorice," "kids would draw the rules," and "artists would be rich."

Working with Carlson and the children, Dave Loewenstein completed an accompanying mosaic bench. Two other public art commissions at the site, housed inside the recreation center, include Ardys Ramberg's hanging sculpture and Kathy Barnard's stained glass windows. The Lawrence Percent for Art program, begun in 1986, authorizes the city to set aside up to 2 percent of capital improvement costs to fund visual art in public places.

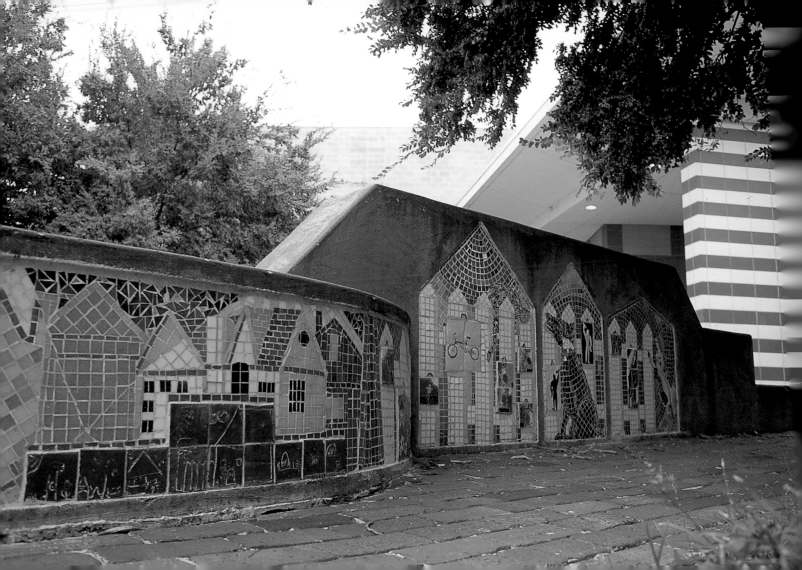

17 *Life Changes* 2002
Apprentice artists directed by Joe Faus and Cathy Ledeker and assisted by Kendra Herring and Bruce Humphries

LAWRENCE
Community Health Facility, 200 Maine St., Bert Nash Center (inside 2nd Fl., Ste. A)

Fairies, birds, butterflies, and gnomes guide the viewer through a journey of "birth, discovery, reflection, acceptance, and renewal," states the text that accompanies this mural odyssey. The mural was painted by eighteen apprentice artists sponsored by a social service program called Jobs in the Arts Make Sense (JAMS), a program of Van Go Mobile Arts in Lawrence. The youth apprentices worked with professional artists for an hourly wage, and in the process learned art-making techniques and job skills.

The mural is a wonderland of lush foliage, roots, rocks, leaves, mushrooms, rivers, streams, and volcanoes. The progression of the life of an individual is portrayed, linked to the cycle of the seasons and the course of a day. Images of earth, wind, fire, and water are integrated into the human form. Transformation continues through the mural as butterflies are metamorphosed into people, stars, and then leaves. "We discover the world as innocents," the accompanying text states, "and grow to play in its bounty as adolescents. We confront fears, establish roots and community as we mature. In old age comes reflection and acceptance."

"When the kids have the confidence to express their ideas, they break out of the box to do stuff that is strong and original," said Cathy Ledeker, one of the professional artists who worked on the project. To plan the mural, the artists and apprentices first toured the mural site, a hallway in a community mental health center, and met with some of the center's staff. Beginning with key words such as "community" and "diversity," the group worked to interpret these words in ways that avoided cliché. Two particularly creative apprentices, with an interest in mythology, led the conceptualization process. The group made sketches, chose themes, and composed a design. Finally they painted the mural, engulfing viewers in a fresh and magical new world.

18 *Starry Way* 1987
Dennis Helm assisted by Dalton Howard, Clare Tucker Bell, and Tamara Brown

LAWRENCE
Liberty Hall, 644 Massachusetts St. (inside large auditorium)

The universe, as the image of All in All, represents the origin of everything and the home to which everyone returns. In Lawrence's Liberty Hall the main auditorium was decorated to form a metaphor of rising, first through the cloud zone beneath the balcony, then up to the universe and reaching the sort of heaven in the child-like imagery painted on the ceiling beams." Thus begins Dennis Helm's description of his mural cycle in Liberty Hall as written in his essay "Sea Above, Sea Below."

In his writing, Helm proposed that a "sea archetype" was the major common influence on the work of several well-known Lawrence artists. From the fossilized remains of ancient seas underlying the landscape to the seas of wheat upon the earth and to seas of stars above, Helm saw the seeds of a regional school emerging in art being shaped by this universal symbol. He connected his own work to this idea, as expressed in his description of the Liberty Hall project:

From 1985–1987 I painted 19 mural areas in Liberty Hall. Other artists were involved: Dalton Howard executed three mural areas on the upper north balcony wall, Clare Tucker Bell made a ceramic frieze for the balcony lip, and Tamara Brown gave us the idea for the connected Saturns motif used throughout the ceiling and the carpet. That anything so thematically coherent as Liberty Hall could grow out of a group effort points to an underlying archetypal influence. My enormous mural Starry Way (1986) was painted above the stage with the help of two assistants. Herein, one is invited to move through a corridor of stars, past comets and endless nebulae, into the depths of space. Surely this is the image of the greatest ocean of all.

19 *First City Mural* 2003
Michael Young

LEAVENWORTH
406 Shawnee St.

Shaped like the state of Kansas with a star pinpointing the site of Leavenworth, this nostalgic mural celebrates the town's early years by re-creating downtown's Shawnee Street circa 1870. For years, First City Photography owner Debbie Bates-Lamborn wanted to recognize Leavenworth's history with a public gesture of some sort. Her vision was finally realized when she put the historical photographs from the David R. Phillips collection in the hands of noted historical painter Michael Young. Young's design is a seamless composite of Phillips's photos painted in sepia tones to imitate their look and evoke a historical feeling.

Anchoring the center of the mural is larger-than-life showman Buffalo Bill Cody who called Leavenworth his home for a time and frequented the Star of the West Saloon pictured to his right. Flanking Cody on the left are inset panels featuring legendary scout and gunman Wild Bill Hickok and behind him the Planter's Hotel where Abraham Lincoln spoke in 1859. If you look closely, you can see Lincoln standing on the hotel's steps. Smart business people at the hotel maintained separate bars there with sympathetic bartenders for both proslavery and antislavery supporters. To Cody's right (in inset panels) are Geraldine Jones, Leavenworth's first African American teacher, and behind her the Union train depot.

The title of the mural comes from Leavenworth's claim as the first city established in the state. It became the first city in June 1854 when proslavery supporters poured into Kansas from Missouri to stake claim to the town site. Their anxious rush was spurred by the signing of the Kansas-Nebraska Act. This act put the future state's position on slavery into question, because it stipulated that the people of these territories could decide for themselves whether slavery would be legal. In their zeal for control, the proslavery men appeared to have little concern for the fact that the land they were claiming belonged to the Delaware tribe, making their taking of it tantamount to stealing.

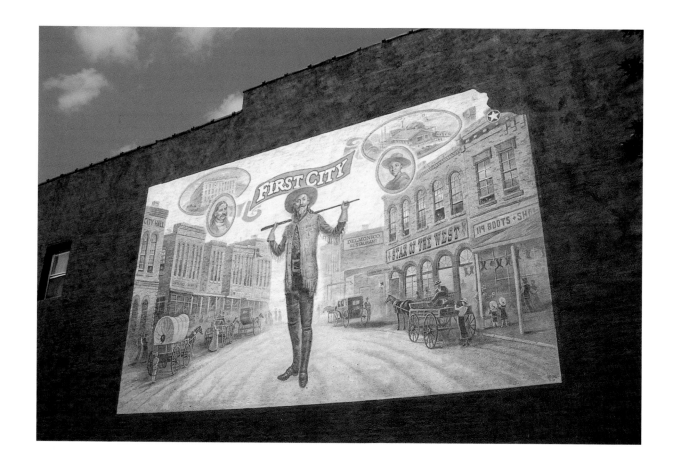

20 *We Are the Dream* 1980
Travis Mosely, Willie McDonald, and Harold Carter

MANHATTAN
Hale Library, Kansas State University (inside 4th Fl.)

Nestled deep within Hale Library, the *We Are the Dream* mural stands as a testament to the vision and dedication of the artists and organizers who imagined an artwork that would "express how Black, Chicano, and Native Americans perceive their cultures" (A. Seals, Black Student Union) and would "be a source of identification and cultural reinforcement for minority students and a symbol to all students of who we are" (T. Guillen, artist).

The idea for the mural emerged from a discussion among members of the student Minority Center in 1978 concerning how to improve their space on the fourth floor of the then Farrell Library. Working closely with campus minority groups, lead artists Travis Mosely, Willie McDonald, and Harold Carter developed the mural's design and incorporated changes and additions during the process to reflect the interests and concerns of their counterparts from different ethnic groups. One important change involved the depiction of Native Americans in front of the waving United States flag that makes up most of the mu-

ral's background. The Native American students did not want images representing their culture to be shown in front of the flag because they perceived the Indian Nation as sovereign. In response to this concern, artists Mosely, McDonald, and Carter altered the design by replacing the flag background behind the Native American imagery with an image of the shape of the United States free of state lines, as it would have been before colonization and as it was still viewed by the Native American student body.

On 24 October 1980, after two years of organizing, designing, and painting, the completed *We Are the Dream* mural was presented to the university. This truly collaborative effort, which expressed the cultural pride of Chicano, black, and Native American students, was hailed by its creators and fellow students alike. Antonio Pigno, director of the Minority Center at the time the mural was painted, summed up the group's efforts best when he said, "This is an accurate representation of creating out of nothing a work of art and a sense of pride and community."

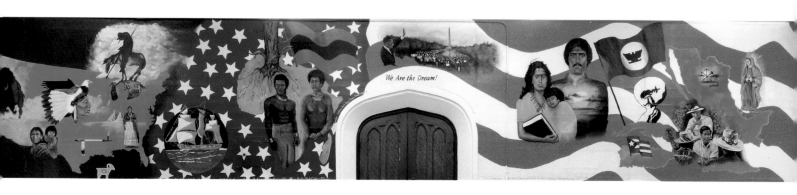

We Are the Dream!

21 *The Industries, Agriculture, The Arts,* and *The Home* 1934
David Overmyer

MANHATTAN
Kansas State University, Hale Library (inside Cathedral Room)

In the middle of the *We Are the Dream* mural (No. 20), below the scene of Martin Luther King Jr. addressing supporters at the Washington Monument, there is a wide doorway set into the wall. Opening it reveals a wonderful surprise. The doorway opens onto a small balcony overlooking the majestic, Gothic-inspired Cathedral Room of the original Farrell Library built in 1927. Looking back up at the balcony from the floor below, one sees that the doorway is magically also at the center of the series of murals painted by David Overmyer and his assistant Byron Wolfe in 1934. Like a portal through time, this doorway connects the work of artists whose very different visions of the college were created on opposite sides of the same wall forty-six years apart.

In contrast to the multicultural imagery in *We Are the Dream*, Overmyer's murals idealize the college by portraying its major fields of study through a series of allegorical figures modeled on classical European art sources. In the four mural panels, Overmyer created scenes relating to the industries, agriculture, the arts, and the home. His conception of these allegorical scenes was influenced in part by his academic art training and by the prevailing trends in illustration and the decorative arts, which integrated elements of classical symbolism with design and coloration found in Art Deco and Art Nouveau styles.

At the dedication of the murals on 26 October 1934, college president F. D. Farrell expressed his support for the artist and praised him, as a writer for the *Kansas Industrialist* recalled, for handling this theme in a conservative style, rather than in the modernistic manner of so many artists of "the last few hectic years" whose work would probably soon be "as obsolete as a glass cage full of stuffed birds."

22 *Student Achievement* 1986
Eric Bransby

MANHATTAN
Kansas State University, Nichols Hall (inside)

If a disaffected student had not set the fire that gutted the interior of Nichols Hall in 1968, Eric Bransby might never have had the chance to paint this unique mural. The arsonist who set the fire was never found, but many people connected the blaze to the emotional protests of the war in Vietnam. After the fire, the fate of the building was in question. It wasn't until 1975, when students raised $10,000 in seed money, that rebuilding began. Years later, after restoration was complete, the students' funds were put to use to commission a mural that would celebrate Nichols' history. Artist Eric Bransby recognized the symbolic importance of the project. He said, "I was very stimulated by the story of how Nichols rose from the ashes and became again an entity at Kansas State University."

The mural, titled *Student Achievement*, is installed high above the floor in the building's atrium, and the complex interior architecture of the space is echoed in Bransby's mural design. Characteristic of his later murals, he divided the mural into individually shaped panels that relate to the architecture. Within the mural's thirty panels, he painted portraits of students representing the building's past and present functions, including music, athletics, academics, and dance.

Like his teachers Jean Charlot and Thomas Hart Benton, Bransby believes that integrating his mural designs with the surrounding architecture is essential. He said, "A mural is not simply a big painting or a view out an imaginary window. It has an architectural function to perform.... If the art does not work with the building, it loses its meaning and becomes even less satisfactory than mere ornament."

23 *D. O. Bacon's Art Gallery* 1901-1902
D. O. Bacon

OSAWATOMIE
Osawatomie State Hospital, Administration Building, Osawatomie Rd. (inside)

In 1901, D. O. Bacon, a patient in the men's ward of the Old Main Building at the Osawatomie State Hospital, the first state-supported mental hospital in the country, began painting murals on two walls of his small, dark room. He painted a patchwork of images likely copied from old postcards, among them floral designs, ocean ships, foreign landscapes, and pastoral scenes. As confirmation of their significance, the murals (a detail is shown here) remained untouched by patients and workers for seventy-one years.

The hospital's beautifully handwritten, turn-of-the-century records contain little information about Bacon's life. He was admitted to the hospital at age sixty-three and was eventually discharged. At the time, work was the main form of therapy at the hospital. Patients farmed, canned, quilted, and sewed. The hospital staff may have provided Bacon with paints. "Bacon imagined he was making large sums of money. From being steady and sedate, he became very jolly. His problems were, like van Gogh's, attributed to sunstroke or heatstroke," stated an article that accompanies the mural.

By 1970, the wings of the Old Main Building needed to be razed, but superintendent George Zubowicz and his staff wanted the murals saved. Preservation was unlikely because the paintings were on plaster attached to walls three bricks thick. Robert Seaborn, who worked to preserve murals in Europe following World War II and whose sister worked at the hospital, provided the answer. In 1971, Seaborn secured the murals between plywood, sawed through the brick walls, and removed the murals "amidst cheering patients, staff, and townspeople."

The hospital staff and patients held bake sales, talent shows, and community events to raise $1,300 for the preservation effort. Bacon's murals, mounted for display in the front hall of the Old Main Building, were relocated to the hospital's administration building in the mid 1980s. These murals remain as a lasting testament to the patient's need for self-expression.

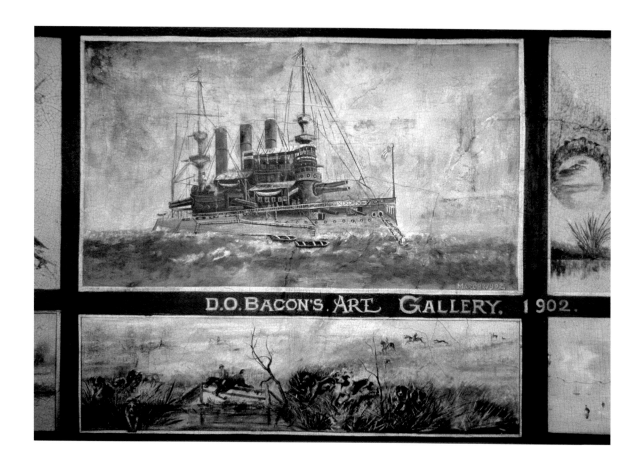

D.O. BACON'S ART GALLERY. 1902.

24 *Cottonwood Falls Monarch Mural* 1977
William H. Howe

OTTAWA
Ottawa Middle School, 5th and Main Sts. (inside)

As William Howe tells it, the defining event of his childhood was when his father, an entomologist, brought home a cage full of caterpillars and left them on the dining room table. During the following days, Howe watched spellbound as the striped caterpillars metamorphosed, first forming chrysalides and then emerging as elegant black swallowtails. From this experience grew a lifetime passion for butterflies. Now, at seventy-eight, Howe is one of the country's most admired butterfly artists. His paintings are in museum collections around the world, and his seminal book *Butterflies of North America*, illustrated with 2,033 watercolors, is hailed by many entomologists as the greatest volume ever published on butterflies of this continent.

Howe is a generous artist and lifelong resident of Ottawa, so when a wall in the middle-school cafeteria became available for a mural, he volunteered knowing exactly what he was going to paint: a memory from September 1962. Howe and a friend were collecting butterflies in the Flint Hills when a spectacular "wall of monarchs" appeared flying south over the crest of a hill. "There were millions as far as you could see," Howe recalled. The mural, a detail of which is shown here, captures this dramatic, dreamlike moment at a scale that allows viewers to enter the scene and inspect the monarchs up close.

In 1995, the middle school was closed, condemned, and slated for demolition. The building, and Howe's mural, would have been lost if not for the efforts of local citizens who fought for five years to have it preserved. Their work paid off. In 2000 the building was placed on the National Register of Historic Places, thus ensuring its protection; in 2005, as the building was being renovated, Howe was able to restore the mural that he maintains is "my masterpiece, the finest work I've ever done".

25 *Potawatomi Children* 1997
Laurie H. White Hawk

POTAWATOMI PRAIRIE BAND RESERVATION

Early Childhood Education Center, 15380 K Rd. (inside hallway, by appointment only, 785-966-2527)

Based on her sketches of children dancing at a Potawatomi children's powwow, Laurie H. White Hawk, an internationally recognized artist, painted this mural for the newly built childcare facility. White Hawk, whose Winnebago name, Wakán Je Pe Wein Gah, means "Good Thunder Woman," is a member of Nebraska's Winnebago and Santee Sioux nations. For White Hawk, it is particularly fulfilling to make art specifically for the enjoyment of native people, "art that makes for a happy environment."

White Hawk's mural, one of three in the center, is painted in the flat style, an Indian painting style with roots in Santa Fe in the 1920s. White Hawk learned this technique of applying colors next to each other but not overlapping while a student at Haskell Indian Nations University in the 1970s. The mural's bright colors reinforce this cheerful children's scene.

The children in the mural wear costumes that represent particular dances. The boy in red represents the Grass Dance, a rev-erential dance to mat down the tall pasture grass to prepare a place for dancing. The two girls represent the Jingle Dance, traditionally performed by women whose costumes themselves become musical instruments with bell-like "jingles" made from the lids of tobacco tins. The smaller boy represents the Fancy Dance, a contemporary free-form dance that incorporates cartwheels, splits, and other movements that draw attention to the dancers and their outfits. The Potawatomi Princess, wearing a crown and banner, is selected every year to represent the nation at events. White Hawk bordered the mural with designs from Potawatomi ribbon work. The ribbon motifs traditionally represent specific families or clans.

The Prairie Band Potawatomi originated around the Great Lakes but were forced west by white settlement and the U.S. government. Today, the murals of White Hawk and other artists help reservation residents actively celebrate cultural traditions.

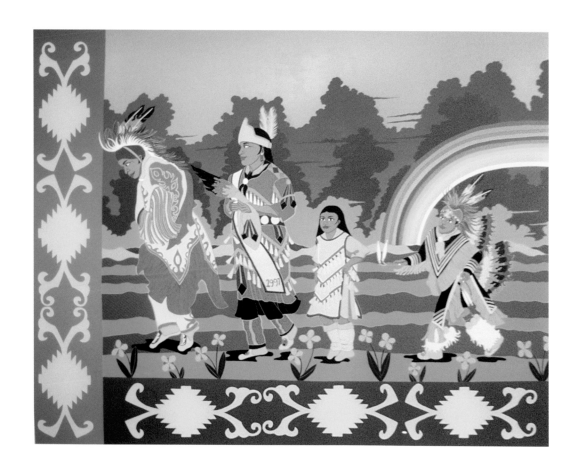

26 Sabetha Bank Murals 1965
Artist unknown

SABETHA
United Bank and Trust, corner of Main and Washington Sts. (facing north and west)

In the mid 1960s, a seven-inch rainstorm damaged the interior of Sabetha's bank. "I just remember when we came to work that day there were two to three inches of rain all over the floor," said Jarry Mishler, who worked at the bank. Thus the directors of the bank, then Farmers State Bank, decided to do a major remodel. As part of this effort, six tile murals were made to replace the upper portion of six large half-moon windows in the bank's lobby (three of six appear in this photo).

"Here the bank has added what many believe will be a landmark of Sabetha for many years to come," said a 1965 article in the local newspaper. Comprising small square ceramic tiles on a grid, the beautifully designed murals depict the community's industry and farming history within a landscape of sweeping diamond-shaped pastures. The three north-facing murals depict a farmer and plow, a cornfield, and a farmer and tractor.

The three west-facing murals depict Holstein cows representing the dairy industry, a factory building, and a steer representing the cattle industry. There was never anything but praise for the murals, said Mishler, because people always appreciated the fact that the murals honored what the community was about. Much of the building's original marble, wood, and brass were retained in the remodel, as well as the impressive eight-ton Mosler vault first installed in 1929.

Sadly, the name of the artist who created these murals appears to have been lost. The architectural firm Hershman & Douglas of St. Joseph, Missouri, remodeled the bank and hired the muralist. This firm no longer exists, and the architects who hold their old records have no information on the bank remodel. The bank has no record of the artist either, nor was the artist's name mentioned in the 1965 article about the bank's remodel.

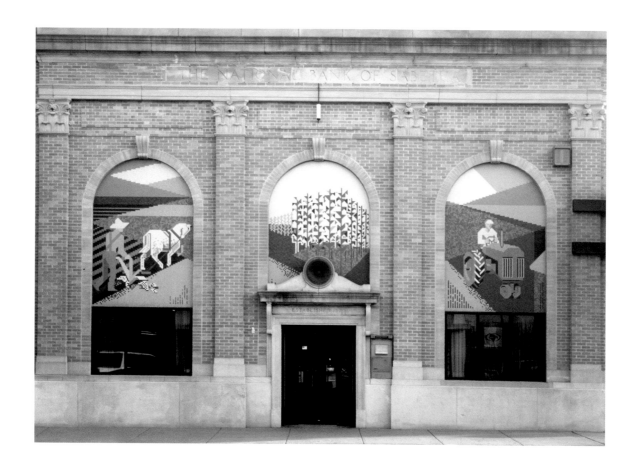

27 *Men of Wheat* 1940
Joe Jones

SENECA
Post Office, 607 Main St. (inside)

Between 1934 and 1942 the federal government commissioned more than 1,000 murals for new post offices and federal buildings across the country. This unparalleled civic art achievement was driven by a series of new art programs designed to combat the effects of the Great Depression. The program responsible for the majority of the new murals was the Section of Painting and Sculpture (later called the Section of Fine Arts). The philosophy of the Section, as it was known, was given by C. J. People in the program's bulletin on 1 March 1935: "Without being sentimental, the Section hopes that in employing the vital talents of this country, faith in the country and a renewed sense of its glorious possibilities will be awakened both in the artists and in their audiences."

In 1939 the Section held the largest mural competition the United States has ever seen—the Forty-Eight States Competition. Its ambitious goal was to place a mural in each of forty-eight newly constructed post offices. In Kansas, Seneca's new post office was chosen as the location.

Artist Joe Jones's (see photo, page 226) original design met with local criticism. Among the concerns were that the farm depicted had only wheat fields and did not represent the diversity of crops grown in the area; the landscape lacked farm buildings or a homestead; and the tractor and combine, both painted green, unintentionally gave the mural a John Deere bias, which upset users of Case International Harvester equipment. These concerns illustrated the difficulties of mounting a national mural program, namely, that some artists were unfamiliar with the specifics of the locality they were trying to depict, while local residents were challenged in giving constructive input to artists. In the end, Jones modified his design at the urging of the Section's director, including replacing the John Deere name on the green tractor with his own signature.

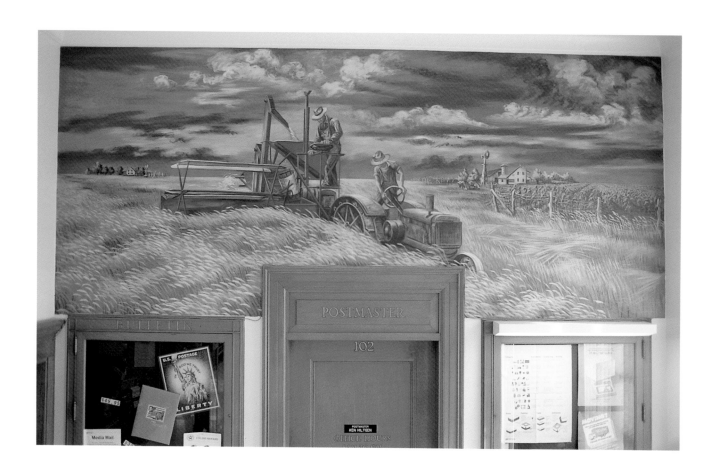

28 *A Look Back* 1992
Charles Goslin

SHAWNEE
Shawnee City Hall, 11110 Johnson Dr. (inside)

Charles Goslin's sprawling historical tableau, prominently installed in the lobby of City Hall, encourages citizens to stop and consider their town's roots. From an early Native American village to the diversity and rapid development of contemporary Shawnee, the mural retraces the events and people that have shaped the town's colorful history.

The mural is divided into three panels that follow Shawnee's past in reverse chronological order from right (past) to left (present). In *Early Beginnings to Civil War*, Goslin juxtaposes the Native American village of Gum Springs with the arrival of a covered wagon along the Santa Fe Trail. These re-created scenes of the town's past are framed, throughout the mural, by portraits of the actual historical figures from each period, including Native Americans, early immigrants, business leaders, and politicians.

The next panel, *Civil War to Turn of the Century* (detail shown here), begins with William Quantrill riding through downtown with a flaming torch in one hand and a gun in the other. Marking a transition to more peaceful times, Charles Bluejacket, known to many as the "Father of Shawnee," is then shown reading to his children. Following this scene is a bustling downtown street in the late nineteenth century that is watched by, among others, Jesse James. *Turn of the Century to Present*, the final panel, highlights the fast pace of change in the twentieth century. A succession of newer and newer automobile models drive into the foreground as modern buildings and new businesses grow along the town's skyline. In a final group of portraits—which includes that of the artist, his son, and his grandson—Goslin brings the mural into the present.

As a chronicler of Shawnee's past, Goslin recognizes that history is often presented in fragments out of context. He therefore takes extra care in reassembling these fragments in carefully choreographed compositions that help viewers to see and appreciate their own connection to history.

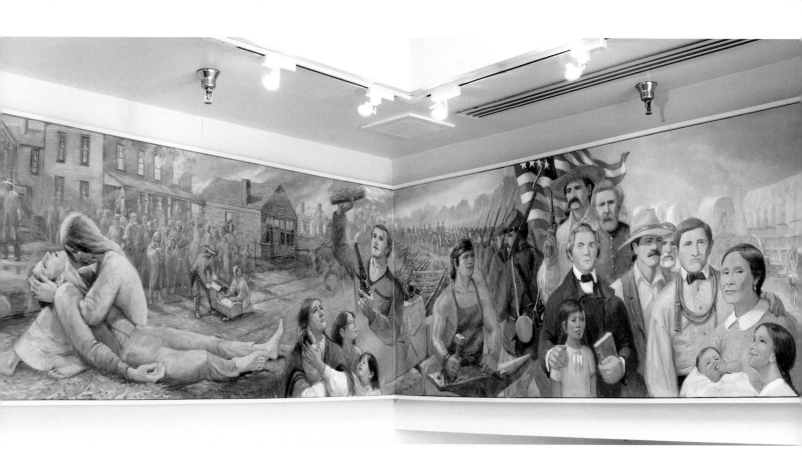

29 St. Mary's Church Murals 1901
George F. Satory and Thor Zukotynski

ST. BENEDICT
St. Mary's Church, St. Benedict and Wichman Rd. (inside)

Rising high above the center of the small community of St. Benedict is St. Mary's Church. The straightforward, unadorned exterior of the Roman-style church, built with limestone quarried by parishioners at a nearby farm, gives few clues about its lavishly decorated interior. It is the treasure of art within the church, including stained glass, sculpture, and wall painting, that is the basis for its place on the National Register of Historic Places.

In 1901, seven years after the church was completed, George F. Satory was hired to illuminate the interior with decorative patterns and designs imbued with Christian symbols. Satory's highly detailed decorative painting, achieved with the use of stencils (see detail), abundantly adorns the church's columns, window openings, vault ribs, bosses, walls, and ceiling. The effect is one of splendor and is unlike any other wall painting in Kansas. Satory was a prolific artist, but of the 150 churches he decorated between 1891 and 1931, it is believed that only his work at St. Mary's has been preserved. This fact makes even more significant the magnificent restoration of the church's interior that was undertaken between 1980 and 1983. Led by Onaga artist Joe Oswalt and assisted by his wife, Anita, and the church's parishioners, all of Satory's original work was patiently and precisely repainted.

In addition to Satory's stenciled wall decorations, fourteen large oil paintings—three painted directly on the plaster wall above the altar—also decorate the church. These were painted in 1901, in cooperation with Satory, by Russian-born artist Thor Zukotynski. Themes for these paintings include Faith, Hope, Love, and the Assumption of the Virgin behind the altar; six scenes from the life of Mary in the nave celestory; and the four major prophets in the transept. An excellent brochure available at the church describes in more detail the subjects and symbolism of the church's artwork and the process of restoration.

30 *Aspects of Negro Life: Slavery through Reconstruction (after Aaron Douglas)*

2005

Directed by Dave Loewenstein, assisted by Stan Herd and high school volunteers

TOPEKA

Aaron Douglas Art Park, southwest corner of 12th and Lane Sts.

There may be no better way to recognize a great artist than to restore his art in the minds and eyes of those in his hometown. This is exactly what a visionary neighborhood revitalization group in Topeka did by coordinating the re-creation of this dynamic and powerful mural by Topeka native Aaron Douglas. Originally commissioned in 1934 by the Public Works Art Project, *Slavery through Reconstruction* is one of a four-panel cycle that Douglas created on the subject of African American history for a Harlem branch of the New York Public Library.

The densely composed mural filled with silhouetted figures, divided into shapes of color by concentric rings of light, combines references to specific historical events with more symbolic images. Douglas described the mural in 1949: "From right to left: the first section depicts the slaves' doubt and uncertainty, transformed into exultation at the reading of the Emancipation Proclamation; in the second section, the figure standing on the box symbolizes the careers of outstanding Negro leaders during this time; the third section shows the departure of the Union soldiers from the South and the onslaught of the Klan that followed."

This historical subject, which might seem out of place in many communities, is appropriate in this Topeka neighborhood, known as Tennessee Town, where many African Americans came to settle, work, and raise families after slavery was abolished. The re-created mural, twice the size of the original, was painted by a diverse group of young people from Topeka's high schools and the surrounding neighborhood, working under the direction of artist Dave Loewenstein. The thought behind this collaboration was that if young people had a hand in painting the mural, they would feel ownership in it and would respect it in the future. Looking at the mural, the viewer has no doubt about the seriousness of their purpose or the quality of their work.

31 *Century of Service* 1999
Anthony Benton Gude

TOPEKA
818 South Kansas Ave. (inside)

Anthony Benton Gude lives and works in the hills of Marshall County on a small farm that was paid for with the proceeds from a painting that Gude's grandfather, Thomas Hart Benton, made of the farm's barnyard and grain silo in the early 1970s. "He bought the farm with a painting of it," Gude says of his grandfather's real estate deal. It was there, in his studio on the farm, that Gude created the mural *Century of Service* for Westar Energy's headquarters in Topeka. After considering a suggestion that the mural depict the entire history of energy from prehistoric times to the present, Gude settled on the more manageable "history of electrical energy in Kansas" as his focus.

Visible to the viewer when walking down Kansas Avenue, the dynamic and richly colored painting complements the austere interior of the headquarters' front lobby. The unusual wide-angle composition of *Century of Service* was partly inspired, Gude says, by studying his grandfather's famous *America Today* mu-rals in New York while searching for a way to connect the many different figures and make it appear as though they "were all breathing the same air."

Under a brilliant cerulean sky and with a towering thunder-cloud looming on the horizon, the composition is divided into three scenes that trace the development and progress of electrical energy in the state through the labor of those who built and now maintain its infrastructure and machinery. Scenes on the left and right show workers outside laying pipeline, erecting utility poles, and building the railroad, whereas in the center of the mural a team of modern-day technicians monitors the gauges of a densely packed combination of turbines, cooling towers, and computers.

Additional large paintings by Gude depicting the four seasons are in an adjoining hallway. *Spring*, which features a fearsome tornado, is not to be missed.

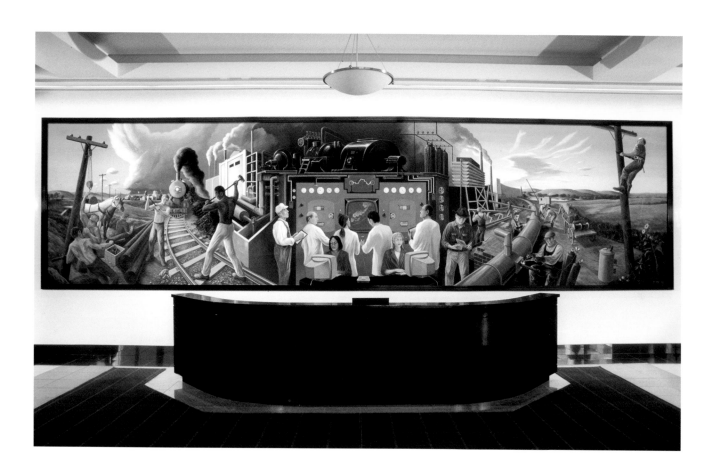

John Steuart Curry

TOPEKA
Kansas State Capitol, 10th and Jackson Sts. (inside)

They are the best-known murals in all of Kansas. Beloved by many today, they were the source of heated controversy at the time they were painted. In 1937, when native Kansan John Steuart Curry was gaining nationwide recognition with Regionalist colleagues Thomas Hart Benton and Grant Wood, newspaper editors from Topeka and Hutchinson wrote Curry in hopes of having him return to Kansas to paint murals for the statehouse. Curry accepted the editors' invitation in part because he wanted to make his mark on his home state and finally gain the respect of Kansans who had been anything but enthusiastic about his earlier depictions of Kansas.

Still, Curry was not satisfied to paint a "soft, soppy presentation of Kansas history." In fact, his murals were strident interpretations of history and farm life. He said of the panel dominated by John Brown, "In this group is expressed the fratricidal fury that first flamed on the plains of Kansas, the tragic prelude to the last bloody feud of the English-speaking people."

Reaction to these images was swift. The Kansas Council of Women issued this statement: "The murals do not portray the true Kansas. Rather than revealing a law-abiding, progressive state, the artist has emphasized the freaks in its history—the tornadoes, and John Brown, who did not follow legal procedure." The criticism led to a contentious debate about the removal of marble in the rotunda to create a location for Curry's panels on the plagues of agriculture and the struggles of early settlers. Bowing to public pressure, the Kansas Senate refused to remove the marble, and thus ended Curry's work on the murals. Curry left his home state for the last time, the murals unfinished and, as a symbol of his frustration, unsigned.

More than sixty years later, Curry's murals continue to inspire viewers, albeit in a more positive way. Governor Kathleen Sebelius said the John Brown panel "is a continual reminder to me of the defining issues of the Civil War and the challenges we still face today in attaining equality for all."

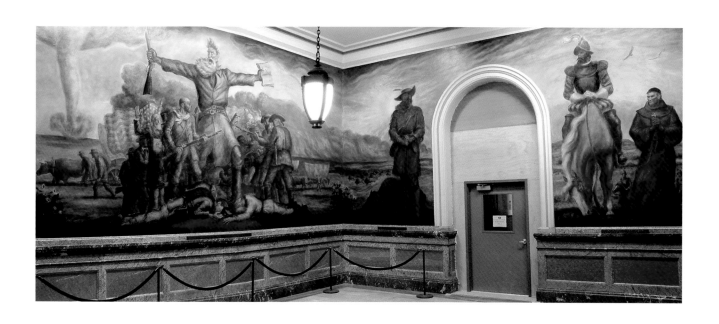

33 Kansas State Capitol Second Floor Rotunda Murals 1978
Lumen M. Winter

In 1976, thirty-four years after John Steuart Curry left Kansas, his murals unfinished and unsigned, Hutchinson artist Pat Potucek (see No. 56) was inspired to complete what Curry had intended but never had a chance to paint in the Capitol's rotunda. Potucek, a great appreciator of Curry, led a campaign to finish Curry's murals based on his sketches. Her persistence and well-reasoned approach convinced the Kansas Legislature to re-form the State Capitol Murals Committee and begin the process. Concerns soon followed. Some in the art world questioned the legitimacy of having another artist finish Curry's work, whereas some constituents worried about the cost.

After some debate the committee decided to have a design competition for the murals. To quell rumblings in the art world, artists were instructed that they could embody the spirit of Curry's intentions in their plans but could not refer to his sketches as Pat Potucek had hoped to do. The competition came down to three finalists: Eric Bransby (see No. 22), a professor at the University of Missouri–Kansas City; Robert Overman Hodgell, who had been Curry's assistant for six years; and Lumen Winter, a well-known sculptor and muralist who had grown up in Kansas. Noticeably missing from this group was Pat Potucek, who had been overlooked in favor of more well known artists. Winter won the competition with a proposal diplomatically titled *Mural Painting—A People's Art*. The mural cycle Winter designed was divided into four themes: history, agriculture, industry, and education. The eight panels would fit in the rotunda above the controversial marble wainscoting, which he wisely never suggested should be removed.

Pictured here is the only panel in which Winter touched on the contentious "Bleeding Kansas" years that had caused Curry so much trouble. The fiery image shows the sacking of Lawrence by proslavery forces in 1856. Unlike Curry's mythic *Tragic Prelude*, Winter's portrayal of these events stayed close to the facts and has never provoked significant criticism.

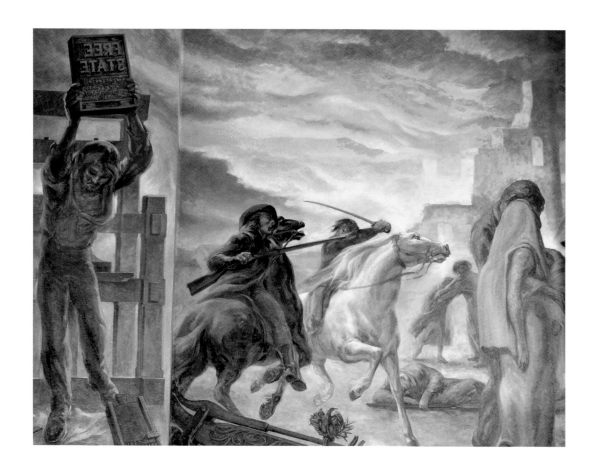

34 Vermillion Murals 1981 (restored in 2000)
JoAnn Dannels and Vermillion children

VERMILLION
Main St. between 1st and 5th Sts.

Artist JoAnn Dannels has seen more than two-thirds of Vermillion's population disappear during her lifetime. "The young people grew up and had to leave to find jobs, and they rarely came back," she said. Along with the people inevitably went the businesses, including the grocery store, movie theater, and hardware store. For years the vacant buildings stood as sad reminders of better times.

In 1981, Dannels decided to do something about the neglected look of her old Main Street. She began simply by pulling weeds between cracks in the sidewalk. The job proved to be too big for one person, so Dannels employed the help of young people in town, whom she paid 50 cents an hour. With generous support from town residents, this beautification campaign led Dannels and her assistants to paint murals on the windows and walls of vacant buildings.

A series of these panels looks back at Vermillion's past. On the empty IGA grocery store are two murals painted in place of the windows. One shows a view into the store as it would have looked when it was still open. In the other window the painters reproduced a grocery receipt from 4 April 1944. The receipt shows that the customer sold fifteen dozen eggs to the store for a credit of $4.50, thus reducing his bill for bread, oleo, soap, sugar, milk, cocoa, lard, cookies, and pork chops to a total of $1.44. Another mural across the street was one of the few painted for an existing business, the Vermillion Valley Apiaries, which specialized in beekeepers' needs. Here Dannels and her mural team painted a series of beehives under a sunset sky and brilliant rainbow. Dannels recalled that the hives were painted from life, and some unlucky bees got stuck in the wet paint on the wall as the artists worked.

35 Columbian Exposition Murals 1893
Theodore Behr

WAMEGO
Columbian Theater, 521 Lincoln Ave. (inside)

Although now hailed as defining features of the town, the historic Columbian Theater and the wonderful murals within it would have never existed had it not been for the trip that local banker J. C. Rogers took to see the Columbian Exposition World's Fair in Chicago in 1893. As the story goes, Rogers was so impressed with the architecture and decorations at the Exposition that he returned to Chicago when the fair closed and purchased two entire buildings filled with statues, paintings, and countless other artworks. The majority of Rogers's collection from the Exposition was then shipped home to Wamego where it was integrated into the newly constructed Rogers Building, now known as the Columbian Theater. Among the treasures installed in the new building were six mural panels by artist Theodore Behr that had originally hung in the rotunda of the U.S. Government Building at the fair.

Today, visitors to the Columbian can view the six exquisitely restored mural panels that have graced the walls of the theater for more than 100 years. Originally these six, along with two additional panels lost in Kansas City, composed two sets of four allegorical paintings—one set representing the economic features of the regions of the United States (North, South, East, and West) and the other set portraying successful business trades and industries. From the back of the theater, the panels *West: Agriculture, South: Agriculture,* and *North: Shipping Trade* are hung on the wall to the left. Opposite them on the wall to the right are *East: Arts and Sciences, Steel and Industrial Trades,* and *Architecture and Building Trades* (three of the six panels are shown here).

Still unsolved is the mystery of the phantom arm draped over the right leg of the allegorical figure representing Arts and Sciences in the East panel (on the right).

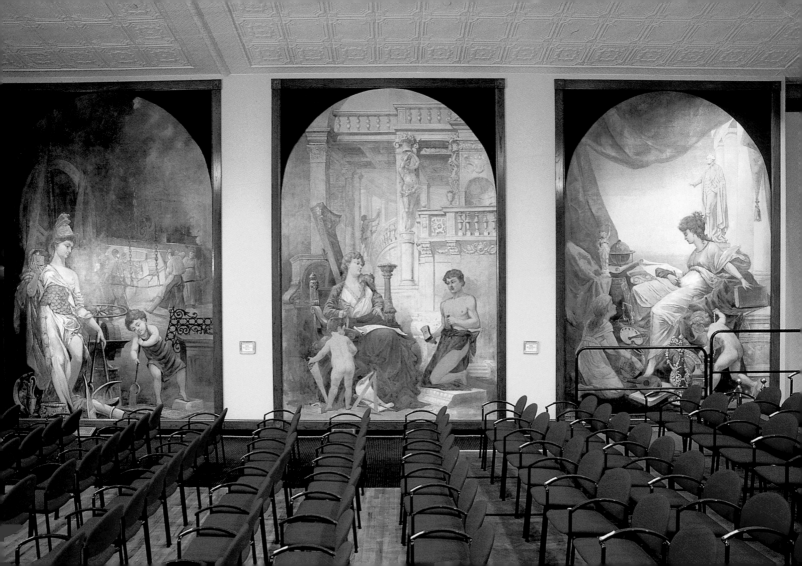

Southeast

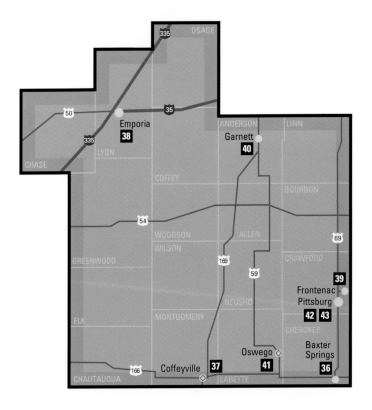

◇ Cities and towns highlighted with this symbol are home to ten or more murals.
Consult the appendix for a complete listing.

Paula Blincoe Collins

BAXTER SPRINGS

American Bank, 1201 Military Ave.

Fragments of Baxter Springs history carved into moist clay bricks were first assembled as a wall on a giant wooden easel in Paula Blincoe Collins's studio. Once the 450 bricks were carved, dried, and fired, the mural was installed as a permanent reminder of the stories that make up the town's colorful past.

In one tale of pre–Civil War "Bleeding Kansas" shown in the mural, a proslavery guerrilla rides past Fort Blair. The image of a burning covered wagon, borrowed from Edmund Ness's mural *Quantrill's Raid on Baxter Springs*, illustrates the horrific massacre of General Blunt's forces in 1863 by Quantrill's raiders. The Civil War soldier wielding a gun represents further skirmishes, and the Grand Army of the Republic (GAR) banner and picnic goers represent a popular reunion of Civil War veterans. Hidden in the mural is the ghost of a black Civil War soldier who, according to legend, still rides near where the fort once stood.

In Baxter Springs, known as "the first cowtown in Kansas," cattle driven from as far as Mexico boarded the rail for Chicago's packing houses. Other mural images include the hanging tree, a site of vigilante justice in the late 1800s; the lead and zinc mining industries; spas that enticed visitors to drink the healing mineral springs water; Kansas' thirteen-mile stretch of historic Route 66; the high-school baseball team's winning state championship legacy; the world's longest hand-carved wooden chain housed in the local museum; and two emblems of transportation—the Spring River Bridge and Street Car Bridge.

Town founder John Baxter, described as a "gun-toting preacher," is remembered with an image of his cabin and general store. Also represented is Victor Griffin, a Quapaw Indian chief known for striving to hold on to Indian ways and who acted as an interpreter between the pioneers and Indians.

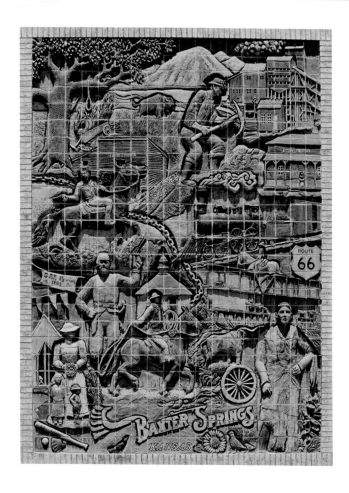

Don Sprague

COFFEYVILLE
Corner of 8th and Buckey Sts. (west wall)

When professional sign painter Don Sprague, together with his wife, Susie, bought Dave Perkins's sign company in 1988, he never guessed he would spend the next five years painting fifteen murals in Coffeyville with the support of local business and community leaders. Yet of all the murals Sprague painted, *Aviation History* was his favorite to work on.

As Sprague painted this mural on the side of a grocery store, he enjoyed the spontaneous involvement of passersby who shared their aviation memories and helped him get the details correct. The mural commemorates early aviation greats such as Joseph and Howard Funk, producers of Funk airplanes in the 1940s; the Army Air Base in operation from 1942 to 1946; Rolly Inman and Betsy Ferguson of the 1930s Inman Brothers' Flying Circus (in the detail of the mural shown here); and the airport owned by Hank Dunkan and his wife, Sally. Sally Dunkan and Betsy Ferguson flew for the Women Airforce Service Pilots (WASP) program during World War II.

Downtown Coffeyville in 1892 is Sprague's best-known mural and, as Susie Sprague suspects, the town's favorite. The mural depicts Coffeyville when the outlaw Dalton gang attempted to rob two banks simultaneously. During this infamous event, townspeople ran to the hardware store for guns and ammo to protect the town. When the shooting was over, four gang members and four citizens were dead.

Sprague, a notorious "baseball junkie" who coached and played the sport, claimed *Walter Johnson* as his favorite completed work. The mural is a tribute to the famous major league baseball pitcher who called Coffeyville home in the off-season. The local Little League team is also depicted, with the batter's home-run ball painted on the awning across the street.

38 *Our Flag Was Still There* 2003
Marilyn Dailey

EMPORIA
11th St. and Commercial Ave.

"You learn a lot of diplomacy working on a mural," recalled Marilyn Dailey, referring to the well-meaning suggestions she received with tact and good humor while painting this tribute for the fiftieth anniversary of Veterans' Day. The holiday is extra special in Emporia, since it was there on 11 November 1953 that Veterans' Day was first celebrated. Before 1953, the United States and several other nations had celebrated Armistice Day on 11 November in remembrance of the truce signed in 1918 ending World War I. If World War I truly had been "the war to end all wars" as people had hoped, we might still celebrate Armistice Day. But then there was World War II, and along with it thousands of new veterans. In 1953, Emporians, led by Alvin J. King, proposed broadening the focus and changing the name of the holiday to recognize all veterans and not just those from World War I. The following year Congress adopted Emporia's example, and Armistice Day was officially changed to Veterans' Day.

Many artists were contacted about the mural project, which was commissioned by the civic organization Leadership Emporia. Dailey herself submitted five designs, and her fourth entry, featuring a determined-looking bald eagle, was unanimously chosen. Dailey, who considers herself a teacher first and an artist second, was thrilled. "It was right down my alley," she said. "I had been doing a lot of patriotic artwork with my students since 9/11."

While painting, the artist said she felt the appreciation of Emporia's veterans, who brought her food, water, and occasionally constructive criticism. "By the end," Dailey said, "it really wasn't my mural anymore, it was Emporia's." At the mural's dedication, Sgt. 1st Class Steve Harmon expressed the gratitude of many when he told the crowd, "This is a true patriotic work of art and beautiful."

39 *Community Trees* 1999
Jim Reed in collaboration with Layton Elementary School students and Sunset Manor Nursing Home residents

FRONTENAC
Layton Elementary School, 200 E. Layton (inside)

"Everyone has their own way or style of painting a tree," said Jim Reed, who worked as an artist-in-residence in Frontenac's elementary school and nursing home to produce *Community Trees*. Trees, particularly their roots and new growth, are for Reed an apt metaphor for the children and elderly people who worked on the mural—who are the roots and growing tips of the community—and for the area's reclaimed mining pits depicted in the mural.

In his month-long residency, sponsored by the Pittsburg Area Arts and Crafts Association and the Kansas Arts Commission, Reed worked with third-, fourth-, and fifth-graders on the process of drawing trees. The students drew trees from memory and in landscapes. They painted trees with watercolors and practiced Reed's tree-making techniques. Finally the students painted trees on soft clay slabs. Reed glazed and fired the slabs to make tiles that border the mural on the sides and top, representing new growth.

The nursing home residents also painted trees onto clay in a workshop Reed conducted with them. This time, Reed asked participants to make trees in their own style, without teaching them specific techniques. He used these tiles to border the bottom of the mural, representing roots.

Reed produced the mural's central image on large clay slabs (see detail). "I'm looking and doing drawings all the time of the local area and the pits," said Reed. He depicted the viewpoint of looking down and across an old mining pit, overgrown with vegetation. Smaller humps represent more pits, with a coal shovel at the horizon. The resulting mural, rich with visual texture, reflects the natural patterns of growth and reclamation in the life of the community and the area's mining landscape.

40 *Kittens on the Prairie* 1993
Robert Cugno and Robert Logan

GARNETT
3rd and Oak Sts.

Artists Robert Cugno and Robert Logan were intrigued by a hooked rug they once found at an estate auction, a piece of folk art with kittens frolicking in the flowers. The two decided to pattern this mural after the rug, embellishing some areas and simplifying others. In addition to this mural, they coordinated a series of murals in Garnett, intentionally departing from the naturalistic depictions common in Kansas murals.

When Cugno and Logan, arts and crafts dealers from California, moved to Garnett, they discovered a community interested in "doing something" with a blank wall in town. "If they mean a mural, let's do it," said Logan, who along with Cugno had the background and wherewithal to make a mural project happen. They received a grant from the Kansas Arts Commission for a community mural project. However, as is sometimes the case in the mural-making process, their efforts to work with community members gleaned little consensus about what kind of mural to make.

"We wanted murals to stimulate conversation and intrigue people," said Logan. Their interests included murals that relied on vivid colors and abstract or nonobjective forms to communicate, rather than the realistic imagery that many in the community were accustomed to. With permission from various building owners, Cugno and Logan abandoned the grant process, yet moved ahead on the mural. The mural series they coordinated involved artists from Lawrence and Baldwin City who completed six murals by 1993. Of those original six, four remain, and another—by a Newton artist—was completed in 2001. In 1996, Cugno and Logan received a new grant to create a mural walking-tour guide. Assisted by artists Marty Olson and Sara Oblinger, they created an interactive coloring book—featuring mural outlines and accompanied by a box of crayons—as a delightful way to promote tourism in their community.

41 *Village of White Hair* 1998
E. Marie Horner and Joan Allen, with assistants Jerg Frogley and Larry Allen

OSWEGO
Corner of 4th and Commercial Sts.

As a child Marie Horner, who designed this mural, roamed the grounds near her parents' farm where the Osage Indians' Village of White Hair was thought to have existed, near present-day Oswego. The mural—one of more than a dozen in Oswego—portrays the interdependence, from 1841 to 1861, of the villagers and John Mathews, the first white settler in the area, who established a trading post there.

With a strong interest in the area's history and in collaboration with the Oswego Historical Society and artist Joan Allen, Horner honed her ideas for an oil painting that was the basis for the subsequent mural. Allen orchestrated the mural painting process with broad community support and funding from the Kansas Arts Commission. Allen, with two assistants, drew the mural's basic design onto the wall using an overhead projector and the city's cherry picker—a truck with a bucket lift. The crew filled in the details in the mornings of a hot Kansas summer.

There were at least five Osage chiefs with the name of White Hair and several locations where the Village of White Hair was thought to be. Historian W. W. Graves suggests that there were probably several "semi-independent villages" under subchiefs with the name White Hair. George White Hair, the first of these chiefs and the only one who never lived in Neosho County, signed many important treaties, including the first between the Osage and the United States in 1808.

For $166,300, the Osage ceded more than eighty million acres of land in Missouri, Kansas, Oklahoma, and Arkansas to the United States between 1808 and 1872. The Osage's last land holdings in southeast Kansas were taken in 1868, part of the American policy of removal of tribes to Indian Territory. The present Osage reservation in Oklahoma contains less than 1.5 million acres. This mural, illustrative of Oswego's early history, offers the reminder that Europeans were not the area's first inhabitants.

42 *Pittsburg State Centennial Mural* 2004
Mark Switlik

PITTSBURG
Pittsburg State University, Nation Hall, 200 block of E. Lindborg St.

A mural is typically part of the architecture," said Mark Switlik, an alumnus of Pittsburg State University who designed and painted this mural for the university's centennial. "It's not just a square, or rectangle, or box—just put up there," he said. "It should complement or work with the architecture." To this end Switlik tilted the overlapping pages of his giant yearbook design onto the side of a dormitory and wrapped the pages around the building's corner.

The mural is based on photos symbolizing important landmarks, activities, achievements, and academic programs of the university's first 100 years. Selected by Switlik and the university's mural committee, the mural's twenty-one images appear chronologically. Among them is a student working on a machine, representing the university's 1903 opening as a state school to educate teachers of the manual and domestic arts. The annual tradition of Apple Day is represented, where fac-

ulty members give apples to students to commemorate the appropriation of funds to construct Russ Hall in 1907. Russ Hall is also significant because, in 1914, it was struck by lightning and burned, but was quickly rebuilt with the resounding support of the Pittsburg community as well as the legislature. A copy of a beautiful tile found in McCray Hall represents the university's music tradition, and the spire of Timmons Chapel is shown, where more than a thousand weddings have taken place.

The mural process began in June 2003. Switlik first made small paintings of each mural image and scanned them into a computer. He then printed small versions to arrange onto a scale model. A "swing-chair" elevated him forty feet into the air to paint, although his work idled during the fall and winter with two unusual nine-inch snowstorms. By the spring of 2004 the mural was complete, a splendid monument to the history and campus life of Pittsburg State University.

43 *Solidarity, March of the Amazon Army—the Women Who Marched on Behalf of Alexander Howat, the Kansas Coal Miners, and the Labor Struggle 1921* 2000

Wayne Wildcat, with apprentices from Pittsburg and Girard High Schools and community members

PITTSBURG

Pittsburg Public Library, 308 N. Walnut St. (inside 2nd floor)

In 1921, 6,000 women, dubbed the Amazon Army, marched from coal mine to coal mine in southeast Kansas in support of a months-long miners' strike defying a new state law outlawing strikes. Kansas Arts Commission artist-in-residence Wayne Wildcat, whose epic paintings involve history and social criticism, worked on this oil on canvas mural with student and community apprentices to commemorate the march. Project affiliate Linda Knoll provided the mural idea and shared her historical knowledge and students' research—including a play written and performed for the mural's unveiling.

The mural is based on historical photos as well as extensive research by Wildcat and his wife, Dr. Tolly Smith Wildcat. Portraits of the women who led the march take center stage. The Amazon Army, shown in the background, marched for three days, growing from 600 to 6,000. They intimidated replacement workers, called "scabs," along the way. They threw red pepper at the scabs, dumped their lunch buckets, chased them with broomsticks, blocked them from getting off the trolley, and dared them to drive over a giant American flag preventing entry to the mines. Wildcat chose Saint Barbara (the patron saint of coal miners) and Lady Liberty to stand on each side of the miners in the foreground as symbols of hope and struggle.

The strike was launched to protest the coal company's denial of adult wages to a boy who had replaced his father, who had died in the mines. The wage issue was resolved but the strike escalated—further challenging the antistrike law—when the local union leader who initiated the strike was jailed. The nation watched as Kansas miners fought for the right to strike. Photos of the women's march, which ended when the state militia was called in, appeared in the *New York Times*, inspiring widespread enthusiasm for workers' rights.

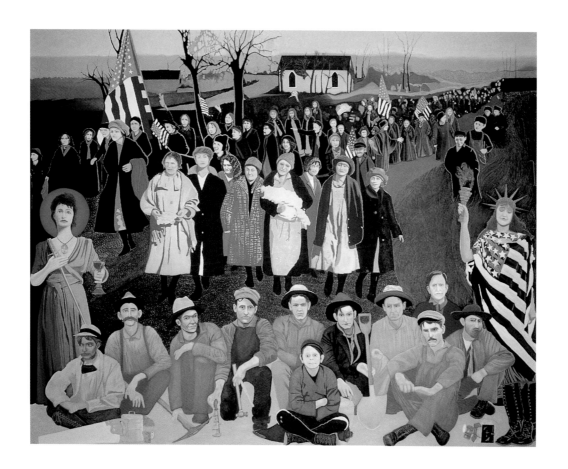

North Central

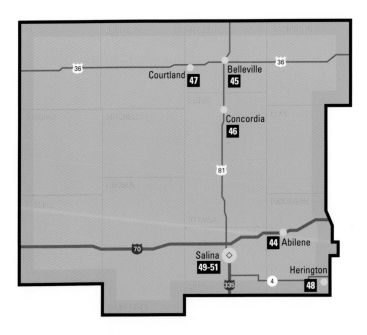

Courtland **47**

Belleville **45**

Concordia **46**

Abilene **44**

Salina **49-51**

Herington **48**

◇ Cities and towns highlighted with this symbol are home to ten or more murals. Consult the appendix for a complete listing.

44 *Patriotic Silo* 2005
Karen Lewis

ABILENE
Corner of 2200 Ave. and Jeep Rd., east of Abilene

Some people may think I'm crazy or eccentric," said artist Karen Lewis, who has transformed her farm's silo into a patriotic tribute to the victims of the 9/11 terrorist attacks, an idea she feels was impressed upon her by God. News of the terrorist act was devastating for Lewis. She grieved for those who died and felt that her personal freedom was under attack. She even wondered if the destruction was "a sign of the end of the world." Years after that terrible day, Lewis fulfilled her goal of commemorating the victims with a silo-mural. Although this tribute may seem unusual to some, memorializing the victims of 9/11 through American flag murals is popular throughout the state.

Among the silo's images are the *Statue of Liberty* (facing New York) and firefighters raising the American flag, an image from a famous photo. Two American flags span the 60-foot-high silo on the north and south sides, representing the Twin Towers. The words "We will never forget September 11, 2001" and "The day the angels cried" are on the west and east sides. Seven flags, lighted at night, top the silo (except in the winter months).

The project has been physically and financially taxing for Lewis, who has relied on donations and her own income to fund the project. Also, the silo's height has made painting difficult. Through her faith, however, and with the help of friends and family, Lewis has persevered and has found the response gratifying. Travelers from across the country have come to see the silo. Military jets and helicopters have flown close by, with one helicopter pausing long enough for her to see a man saluting. Other visitors have stopped by to say the Pledge of Allegiance, offer a donation, and pay tribute to the victims of 9/11 and to U.S. soldiers fighting overseas.

45 *Kansas Stream* 1939
Birger Sandzén

BELLEVILLE
Post Office, 1119 18th St. (inside)

Celebrated landscape painter Birger Sandzén completed more murals for post offices in Kansas than any other artist. He painted one for Lindsborg, one for Halstead, and two identical murals for the post office in Belleville (for which he was paid $670). Of the two murals for Belleville, the one pictured is installed above the postmaster's door, and the other, the first he completed, hangs in the artist's former studio, which is now part of the Sandzén Memorial Gallery in Lindsborg. Due to miscommunication, the artist's first *Kansas Stream* was slightly too large for the 156-by-52-inch space at the post office. Instead of trimming the canvas to fit the space and therefore altering his composition, Sandzén created a second version from scratch.

Unlike many of the other twenty-five Section murals (see No. 27) in Kansas that focus on historical or postal themes, Sandzén's murals are all landscapes of a state many did not see as especially picturesque. He saw more in the places he painted, like the view of the Republican River near Scandia featured in *Kansas Stream*: "We have glorious scenery right here at the very door of Lindsborg. . . . It's all color. It's wonderful. It's different every day of the year."

At age twenty-four, Sandzén came to Kansas from Sweden for what he expected to be a two- to three-year appointment teaching at Bethany College. Fortunately for Kansans, this short-term engagement blossomed into a distinguished fifty-year career in Lindsborg as an esteemed artist and educator. Well known for his generosity of spirit and time, he was a leading advocate for making art accessible to the general public. In addition to his murals, he was instrumental in founding the Prairie Print Makers, Prairie Watercolorists, and the Smoky Hill Art Club, all of which provided greater civic engagement with art.

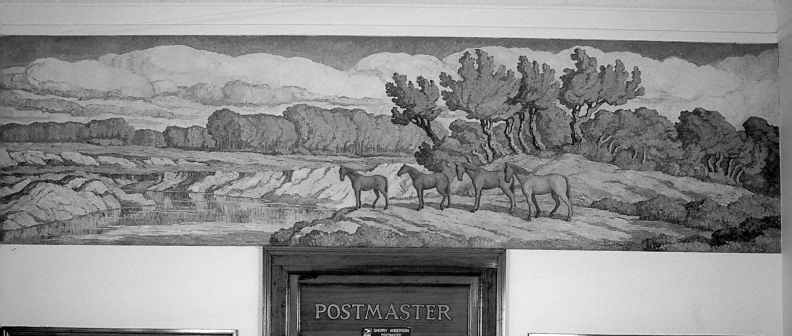

POSTMASTER

SHERRY ANDERSON
POSTMASTER

OFFICE HOURS
8AM TO 12M
2PM TO 5PM

· BULLETIN ·

IDENTITY THEFT

· BULLETIN ·

Packaging Pointers

DO NOT ALLOW
CHILDREN TO CLIMB
OR PLAY
ON

I can take care of
your shipping
needs.

usps.com

Going away?

46 *The Napoleon Curtain* 1979
Twin City Scenic Company (original by J. A. Lewis, 1907; replica by Robert Braun, 1979)

CONCORDIA
Brown Grand Theater, 310 W. 6th St. (inside)

On opening night of Concordia's Brown Grand Theater in 1907, Napoleon Bonapart Brown, the theater's owner, was dazzled by a surprise gift from his son. During the evening's festivities, Earl V. D. Brown unveiled a splendid drop-curtain reproduction of a painting of the French conqueror Napoleon Bonapart by Horace Vernet. The curtain hung in pristine condition for sixty years until it was damaged by a tornado in 1967. After several attempts at restoration, Marian Cook, of Concordia, donated a replica of the curtain for the theater's reopening in 1980.

Both curtains were painted by the Twin City Scenic Company of Minneapolis, a prominent theater curtain company from 1895 to 1979. At the turn of the century, traveling salesmen would show colorful renderings of painted drops to theater owners, telegraphing orders for curtains that were produced in a matter of weeks. The Brown Grand Theater's first curtain, called *Napoleon at Austerlitz* and painted by J. A. Lewis,

was a reproduction of Vernet's *Battle of Wagram* found in the Palace of Versailles near Paris. The 1979 curtain replica, painted by Robert Braun, was the last painted curtain produced by the company.

The Renaissance-style building, designed by Kansas City architect Carl Boller, served many owners and styles of entertainment. Built to accommodate live theater shows en route from Denver, St. Louis, and Chicago, the theater hosted more varied entertainment, such as minstrel shows, local productions, and wrestling matches, as the popularity of live theater productions declined. The theater became a movie house in 1925 and remained so for nearly fifty years. Added to the National Register of Historic Places in 1973, the building was renovated in 1976 and since 1980 has hosted more than fifty events a year, among them weddings, funerals, lectures, films, seminars, and live theater.

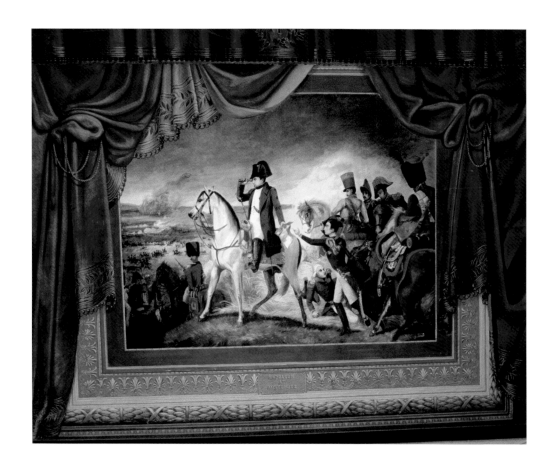

47 *Pictorial View of Courtland* 1984 (repainted in 1996)
Tim Leaf and students, 1984; repainted by Pat Mikesell, 1996

COURTLAND
Main and Liberty Sts.

On a clear summer day, looking west down Main Street, the viewer sees Courtland's skyline repeat itself in this cheerful community mural that celebrates the town's agrarian heritage. In the mural, an outline of Kansas frames a bright blue sky above Courtland's horizon. Within the outline, between the words Courtland and Kansas, a rising star shows where the town lies geographically within the state. This star is an apt symbol for the pride that local residents have for their hometown of 350; they even boast about having their own cable television and high-speed Internet system, which is owned by the city. This sense of community pride inspired Pike Valley art teacher Tim Leaf to organize this downtown mural project with his students.

From its completion twenty years ago, the inventive depiction of a diversified farm populated by a peaceable gathering of farm animals has been a town favorite. The mural was so beloved that when it began to show wear in the mid 1990s, a local mural painter, Pat Mikesell, was hired to completely restore it. Mikesell said he was careful to remain faithful to the original, but he did make a few changes, including changing the combine in the wheat field from a Ford to a New Holland to reflect the town's new implement dealer. (For a related story, see *Men of Wheat*, No. 27).

To compare the original version of the mural with the current one, stop by the Swedish American Bank across the street where they have postcards of the mural before its repainting.

48 *Arrival of the First Train in Herington–1885* 1937
H. Louis Freund

HERINGTON
Post Office, 17 East Main St. (inside)

I n 1880s Kansas, when having access to the railroad was integral to the economic development of a town, rancher Monroe Herington saw an opportunity. Herington's entrepreneurial spirit led him to offer the expanding Missouri-Pacific Railroad free land to build on if they would construct a substantial train depot. The railroad agreed to the deal. The town, which grew up around the new depot and became a major railroad junction, was named Herington after its founder.

A half-century later, thanks to New Deal programs, Herington saw the construction of a new post office and with it the commissioning of a Section mural (see No. 27) by Arkansas artist H. Louis Freund. Freund embodied the Section's philosophy that chosen artists would work closely with community residents to create artworks that accurately reflected their interests. In a letter to Herington's postmaster, Freund wrote, "As long as public money is being used to pay for the murals I believe that local citizens should have a chance to choose the subject matter to be portrayed. After all they are the ones who will be looking at them in the years to come."

The artist responded to citizens' interests in their town's founding story by designing a mural that illustrates the celebration surrounding the arrival of the first Missouri-Pacific train to the new Herington Depot in 1885. Two thousand people were on board the train for the festivities. Upon arrival, they were treated to a huge barbecue put on by the town's founder. In the distance, along the horizon, the original town of Herington is visible on the left and Monroe Herington's ranch on the right.

Freund's willingness to collaborate paid off in a mural that, although not artistically groundbreaking, was well liked by the public—a sentiment noted by Postmaster Doyle in his letter to the Section accepting the artwork: "The work is beautiful and we are indeed proud to have been favored with this artistic addition to the community."

49 *Points of Contact* 2002
Conrad Snider, assisted by Hanna Eastin

SALINA
First Presbyterian Church, 308 S. 8th St. (inside, three sections)

"In a broken and fearful world the Spirit gives us courage," is one of seventy text passages incorporated into the surface of *Points of Contact*, a clay mural embossed with the footprints and handprints (see detail) of 250 to 300 individuals from the church congregation. The mural is a memorial to a woman who had been active in First Presbyterian Church and the Salina community. As stated in a church flyer, the mural reminds viewers of "who God is, the way in which God loves us, and who God calls us to be."

The handprints and footprints were made in wet clay after a church picnic. The process was particularly meaningful to participants because the picnic happened to occur on the first Sunday after the September 11 terrorist attacks. "There was an energy I'll never forget, as if people were saying, 'I was there,'" said Martha Rhea, a participant and member of the church's Liturgical Art Committee. Imprinting the clay was a way to physically mark the moment and bear witness to anger, bewilderment, and grief. Later, artist Conrad Snider made a rubber mold of each print for use in creating the mural.

The mural text, taken from familiar scripture passages, hymns, and parts of the Presbyterian constitution, is incorporated thematically into the three mural sections. Text on the section near the entrance prepares one for the worship experience. Text on the section outside the sanctuary strengthens one to go back into the world and do God's work, and text in the small corner section near the sanctuary reflects the worship experience.

For generations to come, those who touch and explore the imprints become "points of contact," a metaphor for individuals and the church connecting with the broader society and affecting the world through their actions.

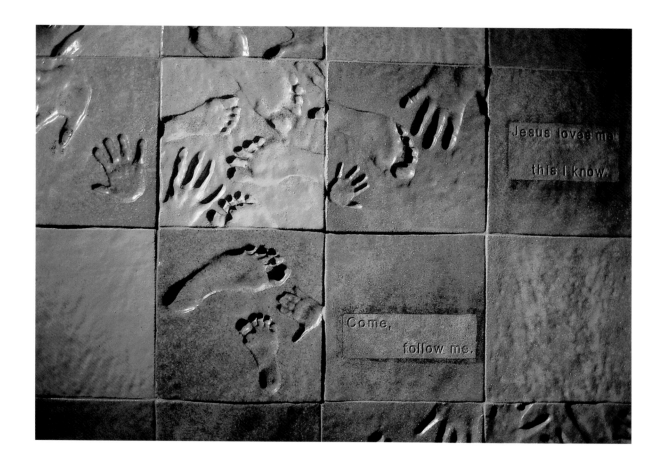

50 *Procession* 1953
Ernest Bruce Haswell

SALINA
Sacred Heart Cathedral, 118 N. 9th St.

The barrel-vault design of Salina's Sacred Heart Cathedral was inspired by a grain elevator, said Father Frank Coady of the Catholic Diocese in Salina. The building, said Father Coady, "is very Kansas and also very Eucharistic, for you need wheat to make the bread to make the Eucharist," the sacrament of Holy Communion in the Catholic Church. Wheat is also a theme in the building's exterior mural by Ernest Bruce Haswell; the carved limestone depicts a processional group preceded by a farmer with his wife and children, one of whom carries a sheaf of wheat. Additional carvings by Haswell are found inside the church.

The mural was "ahead of its time," said Father Coady. The mural's procession, like all Catholic processions, is presented in relation to the Kingdom of God, directed toward the front door of the church—the symbolic door to the Kingdom of God accented by a large crucifix. Above the mural are Jesus's words: "He who does not take up his cross and follow me is not worthy of me." The mural depicts the bishop of the diocese carrying a cross, assisted by priests, nuns, a Capuchin, and laity. The depiction of laity alongside church officials was surprising in 1953, before the egalitarian changes in the Catholic Church brought by Vatican II in 1962.

The cathedral building itself, replacing a more traditional brick church, was considered "shockingly modern," said Father Coady. With a background in theology and art, Bishop Frank Thill of the Salina Diocese suggested the grain elevator idea to architect Edward Schulte. Greek temples and Egyptian tombs also influenced the building's art and design, as well as Art Deco architecture, including Salina's old post office—an art deco building with low-relief carvings near the cathedral. Art deco artists of the 1930s and 1940s talked of egalitarianism, a strong theme in the cathedral's art and design that is fully appreciated today.

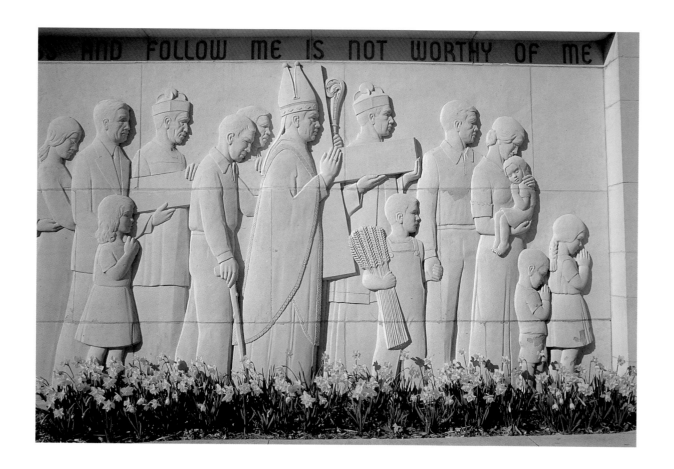

51 *What Do You Love about This Place* 1999
Jane Beatrice Wegscheider with community members, assisted by Andrea Weidman and Julia Crider

SALINA
Salina Bicentennial Center, 800 The Midway (inside entryway to arena)

If you're going to have a mural in a public space, it's important that the people who are going to see it get to participate in some way," said artist Jane Wegscheider. She thus invited Salina residents to contribute ideas for this mural located in the Salina Bicentennial Center, which houses an arena for sports, performances, and trade shows. In the mural whimsical figures stand, leap, and hold hands amid a stars-and-stripes landscape. The figures are filled with the local loves of Salina residents—the history, hobbies, food, and entertainment of their hometown.

The center's director asked Wegscheider to incorporate the American flag into her design. She pondered its symbolism. "America is about the people," she concluded, keeping in mind the diversity of age, ethnicity, race, and opinion of Salina residents. To invite their involvement she set up shop in Salina's schools, mall, public library, and Bicentennial Center. "What do you love about this place?" is the question she put to Salina residents. She gathered written responses and traced around the bodies of participants and photographed their faces.

Wegscheider's mural portrays people and their underlying connectedness in playful ways. She placed face photographs onto the traced silhouettes, with young faces on older bodies and old faces on younger bodies (see detail). Scenes in each figure honor Salina's founding families, quilting groups, the big sky, prairie flowers, monster trucks, the circus, basketball, local landmarks, gardening, and the change of seasons. In one figure Kansas birds send forth their songs, and in another curly fries, shakes, and miniature hamburgers float atop a "Pepto-Bismol pink" background celebrating two local diners.

When observers mused that the mural overlooks Salina's problems, Wegscheider responded, "You have to know what you love first to know why to try to work on things that are problematic."

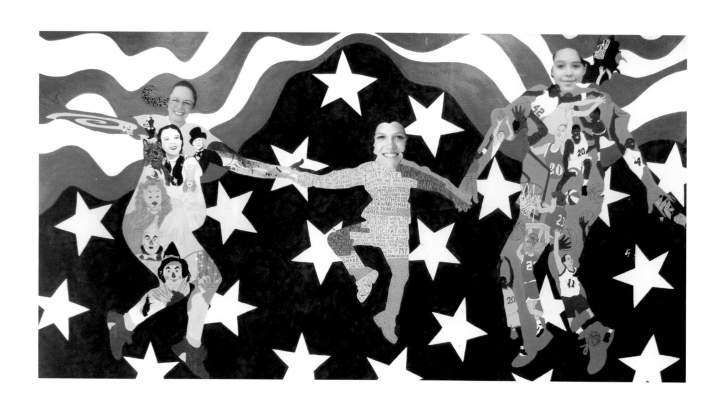

South Central

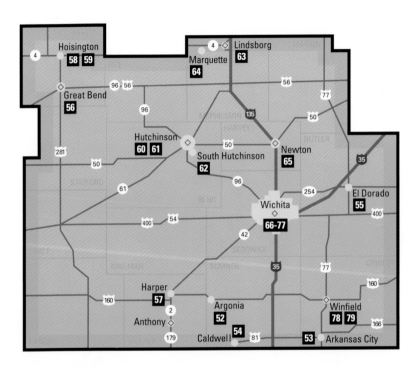

◇ Cities and towns highlighted with this symbol are home to ten or more murals.
Consult the appendix for a complete listing.

52 *Argonia's Past and Present* 2001
Cristi McCaffrey-Jackson, with community involvement

ARGONIA
The original mural (shown here), located at 107 Main, deteriorated and was removed; it will be repainted in a new location.

On 4 April 1887, the little town of Argonia stumbled into international fame by electing Susanna Madora Salter as the country's first woman mayor. More than a century later, Mayor Allan Brundage invited Cristi McCaffrey-Jackson to paint a mural depicting the town's history. The mural includes Salter amid the fields where she liked to walk when facing difficult decisions.

Argonia women became eligible to vote in 1887, yet it was a secret caucus of men who placed Salter on the ballot. That year, Argonia's Women's Christian Temperance Union (WCTU) chose a slate of male candidates who supported enforcement of the state prohibition law. In his article about Salter, Monroe Billington wrote, "A certain group of men in Argonia felt that the field of politics was their exclusive domain and resented the intrusion of women into their affairs. . . . Twenty of them met in the back room of a local restaurant and decided to teach these females a lesson." The men selected the same slate of candidates as the women had, except for mayor. They chose Salter for this position, hoping a woman would get few votes and embarrass the WCTU, to which Salter belonged. Salter was startled to learn on election morning that her name was on the ballot. Agreeing to hold office if elected, Salter, along with the WCTU and the local Republican Party, mounted a vigorous day-long get-out-the-vote campaign—and won!

Unwittingly, this ordinary community changed history by placing women firmly within the political realm. Salter received worldwide congratulations for her victory, and as mayor she was introduced by Susan B. Anthony and addressed the Kansas Women's Equal Suffrage Association's convention in Newton, Kansas.

Salter stands out among the mural's symbols of Argonia's history, among them the 1995 centennial arm patch, the railroad for which the town was built, a covered wagon, a windmill, and the surrounding agricultural landscape.

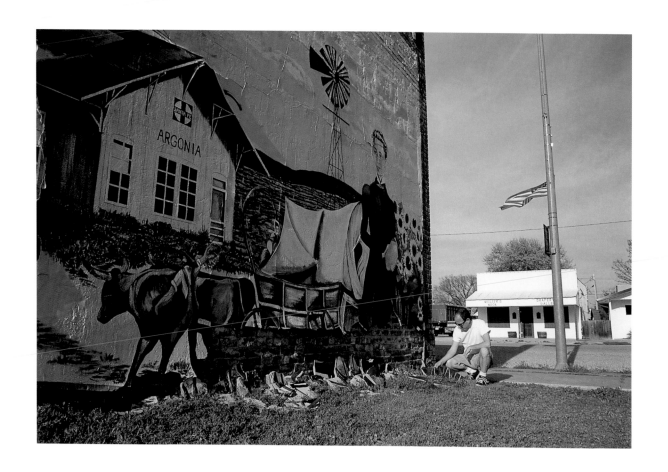

53 Summit Street Windows 1998
Cleo Graves

ARKANSAS CITY
Summit and West Adams Sts.

These window spaces were first painted by students from Cowley College to help brighten this once beautiful downtown building built in 1886. The paintings pictured views into businesses, such as a hair salon and lawyer's office, that might have once occupied the building's second floor in the early 1900s. Over the years these paintings deteriorated, and artist Cleo Graves was one of many who believed that their poor condition needed to be addressed. The town's city manager agreed and offered Graves the job.

Inspired to create a lively and colorful tribute to her community, Graves took a much different approach than the Cowley students to these same thirty window spaces. Instead of painting views into the building as the Cowley students had done, Graves painted windows as if viewers were inside the building looking out. This subtle reversal is enhanced by the re-creation of decorative window moldings. The moldings reinforce the idea that viewers are looking through windows and not just at paintings where windows used to be.

This mural is a refreshing departure from many town murals that focus on historical figures and agriculture. Graves's mural celebrates the region with a gathering of birds and animals in seasonal landscape and farm settings. These windows are shared by hawks and doves, coyotes and sheep, and eagles and squirrels, among others. There is also a cowboy, Native American, U.S. soldier, and a few figures of personal interest to the artist, including John Wayne and jockey Willie Shoemaker.

Paintings that have been put in the place of windows are common in Kansas (see Vermillion Murals by JoAnn Dannels, No. 34), especially in communities with fading downtowns. The beauty of this art is tempered by the fact that it is made to cover up deteriorating or vacant buildings, often replacing what were once real offices and apartments with painted illusions of them.

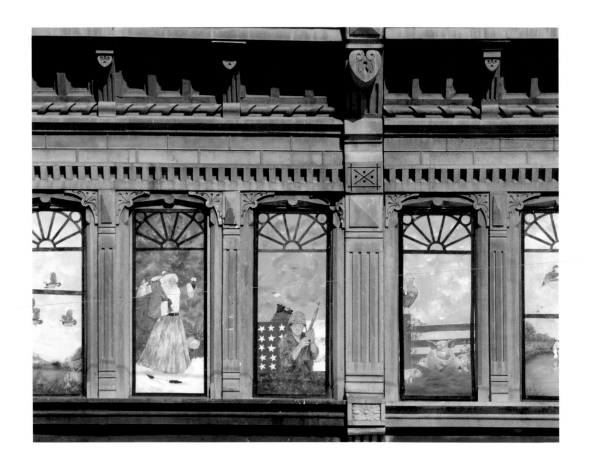

54 *Box Turtle—State Reptile* 1989
Marty Capron

CALDWELL
12 Main St.

On 14 April 1986, the sixth-grade class of Caldwell Elementary School proudly watched as Governor John Carlin signed their proposed bill into law, naming the ornate box turtle the state reptile of Kansas. By the next fall, Caldwell's mayor signed a proclamation declaring Caldwell the "Ornate Box Turtle Capital of the World." To commemorate these events, professional wildlife artist Marty Capron painted this mural above Caldwell's Main Street.

"The best way to teach is to get students involved in something meaningful," said the sixth-graders' teacher, Larry Miller. Miller guided the students' vigorous state reptile campaign, designed as a civics lesson for Kansas's 125th birthday that year. The students researched state symbols and prepared a convincing list of reasons for naming the box turtle as the state reptile. They wrote numerous letters gathering support from schools, educational organizations, and the media. Support came from all regions of the state and from as far away as England.

Although the legislation nearly died in committee, relentless pressure from the students and their supporters revived it. Miller was excited by the opportunity for the students to express themselves through the media and before the legislators. By the end of the school year, when the bill was signed in front of hundreds of supporters, each sixth-grader had been quoted at least once in the newspapers or on television, and each student testified before the senate committee regarding state affairs.

However, the story is not over yet: recent genetic research has led biologists to determine that turtles are not reptiles after all. In fact, they are in a class—called "turtles"—by themselves. This leaves one to ponder whether the state reptile slot will be up for grabs again.

55 *The Glory of the Hills (Flint Hills Landscape)* 1998
Phil Epp, with assistance from Terry Corbett

EL DORADO
110 N. Main St.

Phil Epp's dramatic skyscapes, filled with voluminous and characteristically animated clouds, found a whole new audience when he and ceramic artist Terry Corbett began their creative partnership with this tile mural next door to the Coutts Memorial Museum of Art.

To create the mural, Epp made a one-to-eight-scale mock-up that divided his original design into hundreds of one-by-one-inch squares that corresponded to the mural's ceramic tiles. From this model, Corbett carefully painted the mural tiles with layers of richly colored glazes in a style that mimicked Epp's as closely as possible. The tiles were then fired and installed on the wall. The resulting artwork with its deep and reflective surface is more durable than any painted mural.

The project was privately funded by art patron Clifford Stone, who envisioned an evocation of the Flint Hills that would enliven and open the narrow pedestrian breezeway known as Art Alley. For the plaque next to the mural, Stone chose a quote from C. S. Lewis that expressed high aspirations for the impression art can make: "We do not want merely to see beauty.... We want to be united with the beauty we see ... to pass into it ... to receive it into ourselves ... to become part of it."

The success of their first mural has led Epp and Corbett to do a series of new public projects. In Olathe the artists created the tile mural *Reflective Spaces*, and in Newton they collaborated with sculptor Conrad Snider to produce the monumental *Blue Sky Project*. When asked about the funding difficulties and community skepticism an artist sometimes endures to realize these public commissions, Epp was unequivocal: "I'm on the side of public art, plain and simple. I think it's important."

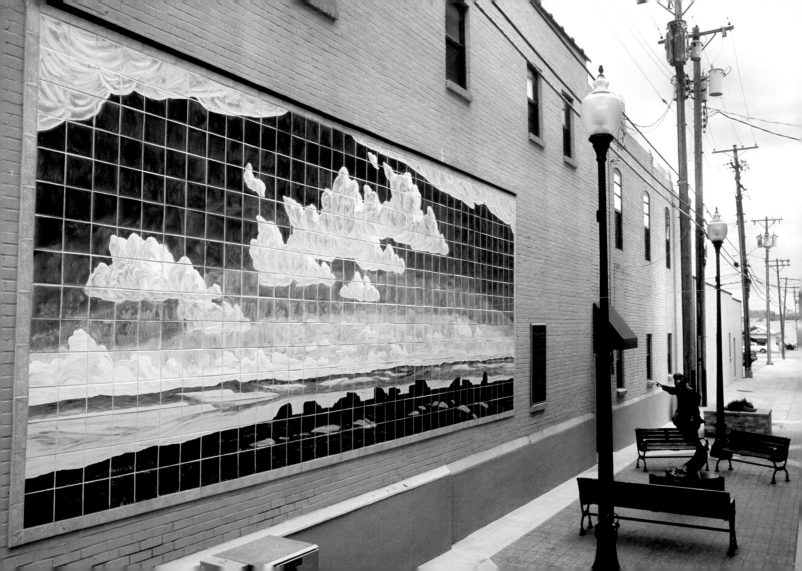

GREAT BEND

Bank of the West, 1222 Kansas Ave. (Inside, the mural is in four sections throughout the bank, with a fifth section at the Santa Fe Trail Center, two miles west of Larned on Kansas Hwy. 156. Some panels may be in storage.)

For nearly sixteen weeks Pat Potucek commuted from Hutchinson to Great Bend to complete her expansive mural *The First Fifty Years of Barton County*, staying nights at a motel or with nuns at a nearby convent. After a divorce left her a single mother of six, she worked hard to support her family by painting murals or bartering artwork for dental care or car repairs. Despite these challenges, she enjoyed representing the early years, history, and livelihood of Barton County on 630 square feet of canvas.

Commissioned by the First National Bank, the mural covered three walls of the Prairie Room until the room was renovated in 1982. Based on historical books, old photos, and information from local historians, Potucek's mural design even included sketches of prairie dogs from a nearby nature reserve. Through her confident handling of paint, Potucek's mural portrays the prairie, settlers (in the detail of the mural shown here), an Indian family, the railroad, cowboys, businesses, street scenes, harvest, and oil workers. Influenced by the compositions of John Steuart Curry, Potucek overlapped scenes to create thematic transitions.

Bolstered by the mural's success and with the support of State Representative John Hayes, in 1975 Potucek proposed painting new state capitol murals based on eight unfinished murals by John Steuart Curry. Although her suggestion to use the Curry sketches became controversial, her efforts paved the way for new original statehouse murals by Lumen Winter.

As one of the state's most prolific and beloved muralists, Potucek began her career in 1949 when her murals for the Mermaid Room, at the new VFW Building in Arkansas City, included scantily clad mermaids, causing a stir among veterans' wives. The story made national news. Some of Potucek's favorite murals, which tell stories of local history, are located at Smith's Market and the Dental Center in Hutchinson, and Berkel and Co. Contractors, Inc., in Bonner Springs.

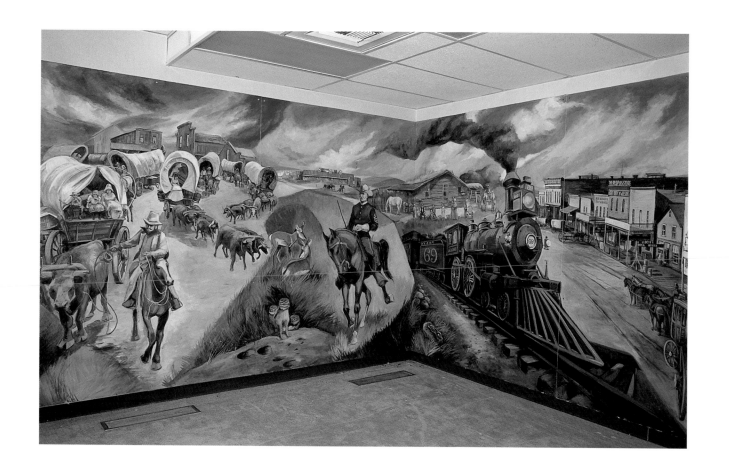

57 *Grow with Us* 1999
Harper junior high school students coordinated by Karen Dunkelberger

HARPER
Corner of Main and Central Sts.

This mural was made by kids. The mural's central image of a boy and girl holding hands—they are 10 feet tall—is playfully titled *Grow with Us*. Each year this mural, located on an open corner lot, serves as the beloved backdrop to the Harper County Fair's mini-tractor pull, talent show, and other children's events.

"The story of this mural is community service," said Karen Dunkelberger, a teacher who coordinated the project as a way to teach life skills to her junior high students. Dunkelberger knows that children love to paint, and paint they have through all manner of projects that have served the school and community. Over the years, Dunkelberger's students have painted playground equipment, fire hydrants, and curbs with street numbers. They have painted three new murals and even restored a faded one.

Grow with Us was the culmination of a yearlong project that offered valuable lessons in planning, collaboration, and communication. The students worked in committees to bring together school administrators, city officials, the Chamber of Commerce, building owners, and community members toward a common vision. The student committees also brought mural designs to the class for final approval, rounded up donated supplies, contacted the local press, and documented the mural's progress.

Grow with Us also depicts town emblems around its central image, among them the locally famous 1886 water tower with a fish sculpture on its top, the stone arch gateway to the city's park, and the town's 1902 fountain. Dunkelberger's first class mural, adjacent to this one, is *Harper History*, which showcases three historic buildings: the Runnymede Church of 1890, the local train depot of 1880, and a restored barn of 1878. *Come Swing with Us*, a third junior high student mural at the Heritage Estates Assisted Living Facility, depicts a garden scene.

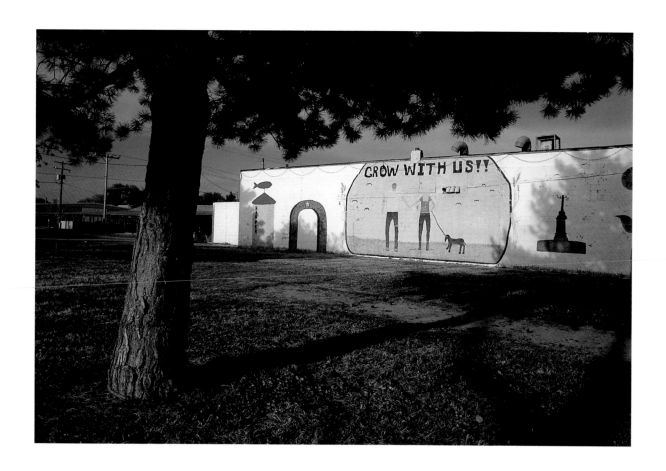

58 *Wheat Center* 1938
Dorothea Tomlinson

HOISINGTON
Post Office, 121 E. 2nd St. (inside, east wall of lobby)

59 *The Generation* 1990
Bob Booth

HOISINGTON
Post Office, 121 E. 2nd St. (inside, west wall of lobby)

Robert Glynn was eleven or twelve years old when his mother brought him to the Hoisington Post Office to see Dorothea Tomlinson's newly installed Section mural (see No. 27), *Wheat Center*, in 1938. "I still talk about it all the time," said Glynn, a history buff who worked at the post office in the late 1940s and 1950s. "It was always considered in good taste and a nice thing to have in the community."

Wheat Center portrays a harvest threshing scene as it would have appeared between the 1910s and 1930s. The Tomlinson mural is based on her sketches of farm life. She once said of her inspiration, "The magnificent celebration of threshing on Iowa farms, when neighbors come in for a day to help one another, seemed a paintable subject. One day I was parked back in the field, waiting for an idea, palette in hand; when the wagon came out of the barn; the hayracks and fields of shocked grain in the distance."

The resulting mural is both accurate and stylized. "Only essential material to the subject or the composition have been used and it is painted direct with extreme simplicity," she wrote. The style of Tomlinson, an Iowa artist influenced by Grant Wood, fits within the school of Midwestern Regionalism, with subject matter relevant to the illustrative realism encouraged by the Section. About 150 of the Section's 850 artists were women. Tomlinson is one of three women with Section art in Kansas post offices. Although the mural is based on an Iowa scene, the subject of harvest was particularly relevant to the

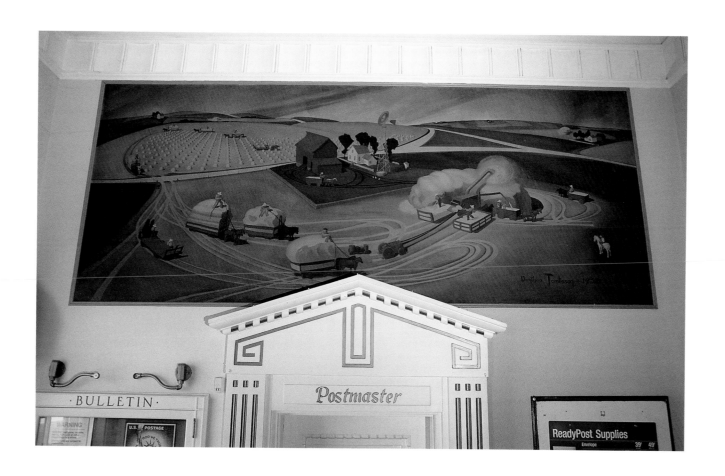

work and economy of Hoisington. "It was true to the times," said Glynn.

Like Glynn, artist Bob Booth also felt a deep appreciation for Tomlinson's mural. With a background in farming, Booth understood the mural's command for reverence regarding a way of life nearly forgotten a half-century later. In 1990, at the request of the local postmaster, Booth painted a mural triptych, *The Generation*, to honor the fiftieth anniversary of *Wheat Center*. The murals by Tomlinson and Booth face each other in the post office lobby, creating a dialogue between artists whose work represents two vastly different eras in agriculture.

Booth's three-panel mural mirrors Tomlinson's composition, yet each panel modernizes her scene in thirty-year increments. The figure of a child, the face of a man "in his prime," and the profile of an elderly man overlay the landscape in each panel. From the physical labor and use of horses taken from Tomlinson's scene of the 1920s to the technological developments of the 1950s and the large-scale industrialized farming of the late 1980s, *The Generation* reflects the monumental changes in agriculture within the lifetime of an individual farmer.

60 *Dream* 2002
Robert McCall

Early in his career, world-renowned artist Robert McCall visited the world's great museums and was astonished by the size of the paintings he saw—some by Rubens and Delacroix. These paintings inspired McCall to also paint large-scale canvases and murals. "To stand on a scaffold and see the vast area of canvas to be the recipient of work and materialize . . . has been a great thrill," he said. McCall's fascination with space, however, extended far beyond the wonder of a large canvas, for aerospace themes have been his lifelong passion. At age eighty-two, McCall painted this mural for the Kansas Cosmosphere to celebrate its founder, Patty Carey.

The mural is a collage of imagery that includes Carey with a telescope. In 1962, Carey was the drive behind Kansas' first public planetarium, which was housed in a poultry building at the state fair grounds in Hutchinson. "From this humble beginning, the planetarium has evolved into a multifaceted space science education museum that today houses one of the world's largest and most significant collections of . . . space artifacts," said Congressman Jerry Moran in a tribute to Carey. The mural depicts several of these artifacts (among them the Liberty Bell 7 space capsule), a gathering of people touched by Carey's vision, and aerospace history.

The mural is fittingly located at the Cosmosphere; it commemorates not only the work of Carey, but also that of McCall. Among his many accomplishments, he created illustrations for *Life* magazine, documented the space program through the National Aeronautics and Space Administration (NASA) artist program, designed movie posters (including one for *2001: A Space Odyssey*), designed postage stamps and space mission emblems, and painted murals for prominent institutions, including the Smithsonian's National Air and Space Museum. As Isaac Asimov once noted, "Robert McCall is the nearest thing we have to an artist in residence from outer space."

61 *Pioneer Center Mural* 2001
Larry Caldwell and AvNell Mayfield

HUTCHINSON
Elmdale Pioneer Activity Center, 400 E. Ave. E (inside Sunflower Room)

We wanted to paint people actively engaged in everyday living, and enjoying their golden years," said artist AvNell Mayfield about the three murals she and her partner, Larry Caldwell, painted in the activity center's Sunflower Room, which is used by senior citizens. When Mayfield and Caldwell asked the patrons what they would like to see in the murals, they suggested that the murals show the different activities available to senior citizens at the center.

With this in mind, Mayfield and Caldwell visited with seniors involved in the center's activities and programs. The two artists talked with people during meals, got to know them, and learned about their backgrounds and families. The artists photographed and sketched people participating in line dance lessons, playing pool, eating together at friendship dinners, and working on the computer. The artists also invited the seniors to paint on the murals. Although most of the seniors were reluctant to paint, one woman did as well as Mayfield's elderly sister. Otherwise the seniors were "quite tickled" to pose and be painted. The resulting murals comprise delightful, slightly caricatured portraits. They are a rare treat, as it is unusual to see the lives of older people portrayed in murals. When participants saw the finished murals, "they were happy and laughing and teasing each other," said Mayfield.

Caldwell and Mayfield, also known professionally as Catalpa Creek Art, work well as a team. Caldwell does the photography work, mural layout, and precision lines and lettering that bring the art together. Mayfield does the drawing and detail painting. Their large-scale mural in a second Hutchinson location, the Flag Theater, depicts an audience of people, from local heroes to national icons to themselves. The theater mural embodies all the lighthearted humor they are known for in their murals that appear throughout the state.

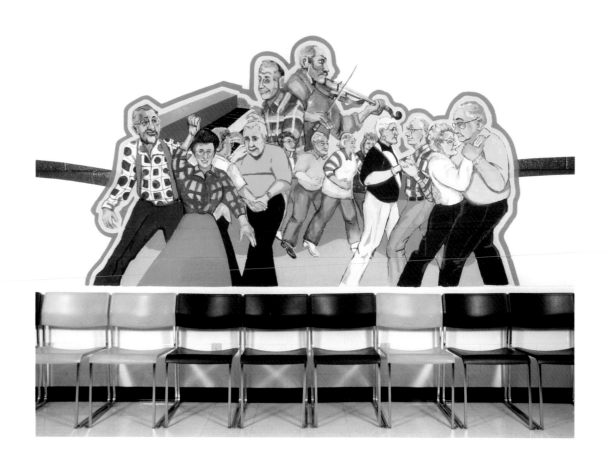

62 *Our Lady of Guadalupe Shrine* 1982
Edward Curiel, Fred Henze, and Migdonio Seidler with the Shrine Committee

SOUTH HUTCHINSON
Outside Our Lady of Guadalupe Church, 612 S. Maple St.

The first church to serve Hutchinson's community of Mexican immigrants who came to work on the railroad was completed in 1927. Fifty-five years and a new church building later, this freestanding mural shrine was erected and dedicated to Our Lady of Guadalupe, the patroness of the parish. Catholics throughout the Americas have a special devotion to Our Lady of Guadalupe through the story of Juan Diego, which is depicted on the shrine.

In December 1531, an apparition of the Virgin Mary, known as Our Lady of Guadalupe, appeared to Juan Diego, an Indian, on Tepevac Hill near Mexico City. The apparition told Diego to summon the Bishop Zumárraga to build a church on that site. The bishop, skeptical of Diego's story, asked for a sign as proof. The apparition appeared again, instructing Diego to find roses on the peak of Tepevac—unheard of in December—to take to the bishop, which he did. When Diego opened his *tilma* (or cloak) to let the roses fall, an image of the Virgin was miraculously im-

printed on the *tilma*, and the new church was built in 1533. The *tilma* was preserved and is enshrined in Mexico City.

Three artists and a committee of parishioners, headed by Father Colin Boor, planned the Hutchinson shrine, whose structural design was refined by architect Migdonio Seidler. Artist Edward Curiel, a parishioner who took over from his father the task of decorating the church for the Feast of Our Lady of Guadalupe, researched and painted four scenes from the Juan Diego story. The ceramic depictions are based on these paintings and the *tilma*'s image. Ceramic artist Fred Henze completed the intricate tile work, and committee members Ted Mora, Leo Wess, Frank Raya Jr., Jim Martinez, Clarence Siegrist, and Father Colin Boor did the rest. Parishioners, community guests, and many area priests and nuns celebrated the shrine's completion during Feast of Our Lady celebrations on 12 December 1982. Murals by Mexican artist Caesar Ramirez are inside the church.

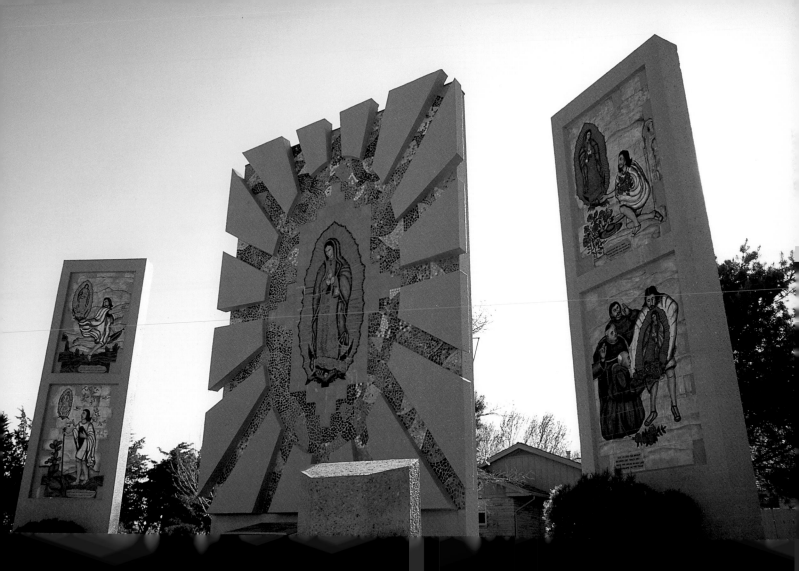

63 *Our Founders in Architectural Heaven* 2001
Eldon B. Swensson

LINDSBORG
Lincoln and Main Sts.

"Do you believe that good buildings die and go to heaven? If you do, welcome to my fantasy of Architectural Heaven." Thus begins the fanciful and charming narrative that accompanies this unique mural by Eldon Swensson in downtown Lindsborg. In Swensson's vision, historically significant buildings from Lindsborg's past have been re-created by the "Master Architect" using precious metals in place of earthly building materials. Among the re-created architecture are the first Bethany Lutheran Church whose grass roof has been remade with interwoven strands of gold, and Old Main, the five-story Bethany College building that was the tallest building between Kansas City and Denver when it was built.

At the entrance to *Architectural Heaven*, twin herald angels greet the city founders, Olof Olsson and Carl Aaron Swensson. Music from Handel's *Messiah*, which has been performed to great acclaim in Lindsborg on Palm Sunday for more than a century, accompanies their arrival. Other angels, dressed in Lutheran robes and named after the founders' wives and daughters, escort the two men through the ethereal landscape of golden buildings and blue palm trees. To heighten the luminosity of the silver, gold, and bronze architecture, Swensson used iridescent paint that creates a shimmering, sparkly effect when illuminated by the sun.

The subject of *Architectural Heaven* is especially fitting for this artist. When this mural was painted in 2001, he had only just retired from a forty-three-year career as an architect. Swensson is also a direct descendant of one of the founders of Lindsborg, Carl Aaron Swensson. This combination of vocation and family heritage, properly encouraged by Swensson's active imagination, has resulted in a unique retelling of the town's past.

Our Founders in Architectural Heaven

64 *Civic Mural of Marquette* 1983, restored in 2003 and 2005
Allan Lindfors with Janis Larson, Vivian Lueckfield, and Barbara Rose

MARQUETTE
Marquette Lumber and Hardware, 101 N. Washington

In 1905, a tornado devastated the small town of Marquette, killing thirty-one people. "It was the worst in Kansas for fifty years," said Allan Lindfors, a local historian and one of several artists who worked on this mural. By 1906 the community was rebuilding itself and promoting the town through a series of advertising postcards. This mural is based on one of those cards. Although the themes have been updated to reflect Marquette today, the mural uses the same basic design and sunflower flourishes as the old postcard did.

The 1906 postcard, on view at the local historical museum, struck Lindfors as a symbol of the community spirit that restored Marquette and keeps it vital today. The postcard included pictures of two churches that were rebuilt after the tornado, the River Bridge over the scenic Smoky Hill River, downtown Marquette, and the railroad depot.

The updated mural design includes five scenes of community pride. "We tried to take the concepts of what made our community special for us," said Lindfors. "Agribusiness," an important aspect of Marquette's economy, is represented by a wheat combine and grain elevator. "Civic Pride" is represented by a family planting flowers at the city park. "Fellowship" is represented by two older men and a young girl visiting together on a downtown park bench. "Education," an important foundation for life, is depicted with children playing outside the grade-school building. "Religion" is in the center of the mural, represented by the Christian cross. Marquette's three churches, explained Lindfors, were the glue that held the community together after the tragic tornado, and they continue to play a central role in the community today.

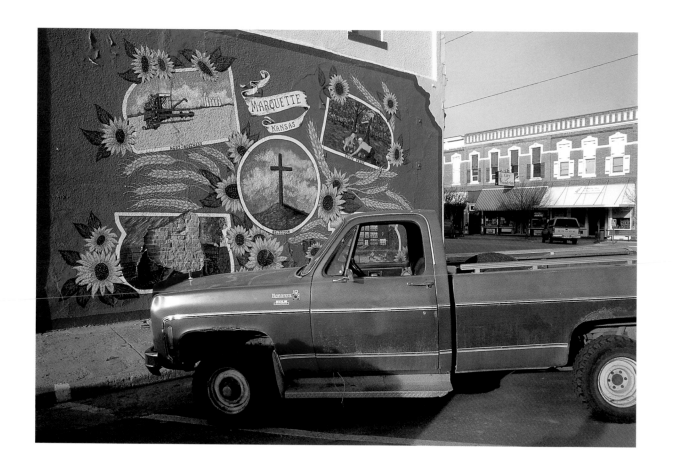

65 *La Vida Buena, La Vida Mexicana (The Good Life, Mexican Life)* 1978
Patrice Olais and Raymond Olais

NEWTON
Sunset Elementary School, 619 N. Boyd (inside main hallway)

Before 1949, segregation meant that Mexican Americans and African Americans could not play on high school and community sports teams in Newton and other Kansas communities. In 1946, in response to this discrimination, Newton's Our Lady of Guadalupe Church sponsored the area's first Mexican American Fast-Pitch Softball Tournament, now the oldest continuous Mexican American ball tournament in the country. Through the use of portraits and historical photos, this mural commemorates the thirtieth anniversary of the tournament, as well as themes common to many immigrant communities, among them hard work, unequal treatment, cultural traditions, and military service.

In the early 1900s, skilled Mexican workers like Secundino Tafolla (in front of the steam engine), eager to escape the violence of the Mexican Revolution, were recruited by the railroad to work throughout Kansas. The Mexican American community in Newton, a hub of railroad activity, founded Our Lady of Guadalupe Church in 1920 (at the far left). Joaquin Estrada (in the World War II service uniform) was a Newton ball player known for his pitching. Born in the United States, he represents the first generation of Mexican Americans to demonstrate their allegiance to the United States through military service. After the war, he fought for equal rights and better opportunities through the GI Forum. Angel "Ace" Torres (in the McGee's team uniform) represents the tournament's first sponsored team. A glimpse of the United Farm Worker's eagle pays tribute to the union and its leader, Cesar Chavez, who gained national attention for achieving labor contracts for Mexican workers through a boycott of California table grapes.

The mural also portrays Mexican cultural celebrations in Newton, among them the 1950s wedding of Raymond and Hope Gonzalez, a folk dance group called Los Tapatios, a church procession, a birthday party piñata, a fiesta queen, and the preparation of traditional foods for sale at the baseball park as a church fund-raiser. The mural, now weatherworn, was displayed at the ballpark for many summers.

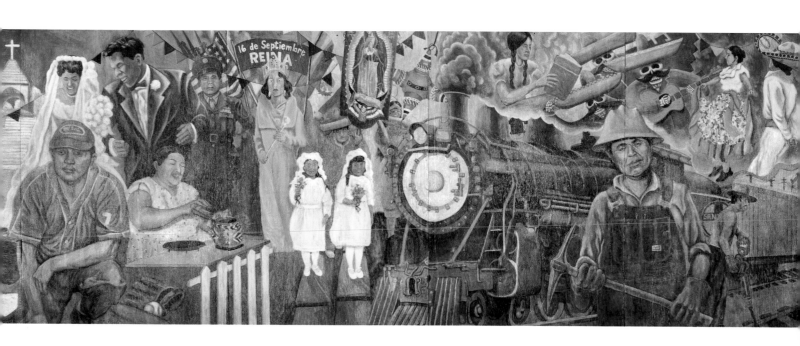

66 *1 in 6 Hungry* 2002
Ryan Bell, Chris Slusser, Rebekah (Ferguson) Bell, Chris Winfield, Karen Morgan, Merle Bell, Connie Pace Adair, and CTECH staff

WICHITA
Davis Furniture, 550 Douglas Ave.

The theme of this mural, like childhood hunger itself, is not immediately obvious. A closer look reveals, however, what its title blatantly states. A study found that one in six Kansas children was classified under federal guidelines as having insufficient food for his or her physical well-being. This grim statistic inspired Ryan Bell, an AmeriCorps*VISTA volunteer with the Campaign to End Childhood Hunger (CTECH), to educate the public through a mural.

This brightly colored mural portrays children playing, picnicking, and sharing food. Three of the children, however, look sad and drab. They are hungry. Connie Pace Adair, CTECH's program director when the mural was created, said that Kansas communities are often in denial about childhood hunger. She noted that the mural includes both a cityscape and countryside, illustrative of the rural and urban communities where hunger exists.

"It really was a community effort," said Bell, who received project support from community organizations, students, friends, and the CTECH staff. Bell involved school children who wrote and drew pictures about hunger. One child's picture of friends sharing food was, for Bell, particularly poignant. This concept was transformed into a mural design by a small group of Metro Boulevard Alternative High School students, who received class credit for their involvement. A friend of Bell's, graphic designer Chris Slusser, helped oversee the mural painting process. Two graffiti artists helped draw the figures onto the wall. Finally, the mural was painted by a small group of volunteers who were occasionally assisted by children from programs such as the United Way's Day of Caring.

The mural was well received at a dedication ceremony attended by community members and local dignitaries. For Bell, however, the most important aspect of the mural is that as it livens up the community, it will educate the public for years to come.

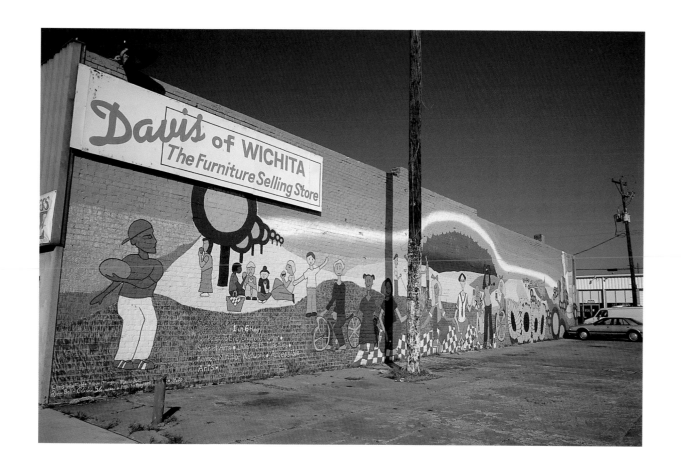

67 *Be Still and Know That I Am God* 1964
Bernard Frazier, assisted by Beverly (Glaze) Frazier, Jim Carr, Ron Hickman, and Jim Banks

WICHITA
First United Methodist Church, 330 N. Broadway

The biblical text "Be still and know that I am God" (*Psalms* 46:10) impressed Bernard Frazier as a profound statement about religion, said his son Malcolm. As a boy, Malcolm and his family helped lay out the mosaic's tesserae (glazed ceramic tile) in patterns on the floor of the hotel room in Wichita, where they stayed during part of the mural-making process. Frazier kept the psalm in mind during the three years it took to complete this 24-by-70-foot relief mosaic, which consists of 70,000 shimmering tesserae.

The dynamic forces of the universe, the universe-creating deity, humanity, civilization, and eternity are symbolized in the mural. "Nature's raw forces flowing through the designing purpose of God became the cradle out of which man arose," wrote Dr. B. Lester Hankins, a longtime church staff member, about the mosaic's meaning.

The mosaic's energetic swirls, based in part on Frazier's observations of snowdrifts, represent nature's wild forces and creative potential. Frazier called snowdrifts "the negative space of the wind," said Malcolm. At night, lights shining through a nearby fountain flicker onto part of the mural, further representing nature's chaos. The mosaic's central figure represents God, the universal deity. Flowing from this figure is a rectangle containing three symbols of preceding religions. Continuing to the right is the cross, representing Christianity, and a larger rectangle containing a square, circle, and triangle, symbolizing the relationship between theology, philosophy, and science, respectively.

The mural's tesserae are affixed to concrete forms with up to six inches of relief. Frazier formulated the mosaic's colors using his own glaze recipes, and he transported the mural's components to Wichita from his studio in Lawrence. Each tessera "was studied, contemplated, and handled at least five times before being placed into the mortar on the wall," wrote Hankins. Through the mosaic's design, color, and symbolism, Frazier intended to portray the good in creation and humanity, which is inherent from the beginning and into eternity.

68 Crystal Ballroom Mosaic, early 1960s
Blackbear Bosin

WICHITA
Radisson Broadview Hotel, 400 W. Douglas (inside)

In 1955, Wichita artist Blackbear Bosin, of Kiowa and Comanche descent, garnered worldwide attention when *National Geographic* reproduced his painting *Prairie Fire* in a double-page color spread. This innovative painting, in the "traditional" or flat-style of Indian painting that originated in the 1920s, helped launch Bosin's prestigious career. Around 1959 the Hotel Broadview, significant for the many important events held there, commissioned Bosin, with his burgeoning reputation, to design a spacious mosaic mural for the hotel's Crystal Ballroom (see detail).

Bill Dwayne Allen, of Wichita, refurbished the mural in 1979. Allen researched the little remaining information about the mural and wrote a brief account of its history. R. C. McCormick commissioned the mural, and Bosin designed it between 1959 and 1961. He depicted "the Advance of Civilization in Kansas" as isolated historical moments against an expansive blue sky. He used tiny semiopaque glass chips (Venetian glass) in more

than fifty colors, which are affixed to panels on the ballroom's four walls and cover about 1,500 square feet. Bosin purchased the mosaic materials in Mexico and brought them to Wichita; architect Thomas Berrera accompanied Bosin from Mexico to install the mural. Among the mural's scenes are native animals, Indian people on horses, Coronado's exploration, pioneers on the Santa Fe Trail, cattle drives, Civil War soldiers, the coming of railroads, and European settlement.

Bosin was involved in the cultural life of Wichita for nearly forty years. His well-known 1974 sculpture *Keeper of the Plains* is located outside the Mid-America All Indian Center, which he helped found. His mural *From Whence All Life* (see page 8), unveiled in 1972 at the Farm Credit Bank, is more typical of Bosin's painting style and themes. This mural depicts the philosophy of the Great Plains and Southwest Indians before European settlement, centering on Mother Earth and the sun.

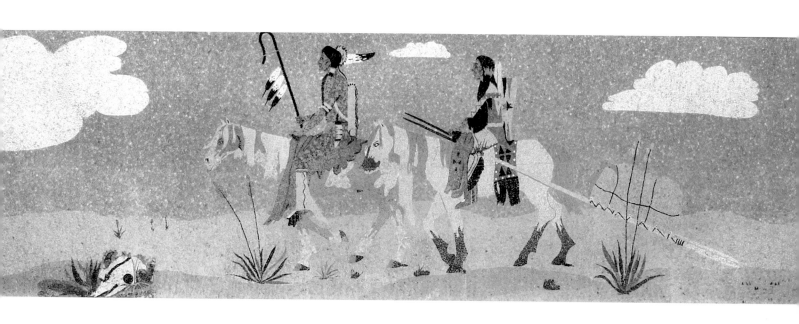

69 *The Evergreen Mural No. 1* 1995
Ryan Drake and Cody Handlin with youth apprentices

WICHITA
Evergreen Recreation Center, 2700 Woodland St.

Murals are important because they're always on public display. They're interactive—touched and appreciated in a personal way—and they are often a reflection of the community," said muralist Cody Handlin. Because of these qualities, Handlin and his mural partner, Ryan Drake, were hired by Wichita's Parks and Recreation Department to facilitate mural projects as a component of a summer-long community service jobs program employing underprivileged youth. More than a dozen young people painted murals on a full-time basis that summer, and this mural represents their first accomplishment.

When Drake and Handlin proposed this mural for an exterior wall of the Evergreen Recreation Center, administrators there were leery because the wall had been routinely spray-painted with graffiti. But Drake and Handlin, not much older than the youth they mentored, were confident that if they used an image that was meaningful to people in the neighborhood and painted by community youth, the mural would be fine. This has remained true for more than a decade.

The Aztec designs and colors in the mural are easily identified and embraced by the people living in Evergreen, a largely Hispanic neighborhood. "Makes me feel like I'm at home," was one comment Drake heard from a passerby. The mural also includes the image of a boy looking at the mural, a much-adored younger brother of one of the youth employed in the program. To the right and left of the boy are two large abstract faces in profile, Aztec symbols for life and death. The muralists placed the boy between the two faces, looking toward life (see detail). "He represents the present moment, and the youth that worked on the project," said Handlin. In addition, the boy—interacting with the mural—seems to invite viewers to do the same.

70 Graffiti Mural 2005
Anonymous artists

WICHITA
The Electric Chair, 1201 E. Douglas (inside and outside)

Graffiti art, or "graffiti writing," began on New York subway trains in the 1970s as an outgrowth of the Hip Hop movement that included DJing, MCing, beatboxing, and breakdancing. Graffiti writing focuses on the creative bending of letters in the writer's street name, or "tag." The multicolored, calligraphic illuminations of tags are called "pieces." This mural, on a tattoo shop, comprises the pieces of two artists who alternated their work (detail shows the style of the two different artists). "First and foremost, it's always about style," said one of the Wichita writers. Writers work hard to improve their pieces, and they often keep sketchbooks of designs.

Some graffiti murals are made with permission, like this one, or without permission on trains, underpasses, or buildings. Illegal writing is a principal aspect of the expression and is often considered vandalism by the larger public. Graffiti art is made alone or in "crews" using spray paint, a medium that is portable, quick, and covers most surfaces. Deaf, a Lawrence-based writer, said that illegal writing makes the art more impressive because the writers risked so much to do it. He finds it gratifying to "take a dead wall and give it life." The common misassociation of graffiti writing with gangs is a negative connotation that is ill deserved.

The 1984 documentary *Style Wars* and the 1983 book *Subway Art* introduced Hip Hop graffiti to a worldwide audience. The Internet increased exposure and has helped writers find each other to share techniques. In addition to tags and pieces, graffiti writers spell out messages (either overt or in code), create cartoon-like "characters," and develop elaborate scenes or "productions." Although visibility is often part of graffiti culture, including "bombing," where writers compete to paint their tags on high-profile spots, some of the most elaborate and interesting writing is done in obscure locations. Graffiti writers "do things to feed their ego," said the Wichita writer, but ultimately graffiti art "is for everybody."

71 *Kansas Daydreaming* 1993
Peggy Whitney and Terry Corbett

WICHITA
214 South Topeka

In 1992, following the lead of other cities across the country, Wichita started a fund to raise money for public art. This fund, commonly known as a Percent for Art program, was set up to bring contemporary art into new public buildings in much the same way that the Section program (see No. 27) had brought murals and sculpture into new post offices and federal buildings in the late 1930s and early 1940s.

The first artwork commissioned through Wichita's new program was Peggy Whitney's *Kansas Daydreaming*. In her proposal for the sleek, curved wall outside the transit waiting area where all the city's buses converge and riders from across the city pass, she envisioned "a Kansas landscape framed by the thoughts of its people." This vision is realized in a vibrant mural based on Whitney's expressionistic landscape painting inspired by the Gypsum Hills in south central Kansas. Using her full-scale painting as a guide, Whitney collaborated with noted Wichita ceramicist Terry Corbett to translate her work into more permanent and durable glazed ceramic tiles.

"Thoughts of the people" were incorporated into the piece in a series of tiles framing the landscape (see the detail of the mural shown here), which were hand-painted with glazes in deep shades of blue by volunteers who participated in free workshops held by the artists at the Recreation Department Art Center and Wichita Center for the Arts. In both words and simple line drawings, participants responded to Whitney's suggestion to think about "what Kansas means to me." Themes emerged in the volunteers' work, including changing weather from sunsets to tornados, agriculture, birds and animals, and Kansas state symbols. The detail here shows community tiles alongside Whitney's landscape.

72 *Larkspur Mural* 1992
Steve Murillo

WICHITA
Larkspur Restaurant, 904 E. Douglas (inside behind the bar; a second mural designed by Steve Murillo and painted with assistants is in the Phyllis Diller Banquet Room)

With a strong interest in abstract pattern and color, artist Steve Murillo evokes a sense of quiet anticipation in this subtly captivating scene. A flock of Canada geese leads the viewer to a patio setting where two men play chess. Chess aficionados will note that either player is set to win; however, one player has become distracted by an attractive woman watching from a nearby window.

The mural comprises five canvas panels mounted high behind the restaurant's bar, making the mural's aerial view all the more intriguing. "You look up on a down perspective," said Murillo, who worked on the mural at home on his basement floor. Murillo looked at murals with particularly strong left-to-right patterns for inspiration. Once he settled on this approach, he invited student assistants from the Ulrich Museum (where he then worked) to serve as models; he photographed them

playing chess. Murillo's research on turn-of-the-century dress revealed that if a man removed his coat and exposed his shirt-sleeves, it was like wearing an undershirt—casual dress appropriate for two men playing such a heated game of chess.

By the time Murillo painted this mural, he probably knew as much about murals as anyone. He began making murals in the 1970s as an artist-in-residence in the public schools. He has documented hundreds of murals, taught classes on murals, and has created countless murals and other large-scale paintings. Even so, the Larkspur murals proved key to Murillo's success as an artist. They garnered great local publicity and put him in touch with David Burk, a Wichita developer "instrumental in keeping me alive as an artist." More recently, Murillo has become well known for his large-scale public sculpture projects and public art consulting, throughout the Wichita area.

73 *The Lindbergh Panel* 1935
Lewis W. Clapp

WICHITA
Kansas Aviation Museum, 3350 George Washington Blvd.

Wichita's city airport, built in the late 1920s, eventually became one of the busiest in the country. In 1930, city manager Lewis W. Clapp broke ground for a new administration building for the airport. Although Depression-era pressures soon caused a work stoppage, construction resumed in 1934 through the Works Progress Administration (WPA). This grand Art Deco building features a colored cast-stone relief mural designed by Clapp commemorating Charles Lindbergh's historic transatlantic flight of 1927.

The Lindbergh Panel depicts Lindbergh's approach to the Irish coast, where he circled three fishing boats to inquire about his location. The mural is based on a watercolor sketch by Clapp, who oversaw all aspects of the project. Volney McClaren and others at Wichita's Cement Stone and Supply Company created a small-scale model that was cast three times to work out the proper color combinations. Suitable colored aggregates for the mural were gathered from around the world, including green Mentholatum jars from a Wichita factory. The full-scale casting, a 37-by-5-foot panel weighing 11,500 pounds, was then the largest single panel casting of its kind; it was completed on a holiday to minimize work interruptions.

Lindbergh toured the country in 1927 following his successful flight, and he was given an honor banquet in Wichita. He had also passed through Wichita on his honeymoon, noted Walt House of the Kansas Aviation Museum, and "gave his blessing on the piece of ground where the new airport would be." In the 1950s, the administration building became part of McConnell Air Force Base, and it was acquired in the 1980s by the City of Wichita. In 1991 the building became home to the Kansas Aviation Museum, where it stands as a monument to the glory days of Kansas aviation.

74 *Medicine Songs* 1986 (repainted 1995)
Rick Regan

WICHITA
Mid-America All-Indian Center, 650 N. Seneca (inside Riverfront Room)

"Through prayer, help is on the way," said Rick Regan about the meaning he hopes viewers will find in *Medicine Songs*. This mural in the Indian Center's Riverfront Room, as well as his two others in the Kiva area, are painted in a traditional Native American style featuring flattened, outlined forms. Regan, of Lakotah, Creek, and Irish descent, derived *Medicine Songs* from the Sundance Way spiritual tradition of his Lakotah ancestors.

"The old people said . . . God lived in the sun," explained Regan. The sun, a circle of yellow with triangle rays, surrounds the image of a spirit, representing God. A man offers the sacred pipe to God, praying for health and help. These prayers are also symbolized by the pipe bag and tobacco pouch on the ground. As the man prays, answers come out of the spirit's eyes, and he is cradled in the arms and wings of the spirit, receiving blessings, power, and vision. The Native American Church, another spiritual tradition, is represented by the peyote cactus in the landscape. Regan's 1978 murals in the Kiva area depict waterbirds that come out of the fire and carry prayers to God.

As a muralist, Regan has many painting styles "from being other people's hands," he said. Although Regan sometimes feels restricted when producing commercial murals, his own imagery and perspectives are represented in this mural and many others. Regan's first mural was as a young draftee in the Vietnam War. With few artistic outlets available, he was "going crazy" when he came across some paints. On the side of a building he depicted jets, a Buddhist temple, and Vietnamese people as an antiwar statement. His recent murals in a Wichita restaurant pay tribute to the famous, revolutionary Mexican muralist Diego Rivera.

75 *Our Lady of Kansas* 1965
Sister Mary Fleurette Blameuser, B.V.M.

WICHITA
Kapaun–Mt. Carmel High School, 8506 E. Central (inside foyer)

Too often contemporary art . . . lacks the qualities of sincerity, reverence and self-discipline. Vacuity and despair—often consequent upon the denial of God and the existence of the supernatural, result in the projection of frustrated ideas completely lacking spiritual content. We must learn to turn not only to nature but to the realm of spiritual realities for our inspirations and ideals. Then only, renewed in hope, will art truly enjoy a second spring.
—Sister Mary Fleurette Blameuser, B.V.M.

Sister Mary Fleurette Blameuser was a serious artist and "the happiest, most charming, adorable person you could imagine," said Andrea Gragert, one of four students at Mt. Carmel Academy selected to help position the mural's tesserae, small glass pieces sometimes called Smalti or Byzantine glass imported from Italy. The finished mosaic, installed on a circular wall in the foyer of Kapaun–Mt. Carmel High School, comprises about 138,000 tesserae with 145 color variations; there are 37 tones of blue alone.

"The labor on the mural was incredible and daunting in so many ways," said Gragert, noting that Sister Fleurette, who began work on this mural during the summer in an unairconditioned studio, always worked in her full nun's habit (see photo, page 249). Conceptual work on the project began in 1960. Sister Fleurette laid the mosaic's first tessera in 1961 and completed the mural in 1965. She spent a total of 2,500 hours working on the mural using the "reverse method." Tesserae were glued to paper sections, front side down. The sections were then cemented to the wall. After the cement dried, the paper was soaked off and the mural was cleaned.

"It is a poetic and somewhat mystical interpretation of the Kansas scene," wrote Sister Fleurette. The mural's central figure is Our Lady, whose "billowing veils are symbolic of the south wind (Kansas means South Wind People.)" The Christ Child's open arms are a gesture of welcome. The mural's background, consisting of astral bodies and rhythmic circular planes, contrasts with the symbols of the Kansas landscape and economy in the foreground. These contrasts "serve as a psychological divider between the mundane and the celestial."

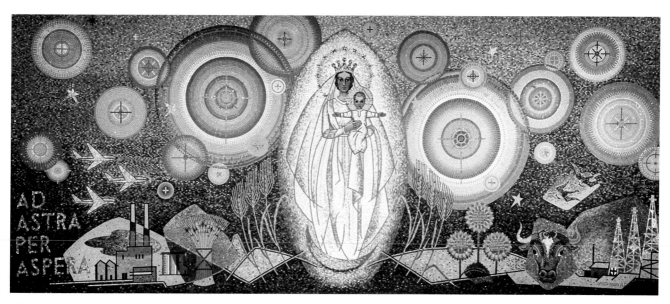

AD
ASTRA
PER
ASPERA

76 *Personnages Oiseaux* 1977
Joan Miró

WICHITA
Wichita State University, Ulrich Museum of Art, 1845 Fairmount St.

Visitors searching for the Ulrich Museum will know they have found their destination when they see on the building's facade this striking mosaic mural by one of the twentieth century's most celebrated artists. Arching out over the museum's entrance, the 28-by-52-foot mural sparkles with more than one million pieces of Venetian glass and marble.

Spanish artist Joan Miró based the design on a painting of the same name that includes his characteristic biomorphic forms filled in with primary colors. Miró's style is characteristic of the Surrealist movement with which he is most often associated. Surrealism as an art movement emerged in the 1920s as an attempt to tap the unconscious mind, usually during dreams, for new ideas and images to use in art.

Some Surrealist artists, like Miró, practiced a process of spontaneous or "automatic" drawing to develop the forms in their paintings, which freed them from making strict depictions of objects and figures. The resulting pictures that Miró created, such as *Personnages Oiseaux* (which roughly translates to "bird people") often appear to be highly abstracted human and animal forms interacting in an undetermined otherworld. To some, the mural may seem to be a personal image that is difficult to decipher. Miró saw his piece as a way of inspiring and communicating with the many young people at the university. As he said,

From what I hear, thousands of students go by it every day. What I want is for my work to become part of the consciousness of those young people, the men and women of tomorrow. One of them—who knows?—may become President of the United States and will have been touched by my mosaic. That is what makes it worthwhile. It's the young people I'm working for, not the old dodos. I'm working for the year 2000 and the people of tomorrow.

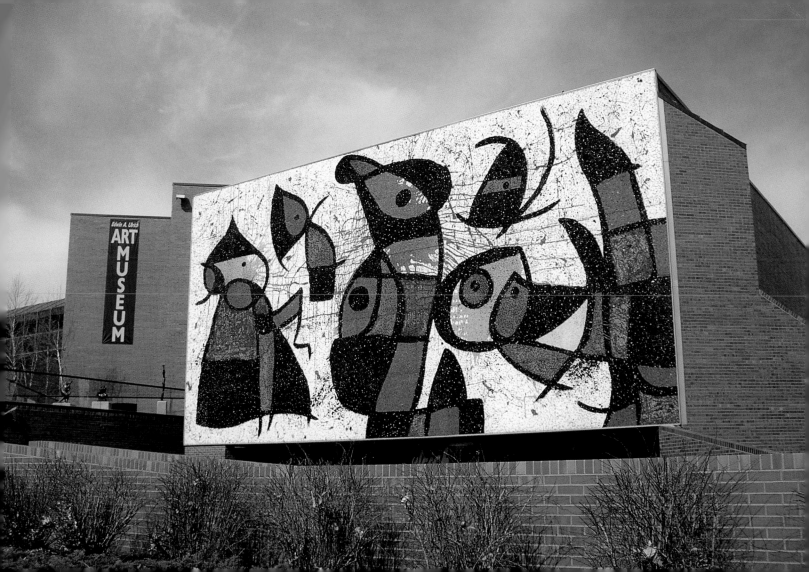

77 *The Spirit of the Prairies* 1915
Arthur Sinclair Covey

WICHITA
Southwest National Bank, 400 E. Douglas (inside)

This mural triptych by Arthur Covey was displayed on three walls of the reading room in Wichita's Carnegie Library for nearly sixty years. The 1915 mural was Covey's first individual commission and launched his distinguished career as a muralist. When the library moved to a new location in 1975, the mural found a home at Southwest National Bank.

The first panel, *Promise*, depicts settlers on the open prairie. One man gazes at a rainbow in the distance. The center panel, *Fruition*, depicts people, young and old, holding baskets spilling over with produce from a bountiful harvest. Two allegorical figures, with books at their feet, study a globe. The last panel, *Afterglow*, depicts Native Americans. A 1985 interpretation of the mural states, "*Afterglow* recalls the fate of the primitive freeholder of Kansas . . . retreating slowly before the irresistible advance of the white man's forces. It is not merely wonder at their advance that he expresses, but it is resignation and acceptance as well." (The bank display has the first and third panels reversed.) The mural reflects many influences, among them Covey's Kansas roots, his education at the Art Institute of Chicago and the Royal Academy in Munich, his years assisting the prominent muralist Frank Brangwyn in England, and some stylistic elements of Postimpressionism and Art Nouveau.

In 1960, Covey's wife, artist Lois Lenski, wrote a fascinating account of his early life that accompanied a donation of his artwork to Southwestern College in Winfield, honoring the memory of his teacher, Edith Dunlevy. One story, later recalled in a Covey lithograph, is the time he went along with his father and brothers—as a stowaway—to make the 1894 Cherokee Strip Land Grab south of Kansas. Lenski concludes that Covey's art reflects "his two hands that once held the plow" as well as "his great soul and spirit."

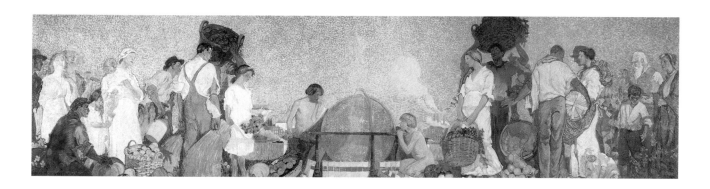

78 *Searching for Magic* 2001
Marjorie Hall Bicker

WINFIELD
Winfield Public Library, 605 College St. (inside children's area)

Kids love belly buttons, and in this mural even the dragon has one. "All the things I loved growing up got thrown in there," said artist Marjorie Hall Bicker about this mural, located in the library's children's area. Bicker created the illusion of objects sitting on top of bookshelves that are built into the wall. Above the shelves, a sweeping Flint Hills landscape joins a tranquil sea while open books cavort with fanciful creatures.

"Mommy, she's drawing on the wall!" said a boy as he watched the artist at work. Unlike most muralists, Bicker first drew the mural's images right onto the wall using a variety of reference materials. A famous NASA photo became the mural's astronaut, but this one holds a roll of duct tape. The train was her husband's childhood toy. "He was tickled to have it immortalized," Bicker said. Trees at the edge of a castle have branches trimmed like parasols. "The only place I've seen trees like that is in Italy." Bicker even drew a bit of water dropped onto a slick surface to represent the puddle that Noah's Ark sits in.

Way atop a hill, there is a tiny tree growing out of the crest. The real tree actually grows on the east side of the turnpike, two miles north of Matfield Green. The first time Bicker saw the tree, growing by itself in the wind and rocks, she dubbed it her "courage tree." "He's just out there being gutsy," said Bicker about the tree. She tries to find a way to work the tree into all of her murals. Bicker hopes children will lose themselves in the mural and enjoy looking at it as much as she enjoyed painting it.

Winfield has more than a dozen murals. A mural guide is available through the Chamber of Commerce, 205 E. 9th Ave. (P.O. Box 640, Winfield, Kansas 67156).

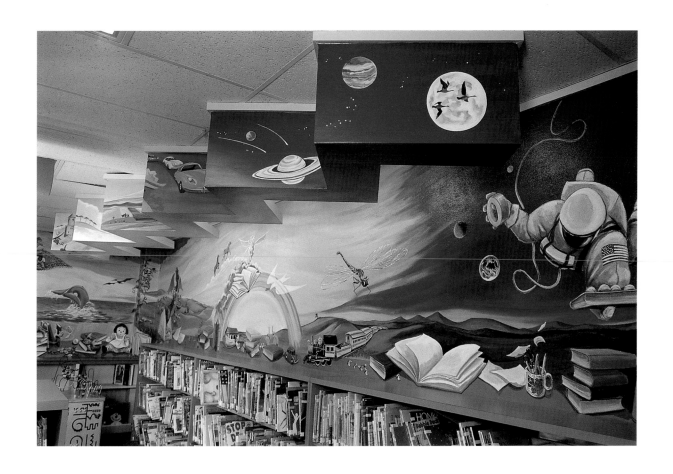

79 *The Story of Winfield* 1951 (revised 1975)
Sue Jean Covacevich

WINFIELD
First National Bank, 900 Main St. (inside)

After a twelve-year sojourn in Mexico, where she worked alongside artists such as Diego Rivera, Sue Jean Covacevich returned to Kansas to become one of the state's most versatile artists and art educators. Among her notable achievements were publishing two books of her prints, developing a pioneering art therapy program for mentally disabled youth that became a model used by the Menninger Clinic, teaching art in the public schools for more than thirty years, and painting this vibrant tribute to the history of Winfield.

This impressive historical montage is composed, as Covacevich wrote, of "dynamic lines cutting across the mural that indicate the passing of time and the changing of the seasons." Within the shapes created by these diagonal lines, the mural follows a narrative of settlement, growth, and prosperity familiar to many town history murals found in the state (see *A Look Back* by Charles Goslin in Shawnee, No. 28).

The section on the left begins with Native Americans and early pioneer settlers peacefully coexisting. The center section depicts the blossoming of commerce and the growth of Winfield, juxtaposed with the region's vulnerability to tornadoes and the economic fallout of the Great Depression. Covacevich painted herself in this section as a first-grade pupil (in the detail of the mural shown here), a gesture reminiscent of Rivera in his mural *Dream of a Sunday Afternoon in Alameda Park*. She stands in a blue dress in the foreground at the bottom-left side.

The artist added the final section of the mural, titled *Cavalcade*, in 1975 when the bank was expanded. Here Winfield is celebrated as a modern American city with strong schools, a diverse economy, and many churches.

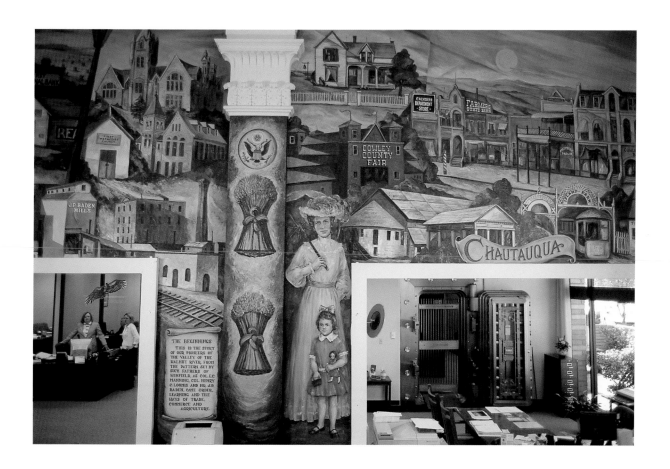

Northwest

◇ Cities and towns highlighted with this symbol are home to ten or more murals.
Consult the appendix for a complete listing.

80 *History of Rawlins County* 1976
Rudolph Wendelin

ATWOOD
Rawlins County Historical Museum, 308 State St. (inside)

This densely packed historical tableau is showcased in its own room at the front of the Rawlins County Historical Museum. Painted by the artist, sculptor, and designer Rudolph Wendelin, who is best remembered as the illustrator of Smokey the Bear, the mural traces the history of Rawlins County from homesteading in the 1880s to 1974.

Moving forward through history from left to right, Wendelin's design is a collage of scenes and activities that depict the county's economic, cultural, and architectural history (detail shows a contemporary farm family). In describing the sweeping changes that Rawlins County witnessed in its first 100 years and that are depicted in the mural, Wendelin observed, "Where buffalo and Indians once roamed on the open plains, large farms on contoured terraced fields dominate the landscape using rubber-tired power machinery to cultivate and plant the fields."

Wendelin, the grandson of Rawlins County homesteaders, did extensive research in preparation for the mural, including many drawings and watercolors that are displayed in the museum. While viewing the mural, visitors can listen to Wendelin on a twenty-minute audiotape; in it he describes the historical importance and source of many of the mural's images, including the following quote at the end of his commentary:

We enrich the present by remembering the past. The mural is a graphic attempt to express this thought. It remembers and honors those who made up the past. It recognizes those who contribute towards the present and challenges members of the future who will continue to shape the history of this county [17 October 1976].

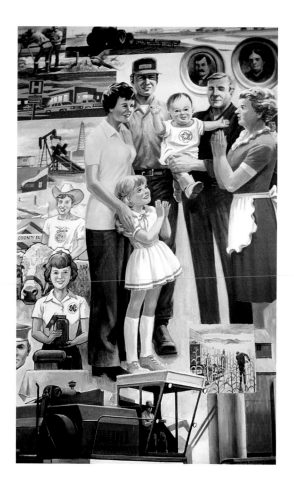

Kenneth Mitchell with Vicki Mitchell, Bruce Bandy, Corbin Stephens, Marlene Carpenter, Bev Kern, Marge Brown, Leon Voke, and many others

COLBY
Colby Community College, Bedker Memorial Complex, 1255 S. Range St. (inside)

Artist Ken Mitchell's mother taught school in a one-room schoolhouse on the plains of Nebraska. His grandfather was the superintendent, and his great-grandmother was also a teacher. Therefore, when Mitchell returned to Colby to paint a mural at the community college where he had taught for twenty years, he was excited that the mural would not only honor 100 years of education in Thomas County, but also his proud family history in education.

Education has always been important in Thomas County. "On every mile section there was a schoolhouse," Mitchell said of the rural landscape a century ago. The mural shows twelve of the county's schools, which were built between 1885 and 1998. Among them are Menlo School (the county's first high school), Colby's Intermediate School (on the historic register), Colby Community College (built in the 1960s), and a large-scale interior view of Halford School (a one-room schoolhouse east of Colby).

The mural also pays tribute to the students and teachers who spent so much time in those schools. Halford school teacher Ida McBride stands in front of the blackboard; the first two graduates of Thomas County, in 1902, stand in front of a graduation certificate naming all the students educated that year; and a self-portrait of Mitchell presenting a diploma to a student named Alice Honas honors the graduates of Colby Community College.

"When I came back to paint the mural, it was as if I'd never left the place," Mitchell said with affection, crediting the many colleagues, friends, alumni, and students who helped on the mural. Mitchell had a little fun with some of his friends' names by adding them into the mural, such as "Albert loves Helen" scratched into a desktop as if it was left by a student once schooled there.

82 Sunflowers after Vincent van Gogh 2001
Cameron Cross

GOODLAND
Hwy. 24 and Sandy Dr.

Perched on a giant easel high above Goodland, this giant reproduction of one of Vincent van Gogh's celebrated sunflower paintings beckons sightseers from nearby Interstate 70. The story of the original painting and how it grew begins in August 1888 in Arles, France. While eagerly awaiting the visit of painter Paul Gauguin to Arles, van Gogh began a series of paintings of sunflowers to decorate his studio and create what he called "a symphony of blue and yellow." Of the seven paintings in the series, it is the second that is reproduced in Goodland.

The story continues in 1996 when artist and teacher Cameron Cross proposed creating a giant copy of a van Gogh sunflower painting as a landmark for Altona, the sunflower capital of Canada. His proposal was accepted, and as the painting seemingly grew up from the ground, Cross's vision for van Gogh's sunflowers expanded. Dubbed the Big Easel Project, Cross foresaw van Gogh's sunflowers spanning the globe in seven different countries. Canada, Australia, the United States, the Netherlands, Japan, South Africa, and Argentina would all be home to one of the giant easels, each placed in a town with a relationship to sunflower agriculture or to van Gogh.

In 1999 the second giant van Gogh was erected in the sunflower capital of Australia, Emerald. Then in 2001, Goodland, the sunflower capital of the sunflower state, saw the installation of the third giant easel (weighing 35,000 pounds) in a new park near the east entrance to I-70. Although its scale and freestanding presentation may remind one of an advertising billboard, the image contains no corporate logos, product placements, or political slogans, just sunflowers against an open sky, "a symphony of blue and yellow."

83 *Protect Our Water Quality* 2001-2003
Rick Rupp and volunteers

HAYS
22nd and General Custer Sts. (under bridge)

They are wonderful, and this is a prime example of what can happen when true collaboration takes place," recalled Project SERV AmeriCorps director Debra Ring about this ambitious community mural project that aimed to raise awareness about how to prevent pollution in the groundwater in Ellis County. Initiated in 2001 by the Wellhead Protection Committee as a service project for Make a Difference Day, thirty-six murals were painted over the course of three years on bridges that span waterways within the city. Leading the project was Rick Rupp, a professional muralist from Hays. Rupp guided volunteers from Fort Hays State University, AmeriCorps, and Mortar Board as they transferred designs onto the bridge walls and painted the murals.

The mural designs came from drawings created by students at local middle and high schools. Rupp and his assistants care-fully reproduced each drawing selected for the project. Rupp said that it was important that the murals be accurate copies of the originals so that "youngsters know that their work is good enough, and doesn't need to be changed by us."

Most of the murals are presented in related pairs facing each other on opposite sides of the bridges. On the wall of one bridge, a giant green frog leaps into an unpolluted pond, whereas the mural on the other side of the bridge shows a boy fishing from a wooden pier, with a surprised expression on his face as he reels in a car tire instead of a fish. The project was well received in Hays and was especially meaningful for the students who participated. Justin Greenleaf, an AmeriCorps volunteer, noted, "The bridge project was awesome. It was a way of letting the community know that we are here and we care."

Chad Haas

HAYS
Holzmeister Liquor, 701 Vine St.

Just off highly trafficked Route 183, this lighthearted mural evokes the commonplace activities associated with the neighborhood where artist Chad Haas grew up. In the mural, a young woman scrubs a blue convertible in a drive-through car wash. A man walks past a newspaper box in front of an unidentified business with an "open" sign in its doorway. In the center panel shown here, two boys—one Hispanic and one white—and a dog sit in the bleachers of a small sports park watching a young man play an acoustic guitar. The kids and their dog are focused on the guitar player, suggesting that the game on the field, if there is one, is of little interest to them. This warmhearted scene has the feeling of a lazy summer afternoon.

The artist, known for painting murals with his fingers in place of brushes, recently completed the world's largest finger-painted mural by an individual. Haas also uses sticks, rocks, leaves, and other objects he finds on site to create different textures and paint details. These methods lend a folksy quality to his paintings, which complements their familiar subjects.

Haas lived in Hays into his twenties and painted many murals there before leaving Kansas to travel the world. Another of his murals is just down the street at 11th and Vine Streets and shows a curious scene of a group of wild animals talking on cell phones.

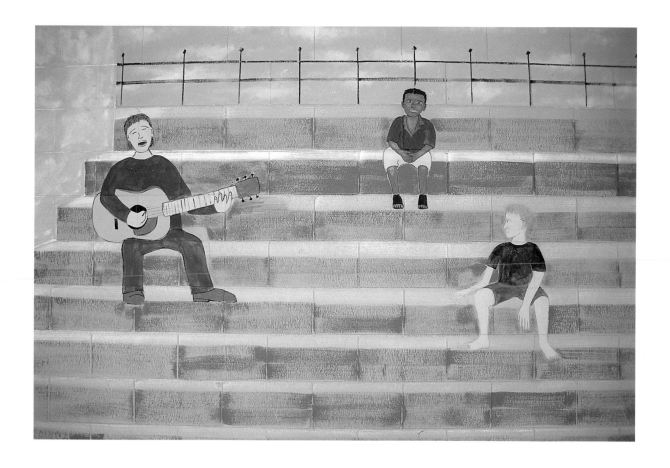

85 Places in Rooks County 1920s
Artist unknown (prisoner in county jail)

STOCKTON
Rooks County Courthouse, 115 N. Walnut (inside County Commission meeting room, 2nd floor)

On the eastern edge of the Great Plains on the second floor of this old county courthouse lies a mystery. There, eight mural panels form a nearly continuous frieze on the walls of the Rooks County Commission meeting room. They are old but have no date; they are painted by the hand of a skilled artist with academic training but are unsigned; and they are thought to depict places in Rooks County, but it is not clear exactly where.

Perhaps the answers lie hidden in the paintings themselves under the accumulated dust and smoke on their surfaces, or maybe the answers are filed away in a drawer from some eighty years ago that lists inmates in the county jail, their crimes, and their sentences. As with all good mysteries there is a sketchy, unconfirmed story that gives a partial explanation.

Clara Strutt, the county clerk, recalled the story of the murals as it has been passed down over the years. Sometime in the late 1920s or early 1930s, she says, a prisoner held in the county jail painted these murals. It appears that he may have bartered his painting skills for some kind treatment or a reduction in his sentence. Strutt says that this artist/prisoner probably used postcards as his source material for the murals, which range in subject from historical scenes to contemporary (circa 1920s) downtown scenes and portraits of what must have been the homes of important people in the community. That is all we know.

Southwest

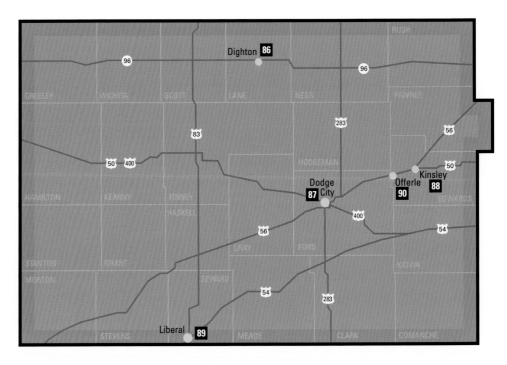

86 *First House of Lane County* 1961
Mary Alice Bosley

DIGHTON
Lane County Courthouse, 144 S. Lane (inside 3rd floor Jury Room)

One might expect a jury room mural to depict "justice" as a woman in flowing robes holding a sword and scale. However, this mural "is just a lonely building on the prairie," said Mary Alice Bosley, who painted it as a backdrop for the state centennial pageant at the Lane County Fair. The lonely building is Lane County's first house; it was made of sod, a combination of earth, roots, and grass that was the primary building material during the Great Plains settlement.

After the centennial pageant, the large-scale mural was installed in the Jury Room, where it has remained for more than four decades. "I remember one of the judges telling me how relaxed it made him feel to look at it," said Bosley. Yet for many, time has rendered the mural invisible, as can happen with public art. "I think it's something people are so used to seeing that they don't see it," she said.

To paint the mural, Bosley unfurled the 26-foot-long canvas in her backyard, dragging it into the garage during thunderstorms. The neighbor kids enjoyed sitting on the grass watching her paint throughout the summer-long process. Bosley painted the sod house on one side; on the other side, now hidden from view, she painted three early Lane County buildings.

The pageant—which was well attended and well received—was performed against Bosley's backdrop fastened to a big truck. "The sides were turned to fit the story," said Bosley. The local paper reviewed the pageant and could not resist some light-hearted ribbing. For instance, the three-tine pitchforks used in the play were declared inadequate: "Old-timers tell us that four-tine forks are much better when pitching wheat." The reviewer continued, "Some of the teams, mules and horses, were a little excited and one of them almost got away, but things turned out real well."

Ted Carlson

DODGE CITY
Dodge City Cooperative Exchange, 710 W. Trail St. (inside)

Artist Ted Carlson remembers what it was like to pull a combine behind a tractor with steel wheels: "The machine had to be greased twice a day with a zerk gun," he said (see photo, page 254). "At night you undid the belts and canvas so dampness wouldn't stretch them. In the morning routine you would tighten the belts and canvas—there were chains galore!" He remembers the hot air downwind and the sweat bees. When the time came for Carlson to take over his father's farm, he declined. Instead, he has spent a lifetime painting Kansas' rural landscape and working as a graphic designer and cartoonist for publications appealing to farmers and ranchers. In 1957, architect Gene Gurtner invited Carlson, his friend, to paint three murals depicting the history of the combine for the new co-op building.

Wheat production overtook corn around 1874, when grasshoppers and drought devastated corn crops. Turkey Red wheat was introduced to Kansas between 1874 and 1884 when German Mennonites emigrated from Russia to Kansas. The winter wheat proved so well suited to the Kansas climate that the U.S. Department of Agriculture introduced new varieties of wheat from eastern Europe in 1900. The railroads, anxious to ship grain, then recruited immigrant farmers to work the soil.

Changes in mechanization, shown in the three mural panels (the right is pictured here), increased wheat production. The horse-drawn header (left panel) was used to cut the wheat heads while the threshing machine separated the kernels from the straw. "No one mentions much anymore about the headers," said Carlson, who relied on the memories of his father, a farmer who worked the coal mines of Osage County as a young immigrant. The first combine of the 1920s (right panel) was a combination of a thresher and header. The first self-propelled combine (middle panel) became popular after World War II. The huge grain elevator in the distance reminds viewers that Kansas is still the largest wheat-producing state in the country.

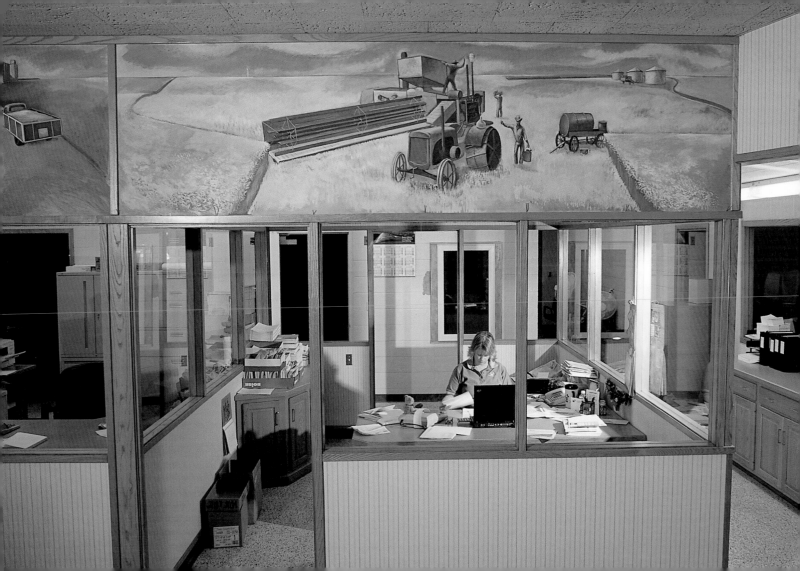

88 Kinsley Carnival Mural 1999
Jessica White-Saddler

KINSLEY
6th and Marsh Sts.

In 1939, one of the country's most popular weekly magazines, *The Saturday Evening Post*, featured Kinsley, Kansas, on its front cover. The illustration showed two cars in Kinsley headed in opposite directions—one east to the World's Fair 1,561 miles away in New York, and the other west to the Golden Gate Exposition 1,561 miles away in San Francisco. In addition to being featured in the magazine, Kinsley, dubbed "Midway USA," benefited from its geographic location by becoming the home base for several traveling carnivals that toured the Midwest and Rocky Mountain states for more than seventy years.

Although the last Kinsley carnival closed in the late 1970s, the legacy of the town's carnival past is maintained and celebrated by the Carnival Heritage Foundation, which opened the Carnival Heritage Museum in 1996 and sponsored Jessica White-Saddler's carnival mural in 1999. Framed by the names of Kinsley's past carnival troupes, White-Saddler's whimsical mural captures the dreamlike feeling of these small-town happenings that disappeared as quickly as they appeared in late summertime. In front of the local grain elevator and a passing freight train, an arrangement of rides and attractions, with a carousel at the center, transforms a vacant lot on the outskirts of town into a playground vibrating with primary colors and motion (see detail).

89 *Entrada* 1979, 1986
Stan Herd

LIBERAL
Dollar Tree, 220 E. Parkway Blvd.

The two scenes in *Entrada* (the buffalo scene, completed in 1979, and the Coronado scene, completed in 1986) were originally part of Stan Herd's *Santa Fe Trail Historical Mural*, which was completed for Dodge City's Hyplains Dressed Beef, Inc. (now National Beef), in 1979. New panels were added in 1986, and these were moved to Liberal and Topeka in 2002. Among the scenes that span eight centuries is the Spanish explorer Coronado, who entered present-day Kansas in 1540 looking for gold (see detail).

Herd's well-crafted murals proliferated across western Kansas in the 1970s and 1980s. By the late 1980s, however, Herd began receiving national attention for a different medium, "crop art": large-scale agricultural artworks that were cut out of fields and documented with aerial photography. Even so, *Santa Fe Trail*, a whopping 660-foot-long mural, remains quite literally one of Herd's biggest accomplishments—all the more so because he repainted the mural twice.

Among the scenes in *Santa Fe Trail* are portrayals of early Indians, the Santa Fe Trail, the cattle industry, and pioneer home-steaders. As in many Kansas murals, Herd's imagery appears to celebrate European settlement. Yet a Hyplains flyer about the mural helps the viewer understand the imagery differently, noting some of the devastating aspects of "the white man's invasion" on the Indians and the land. As a young artist, Herd was interested in bringing his political concerns, influenced in part by the American Indian Movement and the Land Institute—a research institute devoted to studying sustainable agriculture—into his artwork. He felt, however, that he could not do this in murals in western Kansas and still make a living. Herd's departure from murals into crop art and other earthworks provided a more viable artistic platform for political discussion.

Although Herd downplays the influence of his murals, they clearly inspire community pride and have helped launch a statewide blossoming of town murals. Their significance is "like a family album," said Herd, providing communities a focal point for reveling in the past and remembering their history and traditions.

90 *The Saga of the Santa Fe* 1991
Dennis Burghart

OFFERLE
Offerle Cafe, U.S. Hwy. 50/56

The dry-land route of the Santa Fe Trail went directly through where this mural is today. "Rather than hugging the river," said artist Dennis Burghart, "they saved miles going as the crow flies across the land." Offerle and the surrounding area has been a natural thoroughfare for more than 500 years, from buffalo trails, Indian trails, and Coronado's expedition, to the Santa Fe Trail, Santa Fe Railroad, cattle drives, and modern highways. Struck by the words "Santa Fe," meaning "holy faith," the passageways honored in this 50-foot-long mural are for Burghart—who is Catholic—imbued with spiritual significance.

Depicting history in an ethereal manner, Burghart has painted clouds that hold images of Indians pursuing buffalo, Coronado's expedition, and a covered wagon train. Below the sky, workers lay track on the open prairie, bringing forth the railroad. From the railroad comes modern progress—cattle drives, immigrant settlements, and farming. "That soil is com-posed of buffalo bones and remains and everything else," said Burghart, amazed by the prairie's willingness to adapt to human change.

At the mural's center are a woman and child who are watching a farmer break sod. For Burghart, women were integral to the saga of westward expansion, a spiritual essence parallel to Mary as the feminine element of Christianity. Burghart said, "None of the cowboys would be here without their mother. And being so indispensable, she becomes all important."

The mural was commissioned by then-owners of the Offerle Cafe, Rachel and Larry Leith, with broad community support. Cattle brands, both real and fictional, were placed within the mural's blue border to recognize ranchers and local businesses who contributed to the project. The border was left open at the mural's top and bottom. Here, the real sky and the sky painted on the mural merge, reflecting history's borderless, romanticized west where so many journeyed before.

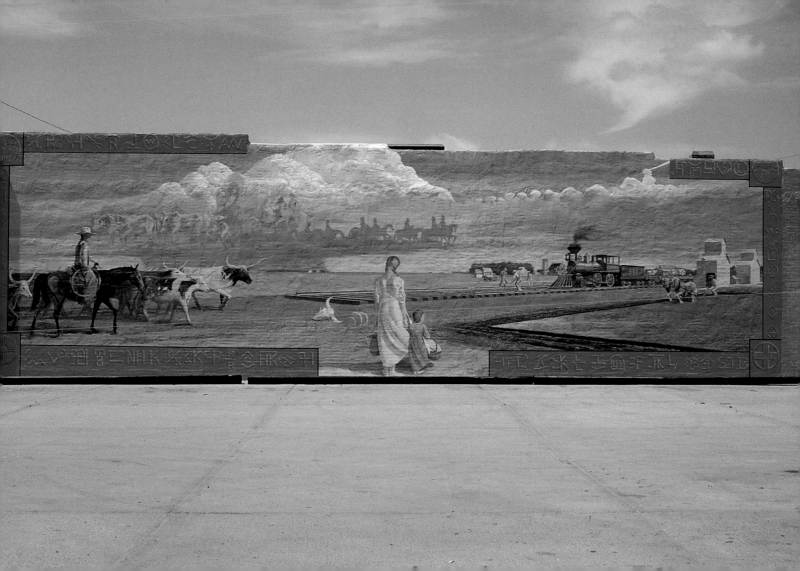

Appendix A: Biographies of Mural Artists

Joan Allen (1942–) has a degree in art education from the University of Alabama at Tuscaloosa. She teaches art at Oswego High School and works with students to paint drama backdrops, murals, signs, and prom decor. Her freelance employment includes painting, murals, graphics, signage, advertisements, window painting, and calligraphy. (Oswego, No. 41)

Ron Allerton (1936–) lives in San Francisco, California, where he is a painter and educator. He attended the University of Kansas and received an MFA from the University of Missouri in 1963. (Hiawatha, No. 6)

D. O. Bacon (c. 1839–early 1900s) was an employee at the Missouri Pacific Railroad. At age sixty-three, he was admitted to Osawatomie State Hospital after unsuccessful treatment at Missouri Pacific Hospital in St. Louis. His mental problems were attributed to sunstroke or heat stroke. He was released from the hospital in 1902. (Osawatomie, No. 23)

Theodore Behr (1861–deceased) was born in Saxony, Germany, and lived in Chicago. (Wamego, No. 35)

Ryan Bell (1976–) received a BA from Wichita State University in 1999. He was an AmeriCorps*VISTA worker from 2000–2001. He owns and runs Davis Furniture and lives in Wichita with his wife and children. (Wichita, No. 66)

Marjorie Hall Bicker (1947–) believes that art is her way to respond to God's beautiful world. Bicker, educated in the 1960s and 1970s, counters art world snobbery with "people art," referring to her eight public murals. She led the restoration of a Winfield, Kansas, building that is now on the National Register of Historic Places. (Winfield, No. 78)

Sister Mary Fleurette Blameuser, B.V.M. (1925–1976) received a BA from Clarke College and an MA from Iowa University. She was a professional painter, lithographer, and muralist. She taught at Mt. Carmel and Kapaun–Mt. Carmel high schools in Wichita from 1956 to 1974. In 1965 she was a Georgio Cini Foundation fellow in Venice, Italy. (Wichita, No. 75)

R. Clay (Bob) Booth (1959–) derives art imagery from his family history in farming and ranching. He received an art degree from Adams State College in Alamosa, Colorado. He taught and did agricultural work for ten years and then became a sculptor in Alamosa and has work in private, public, and corporate collections. (Hoisington, No. 59)

Francis Blackbear Bosin (1921–1980) moved from Anadarko, Oklahoma, to Wichita in 1940 and worked at Beech Aircraft. Later he ran Great Plains Studio, often entered the Philbrook Art Center's Indian Artists Annual, was a fellow of the International Institute of Arts and Letters (Switzerland) and exhibited at national galleries, including the Smithsonian Institution. (Wichita, No. 68; Wichita, page 8)

Mary Alice Bosley (1924–) is from Dighton, Kansas. She became interested in art through an influential Kansas State University teacher, John F. Helm. She majored in art and home economics and became a teacher. She raised three children and now paints landscapes and still lifes in pastels, oil, and watercolor. (Dighton, No. 86)

ERIC BRANSBY (1916–) lives in Colorado Springs, Colorado. Bransby studied with Thomas Hart Benton, Jean Charlot, and Joseph Albers. He served in the military at Fort Leavenworth, where he painted murals about the fort's history. A master of traditional fresco technique, he has other major murals in Sedalia, Missouri, and Colorado Springs, Colorado. (Manhattan, No. 22)

DENNIS BURGHART (1945–) is from Offerle, Kansas, and has a BFA from Wichita State University. He has worked many jobs, from carpentry to machine work, making art on the side. He has painted several murals and currently works full time as a liturgical sculptor. He is married with seven children. (Offerle, No. 90)

LARRY CALDWELL (1953–) was born in Scott City and now lives in Hutchinson. He worked for sixteen years as a photojournalist before he became a full-time artist. He apprenticed with the show painter (a painter of circus and carnival signs) J. B. "Bardo" Holdren and learned techniques applicable to murals and other large-scale artwork. (Hutchinson, No. 61)

MARTY CAPRON (1959–) is a professional wildlife artist with a studio in Oxford, Kansas. His artwork appears in exhibits across the country and in limited edition prints, T-shirts, logos, and advertisements. His illustrations have appeared in many publications, including Jack Rudloe's *Search for the Great Turtle Mother*. (Caldwell, No. 54)

AMY CARLSON (1962–) believes that our inherent desire to create binds us all together. She is a rural Lawrence painter and ceramicist who teaches ceramics from her studio. A Midwest native, she received her BFA in printmaking from the University of Kansas. She is married with three sons. (Lawrence, No. 16)

TED CARLSON (1922–) lives in Dodge City and is a professional painter of landscapes and portraits. He has won numerous awards. He studied at the Wichita Art Association School, taught art courses, was the art director for *High Plains Journal* for thirty-two years, and completed numerous cartoons for *The Territorial* magazine. (Dodge City, No. 87; photo, page 254).

JEAN CHARLOT (1898–1979) was born in Paris. He moved to Mexico in 1921 and painted murals with Rivera, Orozco, and Siquerios. Renowned muralist, illustrator, author, and educator, Charlot completed more than fifty murals in the United States, taught fresco to a new generation of artists, and authored *The Mexican Mural Renaissance 1920–1925* (Yale University Press, 1963). (Atchison, No. 87; photo, page 218).

LEWIS W. CLAPP (1858–1934) was born in Dover, New York. He received a law degree at the University of Iowa and practiced law in Iowa. He moved to Wichita in 1886 and became a businessman who served as mayor, city manager, and president of the board of park commissioners for thirteen years. (Wichita, No. 73)

PAULA BLINCOE COLLINS (1946–) is a ceramicist in Denton, Texas, with a BA from the University of Iowa. She has created more than 200 carved brick murals, including a mural for the Olympic soccer venue in Athens, Georgia. She became a pilot to simplify transportation to job sites. (Baxter Springs, No. 36)

SUE JEAN COVACEVICH (1905–1998) was born in Wellington, Kansas. A painter, illustrator, and educator, she received a BA from Bethany College and an MA from Colorado State University. Her work is in the collections of the Library of Congress and the New York Public Library. In 1981 she received the Kansas Governor's Artist of the Year award. (Winfield, No. 79)

ARTHUR SINCLAIR COVEY (1877–1960) spent much of his childhood in Kansas. He studied art in the United States and abroad, has murals in public buildings nationally, was president of the National Mural Painters Society (1929–1942), taught in the National Academy Schools in New York, and won numerous national awards and honors. (Wichita, No. 77)

CAMERON CROSS (1963–) lives in Winnipeg, Manitoba, Canada. He is a painter, educator, and the director of the Big Easel Project. He received degrees in fine arts and education from the University of Manitoba. (Goodland, No. 82)

ROBERT CUGNO (1934–) was an arts and crafts dealer with Robert Logan in California. Both semiretired to Garnett, where they ran a bed and breakfast and Media Gallery Enterprises, curating exhibits circulated by ExhibitsUSA (a national division of Mid-America Arts Alliance). (Garnett, No. 40)

EDWARD CURIEL (1942–) has an interest in abstract and modern art. He worked as a graphic designer at Lowen Sign Company in Hutchinson for thirty-eight years. He has played the drums in bands since he was fifteen and makes art in pencil, ink, acrylics, and watercolor. (South Hutchinson, No. 62)

JOHN STEUART CURRY (1897–1946), a native of Dunavant, Kansas, was nationally recognized as a painter and muralist of the Regionalist school, along with Grant Wood and Thomas Hart Benton. His work is in the collections of the Museum of Modern Art, Whitney Museum, and the Spencer Museum of Art, among many others. (Topeka, No. 32)

MARILYN DAILEY (1953–) lives in Winter Haven, Florida, and is a teacher and painter. She received a BSE in art education from Emporia State University. She won a teacher of the year award at two elementary schools in Florida. Dailey has done other murals in Eskridge, Kansas, and at elementary schools in Florida. (Emporia, No. 38)

JOANN DANNELS (1930–) lives in Vermillion during the summer and Florida during the winter. A self-taught artist, she operates an antique shop and a flower shop in Frankfort. She has taught art classes to students of all ages out of her home for twenty-five years. (Vermillion, No. 34)

AARON DOUGLAS (1899–1979), born in Topeka, was a prominent muralist, illustrator, professor, and leading artist of the Harlem Renaissance. He was head of the Art Department at Fisk University in Nashville, where he completed many murals. Douglas received a BA from the University of Nebraska and MFA from Columbia University Teachers College in New York. (Topeka, No. 30)

RYAN DRAKE (1976–) is a painter and runs Drake Brush and Fine Art Supply in Wichita. Teacher Gordon Zaradnic, of Wichita's Northeast Magnet High School, provided his start in art. Drake pursued ceramics at the Kansas City Art Institute for a year, and then painted murals for three years. (Wichita, No. 69)

KAREN DUNKELBERGER (1953–) received a BA from Benedictine College and an MA in liberal arts and organizational leadership from Fort Hays State University. Her teaching career began in 1976, and she began teaching in Harper in 1984. She was named the Harper Elementary School Outstanding Elementary Teacher of 2003–2004. (Harper, No. 57)

PHIL EPP (1946–) lives in Newton and is a painter, teacher, and printmaker. He is well known for his characteristic cloudscapes, some of which are in the collections of the Spencer Museum of Art, Museum

of Nebraska Art, Wichita Center for the Arts, and Taos Art Museum. (El Dorado, No. 55)

KENNETH EVETT (1913–2005), from Ithaca, New York, studied with muralists Boardman Robinson and George Biddle at Colorado Springs Fine Art Center. He did murals for the rotunda of the Nebraska capitol building in 1956 and other murals for the Section program in Nebraska, Colorado, and Caldwell, Kansas. Evett was professor emeritus at Cornell University, where he taught for thirty years. (Horton, No. 7)

JOE FAUS (1956–) was born in Colombia and lives in Kansas City, Missouri. He is an artist, poet, and educator. With work-partner Alicia Gambino, he has completed many monumental murals focused on historical and ethnic subjects in the Kansas City area and in Michoacan, Mexico. (Kansas City, No. 8; Lawrence, No. 17)

BERNARD "POCO" FRAZIER (1906–1976) was a nationally recognized Kansas sculptor. He received a degree from the University of Kansas (KU), with additional study in Chicago. He became resident sculptor and teacher at KU and directed the Philbrook Art Center (Tulsa, 1944–1950), where he began an important annual American Indian art exhibition. (Wichita, No. 67)

H. LOUIS FREUND (1905–1979) was born in Clinton, Missouri. Freund studied at the University of Missouri, Washington University (St. Louis), and in Paris and Mexico. He completed other Section post office murals in Heber Springs and Pocahontas, Arkansas, and Camp Chaffee, Arizona. (Herington, No. 48)

ALISHA GAMBINO (1975–) lives in Kansas City, Missouri, and is on the faculty of the Kansas City Art Institute. With work-partner Joe Faus, she has completed many community murals in Kansas City and Michoacan, Mexico. Gambino's work has been featured in Cultures without Borders in Kansas City, Missouri, and the Frida Kahlo Exhibition in Washington, D.C. (Kansas City, No. 8)

CHARLES GOSLIN (1930–) lives in Shawnee, Kansas, where he is a prolific painter, muralist, and amateur historian. He received a BFA in design from the Kansas City Art Institute. Goslin has painted murals for the Steamboat Arabia Museum in Kansas City, Missouri, and the National Frontier Trails Center in Independence, Missouri. (Shawnee, No. 28)

ROBERT W. GRAFTON (1876–deceased) was born in Chicago, and later lived and worked in Michigan City, Indiana. He studied at the Art Institute of Chicago as well as in Paris, Holland, and England. He was a nationally recognized painter, muralist, and portrait artist and has mural panels in the State House in Springfield, Illinois, and at Kansas Wesleyan University in Salina. (Salina, page 7)

CLEO GRAVES (1922–), who was a top rodeo rider as a child, lives on a farm outside Arkansas City where she has her studio and teaches classes. Graves is known for her intricate china painting, which she has shown throughout the state. She is also a wildlife artist. (Arkansas City, No. 53)

FRANKLIN GRITTS (1914–1996) studied art at Bacone College and the University of Oklahoma. He learned mural techniques from Olaf Nordmark while teaching at Fort Sill Indian School. He taught at Haskell Institute (now Haskell Indian Nations University), was art director for *Sporting News* magazine, and has paintings in the Gilcrease Museum and the Philbrook Museum of Art. (Lawrence, No. 13)

Anthony Benton Gude (1963–) lives in Frankfort and is a painter, muralist, and farmer. The grandson of well-known Regionalist painter Thomas Hart Benton, he studied at the Museum of Fine Arts in Boston and the Art Students League in New York. He has painted other murals in Missouri and for Benedictine College in Atchison. (Topeka, No. 31)

Chad Haas (1975–) was born in Hays and lives in Brooklyn, New York. Known for his ambitious finger-painted murals, he is also a musician and poet. He has completed other murals in New York, Colorado, Germany, and the Bahamas in addition to many in Kansas. (Hays, No. 84)

Richard Haas (1936–) was born in Spring Green, Wisconsin, which was also the home of Frank Lloyd Wright. Haas, who now lives in New York City, is an internationally recognized muralist whose trompe l'oeil architectural narratives can be found around the world. He studied at the University of Wisconsin–Milwaukee and the University of Minnesota. (Kansas City, No. 10)

Cody Handlin (1976–) currently teaches English in China, where he was the first foreigner with a live radio talk show. He was influenced in art by teacher Gordon Zaradnic of Wichita's Northeast Magnet High School and then painted murals for several years and taught English in Mexico. (Wichita, No. 69)

Ernest Bruce Haswell (1889–1965) was a nationally recognized sculptor, born in Kentucky. He was on the faculty of the University of Cincinnati and president of the Cincinnati Art Club from 1924–1927. His sculptures can be found at the University of Cincinnati, cathedrals in Cincinnati and Toledo, and elsewhere. (Salina, No. 50)

Dennis Helm (1946–1992) lived and worked in Lawrence. Helm was a painter well known for his landscapes and still lifes. He received a BFA from the University of Kansas, where he studied with Robert Sudlow. His paintings are in many public and private collections. A small mural by Helm is at the Ninth Street Baptist Church in Lawrence (Lawrence, No. 18)

Fred Henze (c. early 1900s–1980s) was born in Dortmund, Germany, and spent his later years in St. Louis, where he was a member of the St. Louis Art Society. He was an accomplished watercolor and ceramic artist with work in hospitals, museums, churches, and private collections. (South Hutchinson, No. 62)

Stan Herd (1950–) grew up on a farm in Protection, Kansas. He is a well-known painter with dozens of murals across the state and is internationally recognized for his crop art and earthworks. He is currently working with Kevin Wilmott and Scott Richardson combining art, music, and film. (Liberal, No. 89; Wilmore, page 9; Topeka, No. 30)

E. Marie Horner (1921–) was born in Oswego. She took two years of college and private art lessons. She raised six children, has taught community art classes since 1973, sits on the Oswego Art and Humanities Council, and is an adjunct teacher at Labette Community College (Oswego branch). (Oswego, No. 41)

William H. Howe (1928–) lives in Ottawa. Howe is a painter, illustrator, author, and lepidopterist (butterfly expert). He studied biology at Ottawa University and art at the Kansas City Art Institute. His paintings are in the Smithsonian Institution in Washington, D.C.; the Museum of Anthropology, Mexico City; and the Ottawa Carnegie Cultural Center, Ottawa, Kansas. (Ottawa, No. 24)

FREDERIC JAMES (1915–1985) was a prominent Kansas City artist in watercolors and silverpoint drawings, known for his portrayals of the Flint Hills and Martha's Vineyard. A trained architect, he taught at the Kansas City Art Institute and made set designs for Kansas City's Lyric Opera and Missouri Repertory Theater. (Bonner Springs, No. 5)

JOE JONES (1909–1963), a largely self-taught artist, was born in St. Louis, where he organized art classes for unemployed youth. He later became a nationally recognized social realist painter. During World War II, he was an artist for *Life* magazine. Jones completed five Section commissions, including a second one in Kansas in Anthony. (Seneca, No. 27; photo, page 226).

LORA JOST (1964–) lives in Lawrence, where she is an artist, mother, and community volunteer. She received an MFA from the University of Wisconsin–Madison and a BA from Bethel College (North Newton). Jost has exhibited in the United States and Canada, most recently with a series titled *The Experience of Farmers*, incorporating text from interviews with farmers into graphic scratchboard and collage images. (Lawrence, No. 15)

TIM LEAF was a schoolteacher in Courtland who led his students in painting the mural *Pictorial View of Courtland* in 1984. (Courtland, No. 47)

CATHY LEDEKER (1950–) has studios in Lawrence and Creede, Colorado. She is a freelance artist who teaches workshops around the country. She is also the art director for Van Go Mobile Arts in Lawrence. She completed a mural for the Kansas City public library in 2004. (Lawrence, No. 17)

KAREN D. LEWIS (1957–) went to Kansas State University as an art major and later went to cosmetology school. She is a hair stylist, reflexologist, and massage therapist and currently does auto body work for Eldorado National in Abilene. (Abilene, No. 44)

ALLAN LINDFORS (1952–) has deep roots in his hometown of Marquette, where he currently is the bank vice president. He went to Bethany College in Lindsborg in the 1970s. He loves local history and paints as a hobby. (Marquette, No. 64)

DAVE LOEWENSTEIN (1966–) is an artist and muralist who has directed more than fifty mural projects across the United States and in Northern Ireland. Themes in his art include history, community revitalization, and cross-cultural understanding. (Lawrence, No. 12; Topeka, No. 30; Kansas City, No. 11)

ROBERT LOGAN (1936–) was an arts and crafts dealer with Robert Cugno in California. Both semiretired to Garnett where they ran a bed and breakfast and Media Gallery Enterprises, curating exhibits circulated nationally. He also curated for the Walker Art Collection of the Garnett Public Library. (Garnett, No. 40)

CYNTHIA MARTIN (1958–) lives in Onaga, Kansas. She is a painter and farmer. Martin has a degree in animal science. She has other murals at the Duluth Lutheran Church and the Oz Museum in Wamego. (Belvue, No. 3)

AVNELL MAYFIELD (1941–) was born in Hutchinson. She has a BA in architecture and allied arts (University of Oregon, Eugene) and an MA in arts and education (Wichita State University). She taught school for thirty years and then became a muralist, commercial artist, scenic director for children's theater, and community art educator. (Hutchinson, No. 61)

CRISTI MCCAFFREY-JACKSON (1969–) has a BFA from the University of South Florida (Tampa). She paints portraits, works in stained glass over-

lay, and refurbishes houses. While in the military, she painted murals at bases around the country. She works as an avionics technician at Cessna in Wichita. (Argonia, No. 52)

ROBERT MCCALL (1919–) was born in Columbus, Ohio, and has a studio in Paradise Valley, Arizona. He is known internationally for his space-related paintings, illustrations, murals (including at the Smithsonian), documentation of NASA's space program, movie posters, U.S. postage stamps (sent to the moon), and NASA mission patches. (Hutchinson, No. 60)

MISSY MCCOY (1955–) lives in Lawrence, Kansas. McCoy has been painting murals for more than twenty years. She received a BFA from the University of Kansas and has painted other murals at Back to the Garden, the Gruber residence, and Cottin's Hardware, all in Lawrence. (Lawrence, No. 14)

PAT MIKESELL (1955–) grew up in California and now runs Advantage Sign and Graphics in Belleville, which specializes in racecar and truck graphics. His signs and graphics appear all over the Midwest on billboards, water towers, and vehicles. Mikesell's only other mural is in Belleville. (Courtland, No. 47)

JOAN MIRÓ (1893–1983) was born in Barcelona, Spain. A major twentieth-century Surrealist artist, his work is in the collections of major museums around the world. (Wichita, No. 76)

KENNETH MITCHELL (1942–) was a midwesterner until 1989. He received a BA and MA from Northern Colorado State University and taught art at Colby County Community College in Colby from 1968 to 1989. He has completed several murals and currently teaches high school in Washington. (Colby, No. 81)

TRAVIS MOSELY, WILLIE MCDONALD, and **HAROLD CARTER** attended Kansas State University in the late 1970s and early 1980s. They were the principal designers and painters for the *We Are the Dream* mural at Kansas State University. (Manhattan, No. 20)

STEVE MURILLO (1949–) is a professional artist with numerous public murals. He has an MFA from Wichita State University and has worked as an artist-in-residence, adjunct professor, and curator. He is an art consultant to the city of Wichita and has completed several large-scale public sculptures. (Wichita, No. 72)

PATRICE OLAIS (1957–) was born in Newton. She graduated from the San Francisco Art Institute and received her teaching certificate from Emporia State University. Her paintings reflect her life, family, and blessings and honor her Mexican American heritage. She also teaches art at Newton High School. (Newton, No. 65)

RAYMOND OLAIS (1952–) was born in California. He graduated from the San Francisco Art Institute and received his teaching certificate from Emporia State University. His paintings deal with home life from a Chicano perspective, and he is also influenced by the 1960s activism and the related Chicano influence on contemporary art. He teaches at Newton High School. (Newton, No. 65)

JESUS ORTIZ was born in Mexico and immigrated to the United States when he was seventeen. With partners Alicia Gambino and Joe Faus, Ortiz painted many large-scale murals in the Kansas City area and in his hometown of Tangancicuaro, Michoacan. (Kansas City, No. 65)

DAVID OVERMYER (1889–1973), born in Topeka, was a well-known painter and illustrator. He studied at the Art Institute of Chicago and

the Art Students League in New York. Overmyer completed other murals in Kansas for the First Floor Rotunda of the Kansas State Capitol, the Bourbon and Norton County Courthouses, and Topeka High School. (Manhattan, No. 21)

PAT POTUCEK (1925–) was awarded a Hallmark Scholarship and attended the Kansas City Art Institute. She then directed department store displays, winning national awards. She raised six children while pursuing a professional art career working in diverse media. Her numerous murals recount history and tell stories. (Great Bend, No. 56)

JIM REED (1955–) grew up in the Kansas City area and received a BFA from Kansas State College of Pittsburg in 1978. With a studio in Arcadia, Kansas, Reed's ceramic work includes wheel-thrown pottery, hand-built sculptures, and tile designs. He has taught pottery workshops in Kansas schools since 1990. (Frontenac, No. 39)

RICK REGAN (1949–) is from Rose Hill and Wichita. He received a BFA from Wichita State University and learned from artist-mentors Sue Jean Covacevich and Blackbear Bosin. He is a muralist, painter, illustrator, and actor, with art in the Gilcrease Museum and the Philbrook Museum of Art collections. (Wichita, No. 74)

RICK RUPP (1950–) lives in Victoria, where he owns Rupp Art and Signs. He has completed many commercial and private commissions throughout Kansas, including historical murals in Ellis, Hays, and Russell. (Hays, No. 83)

BIRGER SANDZÉN (1871–1954) was born in Sweden. An acclaimed landscape painter influenced by Post-Impressionism, he was founder of the Prairie Printmakers and was an influential professor at Bethany College in Lindsborg, where he taught art and language. He completed two other Section murals for post offices—one in Lindsborg and the other in Halstead. (Belleville, No. 45)

GEORGE F. SATORY and **THOR ZUKOTYNSKI** were the principal artists of the murals and wall stencils at St. Mary's Church in St. Benedict. (St. Benedict, No. 29)

MIGDONIO SEIDLER was born in Nicaragua and lived in Panama before studying architecture at Kansas State University. He was a partner in the architectural firm Seidler & Owsley in Pittsburg and a working partner in Allgeier & Son in Dallas, Texas. He designed schools, office buildings, churches, and homes. (South Hutchinson, No. 62)

CONRAD SNIDER (1962–) is a ceramicist, kiln maker, and owner of Muddy Elbow Manufacturing (clay mixers) from Newton. He has a degree from the Kansas City Art Institute and is known for his large-scale pots and ceramic murals. He apprenticed with Jun Kaneko in Japan, Holland, and Nebraska. (Salina, No. 49)

DON SPRAGUE (1939–1994) is from Coffeyville. He took courses from the Famous Artists Correspondence School (Westport, Connecticut) while in the air force from 1961 to 1965. He was a professional sign painter, muralist, and cartoonist. His painting of Joe Sewell was accepted for display by the National Baseball Hall of Fame in 1985. (Coffeyville, No. 37)

ELDON SWENSSON (1926–) lives in Lindsborg. He worked as an architect for forty-three years in Kansas, Texas, Pennsylvania, and Florida before retiring to become a full-time artist. He has served as the curator of the Bethany College Art Collection, shown watercolors throughout the

region, and designed stained glass windows for the Messiah Lutheran Church in Lindsborg. (Lindsborg, No. 63)

MARK SWITLIK (1947–) is from Parsons and is a full-time muralist based in Phoenix. He graduated from Pittsburg State University. In his early twenties he contacted Thomas Hart Benton for mural tips and remained in touch until Benton's death. Switlik also worked as a sign painter and railroad worker. (Pittsburg, No. 42)

DOROTHEA TOMLINSON MARQUI (1898–1985) was from Fairfield, Iowa. She studied with Charles Cumming, Grant Wood, and Marvin Cone. She was a professional muralist, painter, lithographer, industrial designer, and instructor at Parsons College in Fairfield. In addition to the mural in Hoisington, she has a Section mural in Mount Pleasant, Iowa. (Hoisington, No. 58)

MICHAEL TOOMBS (1955–) is from Kansas City, Missouri. He is a self-taught artist who worked in the service industry before graduating from Donnelly College's entrepreneurial program. An African American, he founded Storytellers Inc., a multicultural performing and visual arts program providing opportunities for artists to educate and "resensitize" young people. (Kansas City, No. 9)

TWIN CITY SCENIC COMPANY (TCSC) (1895–1979) was, by the 1920s, one of the country's premier studios producing painted theater drops. *The Napoleon Curtain* in Concordia's Brown Grand Theater was painted by TCSC artists J. A. Lewis (in 1907) and Robert Braun (in 1979), the last theater drop painted by the company. (Concordia, No. 46)

BROTHER BERNARD (WILHELM) WAGNER (1915–1993) grew up in Geusfield, Bavaria, Germany, but fled to the United States to avoid being drafted by the Nazi army. A painter, architect, and metalsmith, he studied liturgical art at the Maria Laach School in Germany. (Atchison, No. 1)

JANE BEATRICE WEGSCHEIDER (1960–) was born and raised in New York and later moved to Kansas. With an MFA from the Chicago Art Institute, she explores place, memory, and sacred story in her paintings, murals, and sculpture. She now lives in Massachusetts, where she teaches art in the public schools. (Salina, No. 51)

RUDOLPH WENDELIN (1910–2000) was born in Herndon in Rawlins County. A respected illustrator, painter, and sculptor, he studied architecture at the University of Kansas before working as a navy artist during World War II. Wendelin's best-known works are his illustrations of Smokey the Bear and his designs for commemorative postage stamps. (Atwood, No. 80)

LAURIE H. WHITE HAWK (1952–) lives in Washington. She learned the "flat style" as a Haskell Indian Nations University student. She carries on and "reidentifies" her cultural roots through research, painting, exhibiting, and teaching. She painted a mural for the American Expo at the World's Fair in Seville, Spain (1992). (Potawatomi Prairie Band Reservation, No. 25)

JESSICA WHITE-SADDLER (1978–) lives in Wichita. While living in Kinsley, where her father, Bruce White, was a nationally known carver of carousel figures, she painted the *Kinsley Carnival Mural*. (Kinsley, No. 88)

PEGGY WHITNEY (1957–) lives in Florissant, Colorado. She is an artist and educator who has exhibited her work in galleries throughout the Midwest and Southwest. Whitney studied at Bethany College in Lindsborg and received a BFA from Wichita State University. (Wichita, No. 71)

Wayne Wildcat (1955–) is from Coffeyville and is of white and Euchee descent. He works as a painter, portrait artist, muralist, and artist-in-residence. His epic paintings, exhibited nationally and internationally, combine history and social criticism. He received the Kansas Governor's Award for Visual Art in 1998. (Pittsburg, No. 43)

Kenny Winkenwader (1936–) is a semiretired farmer who lives and farmed on the same ground where he grew up. Encouraged in art by his mother, he included rural scenes, wildlife, and history in his paintings. He is involved in the Marshal County Historical Railroad Society and the Waterville Depot Museum. (Blue Rapids, No. 4)

Lumen M. Winter (1908–1982) spent much of his youth in Kansas. He completed his first mural in 1942 in Hutchinson. A sculptor as well as painter, he created the Apollo 13 medallion for Captain James Lovell and the mural *Titans* for the United Nations. Winter's work is in many collections, including the Library of Congress and the Vatican. (Topeka, No. 33)

Michael Young (1952–) lives in Merriam, Kansas. He studied at the Art Students League in New York and has done murals for the Boston Aquarium, Bally's Casino, and Chevron Aviation, among others. (Leavenworth, No. 19)

Appendix B: Kansas Murals

This list of Kansas murals is based on information provided by many sources, individuals, and organizations. The murals, listed by region, are intended to be accessible to the public and include interior murals (designated as "inside") and exterior murals (with no special designation). When possible, we have included in each listing the title, artist, date, location, theme, and special media. Some locations have limited hours; when visiting locations such as schools, it is necessary to check in first with the office. Although this list is comprehensive, murals come and go rapidly so it is in no way complete. We regret that this list will inevitably contain some errors and omissions. We invite you to submit additional information about these and other Kansas murals to lorajost@hotmail.com and dloewenstein@hotmail.com.

* Section of Fine Arts murals (and a few sculptures) are designated with an asterisk.

Cities with artworks commissioned by the Section of Fine Arts

Northeast Region

Atchison

Armory Murals, V. Celano, National Guard Armory; 405 N. 17th St., inside, Drill Room; scenes depicting the Revolutionary War, Civil War, World War I, and World War II.

Atchison Elementary School Mural, students and community volunteers coordinated by Michael Toombs and Storytellers Inc., 1998; Atchison Elementary School, 25 N. 17th St., inside; scenes from five elementary schools that merge with student artwork.

Atchison Historical Murals, Walter Yost; Atchison, Topeka, and Santa Fe Depot, 200 S. 10th St., inside; scenes from across the country and seasons; river scene illustrating events leading up to the founding of Atchison and the early days of the community.

Atchison . . . Window to the West, Don Huff, Dennis McCarthy, Max Byer of St. Mary's Stone, and the Kansas Sculptors Association, 2000; U.S. 59 (Utah) and S. 10th St.; historical; freestanding carved limestone mural.

College History Mural, Anthony Benton Gude, 2003; Benedictine College, 1020 N. 2nd St., inside; college history.

Harmony, Ree Greenwood and her seventh-grade homeroom class from Atchison Middle School, 1993; S. 11th and Main Sts., back of

convenience store; promotes peace, love, tolerance, and environmental stewardship.

1900 Atchison, Don Huff, 2004; Atchison, Topeka, and Santa Fe Depot, 200 S. 10th, inside; painted on an old freight door as if looking out the window at a scene from the 1900s.

Remnants of Old Atchison, Don Huff and Mark Pantle, 2005; Mall Towers, 7th St. between Commercial and Main Sts., inside lobby; painted like an old postcard with a collage of historic buildings.

St. Benedict's Abbey and Church Murals and Mount St. Scholastica Murals

Abbot's Chapel Mural, Brother Bernard (Wilhelm) Wagner, 1938 (No. 1).

Our Lady of Guadalupe and the Four Apparitions, Jean Charlot, 1959; St. Benedict's Abbey Church, Our Lady of Guadalupe Chapel, 1001 N. 2nd St., inside; story of Juan Diego and Our Lady of Guadalupe; fresco.

St. Benedict, Brother Bernard (Wilhelm) Wagner, c. 1938; St. Benedict's Abbey, 1020 N. 2nd St., inside, hallway between Abbey and Guest House; St. Benedict with symbols of church and college together.

St. Benedict and *St. Scholastica*, Brother Bernard (Wilhelm) Wagner, c. late 1930s; Mount St. Scholastica Monastery, 801 S. 8th St., inside, entryways to hallway leading to St. Scholastica College Chapel; depictions of St. Benedict and St. Scholastica with related symbolism.

Jean Charlot working on his fresco in Atchison, 1959.

St. Joseph's Workshop, Jean Charlot, 1959; St. Benedict's Abbey Church, St. Joseph's Chapel, 1001 N. 2nd St., inside, basement; Joseph and Christ Child in workshop; fresco.

Trinity and Episodes of Benedictine Life, Jean Charlot, 1959 (No. 2).

AUBURN

Hands across the Waters, Shirley Akers with students, 1998; Auburn Elementary School, 810 N. Commercial St., inside; handprint rainbow over water with ocean life.

BELVUE

Oregon Bound, Fall Hunt, and Kansas Wildlife, Cynthia Martin, 1996 (No. 3).

BLUE RAPIDS

Gypsum on the Blue and Arrival at Alcove, Kenny Winkenwader, 1997 (No. 4).

BONNER SPRINGS

Farmland Mural, Frederic James, 1956 (No. 5).

Harvest Queen, George Stone, 1915; National Agriculture Center and Hall of Fame, 630 Hall of Fame Dr. (N 160), inside; the mural won first prize at the Panama Exhibition in St. Louis; an allegorical figure representing harvest with scythe, shocked corn, sunflowers, and horn of plenty.

Lasting Foundations, Pat Potucek, 1991; Berkel & Co. Contractors, Inc., 2649 S. 142nd, inside; depicts the work of building concrete foundations for large structures.

COUNCIL GROVE

* *Autumn Colors*, Charles B. Rogers, 1940, re-signed 1980; Post Office, 103 W. Main St., inside; a composite of sketches of rural scenes from Council Grove to Herington (the Santa Fe Trail); sumi egg-emulsion on canvas.

Buffalo Street Scene, Mike Fallier, 1998; City Hall, 313 W. Main St.; buffalo.

Courthouse Murals (two murals), Sharon Mock with high school students, 1986 and 1988; Morris County Courthouse, 500 W. Main St., inside, basement; Morris County heritage and a rural scene.

Historic Cityscape, Cody Handlin and Mike Fallier, 1994; Duckwall's, 102 W. Main St.; historic Council Grove cityscape.

A Proud Tradition, Sharon Mock, 1987; Post Office, 103 W. Main St., inside lobby; postal history in Council Grove.

Santa Fe Trail, M. E. Norton (repainted by Lois Olinger), 1980s; Council Grove Public Library, 829 W. Main St.; Santa Fe Trail history.

The Station Mural, Marjorie Hall Bicker, 1998; The Station, 219 W. Main St., inside; Council Grove history.

Wagon Trail, Mike Fallier and Cody Handlin; Ray's Apple Market, 115 E. Main St.; wagon train scene.

DE SOTO

Identity D.H.S., Shawn Henry, Natasha Potratz, Melissa Parsons, 1999; De Soto High School, 35000 W. 91st St., inside, main hall to right as enter; depicts the outside of the school, inside hall, and cafeteria, framed by representations of student activities.

EDGERTON

Eagles, Peter Castellanos; Community Building, 404 E. Nelson St., inside; eagles.

Theater Drop, c. 1937; Community Building, 404 E. Nelson St., inside; theater backdrop depicting nature and park scene bordered by ads.

We All Call the Earth Home, Dave Loewenstein with elementary school children, 1995; Edgerton Elementary School, 400 W. Nelson St., inside; children's visions of the earth as home.

ESKRIDGE

Buffalo Mural, Marilyn Dailey; Buffalo Inn, 103 S. Main St.; Native American buffalo hunt and historic Eskridge.

GARDNER

Southwest Johnson County, Jamie Lavin, 2005; Gardner Historical Museum, 204 W. Main St., inside; movable mural with sunset, timeline, and historical imagery.

Price Chopper Murals (two murals), Buck, 1999 and 2000; Price Chopper, 830 E. Main St., inside near customer service area; Santa Fe and Oregon Trail scenes and first grocery store of the Cosentino brothers in 1948.

HIAWATHA

History of Brown County, Ron Allerton, 1961 (No. 6).

HOLTON

Mountain Murals (two murals), Lester Arnold, 1994; P. J.'s Restaurant, 21748 U.S. 75, inside; mountain landscapes.

HORTON

* Changing Horses for the Pony Express (1939) and Picnic in Kansas (1938), Kenneth Evett (No. 7).

HOYT

Water House Garden, Christina Frederick, 2005; Hoyt Park, 8th and Highland Sts., restroom; English cottage.

KANSAS CITY

1920s Wyandotte, William Luse, 1991; 1310 W. 78th Terr.; Wyandotte County of the 1920s.

Anthology of Argentine, Jesus Ortiz, Joe Faus, and Alisha Gambino, 1998 (No. 8).

Building Blocks, Alisha Gambino, 2003; El Centro, on Strong in the Argentine neighborhood, inside; preschool children with blocks; cloth.

Church Mural, Charles Goslin; Rosedale Church of God, 4473 Adams St., inside; religious.

Cityscape Mural; Central Family Medicine, 720 Central Ave.; cityscape with figures extending open arms.

Community Hands, Alisha Gambino with volunteers; Central and 10th Sts.; history of Central Ave. neighborhood.

Crossroads, Michael Toombs with community participation, 1995 (No. 9).

Dawning of a New Day, Joe Faus and Alisha Gambino with children, 2004; 1207 N. 7th St.; celebration of African American culture and history.

Dream for Harmony, Wayne Wildcat with student apprentices, 1997; J. C. Harmon High School, 2400 Steele St.; celebrates the cultural diversity of the school.

Education Mural, Jesus Ortiz, 2000; Emerson Elementary School, inside, 1429 S. 29th St.; education themes.

El Baile de la Vida (The Dance of Life), Joe Faus and Alisha Gambino, 2004; 826 Minnesota Ave.; Latino cultural mural.

Flight of the Parakeets, directed by nine teens who are blind or visually impaired with companions from several Native American tribes and public participation (sponsored in part by Accessible Arts, Inc.), 2004; Kaw Point Bicentennial Park, floodwall on northwest edge of park; parakeets rising from underbrush along the Missouri River as Lewis and Clark had watched.

Hmong Cultural Mural, Joe Faus and Alisha Gambino with high-school students, 2005; 749 Minnesota Ave.; based on Hmong story cloth, recognizes Hmong presence in Kansas City.

Justice and **The Prairie**, Richard Haas, 1993 (No. 10).

Mexican and Polish Cultural Mural, Joe Faus, Alisha Gambino, and Jesus Ortiz with the St. Joseph and St. Benedict Youth Group, 2002; 11th and Mill Sts.; Mexican and Polish cultural heritage.

Panda Bear Fantasy Mural, Joe Faus and Alisha Gambino, 2005; Pandarama Preschool, 7th and Nebraska Sts.; dream scene using panda characters.

Parking Lot Mural; corner of 7th and Ann Sts., Municipal Parking Lot No. 1; education and parenting.

Pillars of Hope and Struggle, Students at West Middle School with facilitators Christal Clevenger and Dave Loewenstein, 2002 (No. 11).

Summer Fun, Joe Faus and Alisha Gambino with youth, 2000; 10th St. and Central Ave.; summer fun.

We Are the Dream, Dave Loewenstein with students, 1994; West Middle School, 2600 N. 44th St., inside; dreams for the future.

YMCA Mural, hundreds of community volunteers coordinated by Storytellers Inc., Youth Friends, YMCA, and AmeriCorps, 1997; Downtown YMCA, 8th and Armstrong Sts., inside; past, present, and future.

Kickapoo Reservation (Holton)

Casino Murals (two murals), David Knoxsah, 1996–1997; Golden Eagle Casino, 121 Goldfinch, inside; animals and ceremonial imagery.

Lawrence

A Thousand Miles Away, Dave Loewenstein, 2001 (No. 12).

Alone We Can Do So Little, Together We Can Do So Much, grade school and junior high artists directed by Amy Carlson and Scott Garrette, 2003; Kennedy Elementary School, 1605 Davis, inside lunchroom; includes children's artwork about being respectful.

artWork, Dave Loewenstein, 2001; 411 East 9th St.; artist studio mural.

Back to the Garden Mural, Jeff Shumway; Back to the Garden, 619 N. 2nd St., inside; planetary imagery.

Back to the Garden Murals, Missy McCoy; Back to the Garden, 619 N. 2nd St. (outside and on outside door); abstract and planetary, inspired by Jean-Jacques Rousseau painting.

Baptismal Font and Stations of the Cross, Randal Julian, 2001; Corpus Christi Catholic Church, 6001 Bob Billings Hwy., inside; baptismal font and stations of the cross; bas-relief.

Baptist Church Mural, Dennis Helm; Ninth Street Baptist Church, 947 Ohio St., inside.

***Berkosaurus, Out Standing in His Field, Cornfield, Barnyard*, and *Apprentice*, Missy McCoy, 1998–2004 (No. 14).**

Celebration of Cultures, Dave Loewenstein and community volunteers, 1995; 828 Massachusetts St.; hands and doves.

Central Time, Wayne Wildcat with student apprentices, 1996; Central Junior High School, Liberty Memorial Building, 1400 Massachusetts St.; portraits of people who shared time at Central Junior High School.

Century School Mural, Tim Holtzclaw with grade school students, 2005; 825 Vermont St., faces north; school and garden imagery.

***Cranes*, Lora Jost, 2001 (No. 15).**

Created in God's Image . . ., Dee A. Link, 2005; Ecumenical Christian Ministries, 12th and Oread, inside, basement, open only during events; human sexuality.

East Lawrence Waltz, Dave Loewenstein and community volunteers, 2004; 11th and Delaware Sts.; history of east Lawrence.

From the Hills, through the Prairie, to the Wetlands, Jan McElwain with children and adult participants, 2003; Lawrence Arts Center, 940 New Hampshire St.; landscape with bugs, butterflies, and animals.

Gateway to the Arts, Joe Faus, Alisha Gambino, Jesus Ortiz with artist apprentices; Van Go Mobile Arts Building, 7th and New Jersey; art-related themes.

Guardians of the Arts, Dave Loewenstein and community volunteers, 1993; 720 Massachusetts St.; arts-related themes.

Habitat for Humanity, Dave Loewenstein with Karl Janssen, Rebecca Bruce, and Janet Reeves, 2004; 840 Connecticut St., inside, Ste. B; housing related.

HASKELL INDIAN NATIONS UNIVERSITY MURALS, 155 INDIAN AVE.

Auditorium Mural, Franklin Gritts, 1941 (No. 13).

Crow Brave, Allen Knowsgun, 2001; Oseola-Keokuk Hall, inside, front lobby; Crow brave.

Five Regions Represented by Men in Regalia, Don Secondine, 1974; Winnemucca Building, inside, security office; Native American cultural themes.

Full Moon Lodge, Allen Knowsgun, 2001; Oseola-Keokuk Hall, inside; full moon lodge.

History Classroom Murals (five murals); Parker Hall, inside, classrooms.

Indian Summer and the Crazy Mountains, Allen Knowsgun, 2003; Roe Cloud Hall, inside, front lobby; mountain scene.

Pontiac Hall Conference Room Murals, T. Racehorse (skull and mountain scene), Carole Tomlinson (1977, flowers on door), Unknown Artist (corn), Unknown Artist (man with bearskin, 1977); Pontiac Hall, inside, conference room.

Pontiac Hall Hallway Murals, seven murals by students (listed from left) M. Edaakie (Zuni), Jim McNac (Seminole), Franky Dreadfulwater, artist unknown, Herman T. Schildt, Harrison Smith (Navaho), artist unknown, 1981; Pontiac Hall, inside, hallway; Native American cultural themes.

Pontiac Hall Wall Paintings (small paintings on the walls); Pontiac Hall, inside, two science classrooms.

Tecumseh, Preston Ivy (Ponca, Creek, Seminole); Tecumseh Hall, inside, basement near snack bar; portrait of Tecumseh.

Healing Hands, Jan Gaumnitz and Cathy Tisdale, 1999; Community Health Facility, 200 Maine St., inside, 1st floor; healing; ceramic tile.

Ignorance, Pride, and Fear, Dave Loewenstein assisted by Mike Han, 1993; 615 Massachusetts St.; figures in boxes.

In Good Standing amidst the Powers That Be, Ardys Ramberg and Missy McCoy, 2002; Cottin's Hardware and Rental, 1832 Massachusetts St., south wall; honors 100-year-old elm tree in Lawrence killed when developers paved over the roots with a parking lot.

Let America Be America Again, Lawrence High School students with Lora Jost and Dave Loewenstein, 2002; Langston Hughes Elementary School, 1101 George Williams Way (in storage); based on Langston Hughes poem.

Life Changes, eighteen apprentice artists directed by Joe Faus and Cathy Ledeker, 2002 (No. 17).

Lounge Mural, Cathy Ledeker with artist apprentices, 2005; Amarr Garage Doors, 3800 Greenway Cir., inside, lounge; company history and themes.

Make Your Life in Harmony, Amy Carlson with school children, 1997 (No. 16).

Nature Nurtures, mentor artists Kendra Herring and Amie Spitler with apprentice artists Barbara Reliford and Stephanie Rogers, 2002; Community Mercantile, 901 Iowa, inside; landscape seasons.

Open the Window of Your Heart to Everyone, All Good Thoughts and Things, grade school and junior high artists directed by Amy Carlson, 2001; New York Elementary School, 936 New York, inside, gym; includes children's artwork about being respectful, centered around a window—the catalyst for assembling the children's artwork.

Pages in Time, Cathy Ledeker with youth apprentices, 2004; Lawrence Public Library, 707 Vermont St.; Lawrence history as pathways, portals, bridges, and open books.

Perpetual Garden, Missy McCoy, 2000; 1425 New York St., south wall; garden scene.

Replay Lounge Murals, Travis Millard, Brad Clark, and others, 1997–2002; Replay Lounge, 946 Massachusetts St., inside and on patio; music and pinball.

River Scene, Tom Mersman, 2004; Astaris, 440 N. 9th St., inside (view by appointment, 1-785-749-8102); Kaw River scene.

Starry Way, Dennis Helm with others, 1987 (No. 18).

Seeds, Dave Loewenstein assisted by Sandy Broughton, 1996; 9th and Mississippi Sts.; themes relate to the food co-op once housed in the building.

Sunflower Cycle, Dave Loewenstein, 1992; 615 Massachusetts St., back beer garden; sunflowers.

Sun Room Mural, students, 2005; Central Junior High School, 1400 Massachusetts St., inside, fourth-floor sunroom; stars, trees, sky, and other images.

Synchronicity, Dave Loewenstein with Central Junior High students, 1997; East Lawrence Center, 1245 E. 15th St.; community center activities; glass and ceramic mosaic on bench.

Teller's Mural, Stan Herd; Teller's Restaurant and Bar, 746 Massachusetts St., inside, bar; abstract.

Together We Are One, grade school and junior high artists directed by Amy Carlson and Elizabeth Hart, 1999; East Heights Early Childhood Center, 1430 Haskell St., inside, gym; includes children's artwork about being respectful, expresses the idea that although we are all different, together we are a single source of goodness and strength.

UNIVERSITY OF KANSAS MURALS

Jungle Mural, restored by Jan Morris in 2000; University Relations, 1314 Jayhawk Blvd., inside; jungle scene.

KU Donor Mural, Steve Smith, 2001; Pearson Hall, 11th and W. Campus Rd., inside; honors donors to the university; ceramic tile.

Lindley Hall Relief Mural, 1943; Lindley Hall, 1475 Jayhawk Blvd.; engineering.

Watkins Memorial Hospital Mural, Marjorie Whitney, 1931; Watkins Memorial Health Center, 1200 Schwegler Dr., inside; "Jayhawk" health.

School of Social Welfare Mural, Carolyn Payne, 1997; Twente Hall, 1545 Lilac Ln., inside, foyer; celebrates fiftieth anniversary of the School of Social Welfare and donors; ceramic tile.

Vermont St. BBQ Mural, Chad Haas, 2005; 728 Massachusetts St., inside; new world record for largest finger-painted mural.

West Junior High School Mosaics, Steve Smith; West Junior High School, 2700 Harvard St.; education.

Wheat State Pizza Murals, Ivan Fortushniak (2005) and Betheny Hoffman (2004); Wheat State Pizza, 711 W. 23rd St., inside front and hall; pizza-making; cows, moon, wind.

Z's Mural, David Montgomery, 1993; Z's Divine Espresso, 1800 E. 23rd St., inside; playful mural that makes the point that humans and the environment are not separate from each other.

LEAVENWORTH

First City Mural, Michael Young, 2003 (No. 19).

The First Dragoons, Keelboats on the Missouri: The Founding of Fort Leavenworth, and *The Fork—The Oregon and Santa Fe Trail* (three murals), Eric Bransby, 1944; Frontier Army Museum, 100 Reynolds, inside; early history of Fort Leavenworth.

LECOMPTON

History Mural, Ellen Duncan, 1985; Post Office, 525 E. Woodson, inside; Lecompton history.

MANHATTAN

Bergman Elementary School Murals, Ralph Fontenot; Bergman Elementary School, 3430 Lombard Dr., inside; dolphins swimming (cafeteria and office) and mountain scene (gym).

KANSAS STATE UNIVERSITY MURALS

The Industries, *Agriculture*, *The Arts*, and *The Home*, David Overmyer, 1934 (No. 21).

Student Achievement, Eric Bransby, 1986 (No. 22).

We Are the Dream, Travis Mosely, Willie McDonald, and Harold Carter, 1980 (No. 20).

Rusty's Mural; Rusty's Last Chance, 1213 Moro St., inside courtyard.

Sixth Grade Murals (three murals), one of the three is repainted every year by sixth graders; Theodore Roosevelt Elementary School, 1401 Houston St., next to glass walkway; events from the year.

Theodore Roosevelt, c. early 1980s; Theodore Roosevelt Elementary School, 1401 Houston St., inside, library hallway; portrait of Theodore Roosevelt as a Rough Rider.

Farm Scene, c. early 1980s; Theodore Roosevelt Elementary School, 1401 Houston St., inside stairway landing; farm scene with rainbow, combine, and wheat fields; spray paint and stencils.

MARYSVILLE

Marshall County Crossroads, Kenny Winkenwader, 1999; Visitor's Center, 10th and Center; pioneers traveling through Marshall County.

The Otoe-Missouri Indians, Lois Cohorst, 1998; Doll and Indian Museum, 912 Broadway St.; the Otoe tribe and culture from 1855 to 1881.

Pony Express, Marysville, Kansas, 1860, D. Vernon Manrose; Post Office, 109 S. 9th St., inside; Pony Express.

St. Gregory's Mural, Stan Eisentrager, 2001; St. Gregory's School, 207 N. 14th St.; shows original 1894 St. Gregory's Catholic Church building and 1899 rectory that burned down.

Washing Clothes, Oswalt, 1975; Marysville Wash and Dry, corner of 5th and Broadway Sts.; women washing clothes, old-fashioned washing machines.

MAYETTA

Train Station, Lester Arnold, 1986; downtown, faces east; steam engine and station.

MERRIAM

Downtown Merriam, Michael Young, 1999; Community Center, 5701 Merriam Dr.; 1940s downtown Merriam.

Historic Merriam, Charles Goslin, 1986; City Hall, 9000 W. 62nd Terr., inside, Community Training Room; history of Merriam.

MISSION

Church Mural, Frederic James, c. 1940s; Trinity Lutheran Church, 5601 S. 62nd St., inside, old entrance; religious themes.

Historic Mission, Charles Goslin, 1988; City Hall, 6090 Woodson, inside; history of Mission.

Section committee reviewing Joe Jones's design for the Seneca post office mural.

Olathe

* *The Mail Must Go Through*, Albert T. Reid, 1937; 110 N. Chestnut, inside; oil on canvas.

Reflective Spaces, Phil Epp and Terry Corbett, 2003; R. R. Osborne Plaza, 100 E. Santa Fe; sky.

Osawatomie

D. O. Bacon's Art Gallery, D. O. Bacon, 1901–1902 (No. 23).

Ottawa

Cottonwood Falls Monarch Mural, William H. Howe, 1977 (No. 24).

Overland Park

Fun beneath the Waves, Missy McCoy, 2003; Children's Mercy Hospital, 5808 W. 110th St., inside, cafe; the mural of dolphins and frol-

icking fish was painted to one-quarter scale and was then digitally photographed and reproduced to full scale on contact paper for installation.

Potawatomi Prairie Band Reservation (Mayetta)

Bingo Parlor Murals, Lester Arnold; Bingo Parlor, 16277 Q Rd., inside; Prairie Band of Potawatomi Indian Nation signs.

Look Buffalo, Clifford Knoxsah, 1997; Early Childhood Education Center, 15380 K Rd., inside hallway (view by appointment, 1-785-966-2527); landscape with buffalo and Potawatomi people.

Potawatomi Children, Laurie H. White Hawk, 1997 (No. 25).

Traditional Potawatomi Game, Josias Aitkens, 2001; Early Childhood Education Center, 15380 K Rd., inside hallway (view by appointment, 1-785-966-2527); people playing traditional Potawatomi game.

Prairie Village

Life, Junior High students directed by Dave Loewenstein, 1998; Indian Hills Junior High, 6400 Mission Ave., inside; *Life* board game.

Sabetha

Sabetha Bank Murals, artist unknown, 1965 (No. 26).

* *The Hare and the Tortoise*, Albert T. Reid, 1937; Post Office, 122 S. 9th St., inside; the stagecoach versus the Pony Express; oil on canvas.

Seneca

* **Men of Wheat, Joe Jones, 1940 (No. 27).**

SHAWNEE

Cultural Haven, 600 elementary students coordinated by Michael Toombs and Michele Bridges of Storytellers Inc., 2000; Rhein Benninghoven Elementary School, 6720 Caenen, inside, near cafeteria; tribute to the cultural diversity and cultural symbols of the school.

A Look Back, Charles Goslin, 1992 (No. 28).

Piecing History, Judy Truckness, 2004; Nieman and Johnson Rds.; history of Shawnee.

ST. BENEDICT

St. Mary's Church Murals, George F. Satory and Thor Zukotynski, 1901 (No. 29).

TONGANOXIE

Beach Mural, V. C. N. Frese, c. 1994; Glen's Opry, 4th and Main Sts., faces west; beach with palm tree.

The Good Samaritan, Ann Gower, 1988; Tonganoxie Public Library, 303 Bury St., inside; Chief Tonganoxie hiding a man injured by border ruffians and the displacement of Indians into Oklahoma (depicted in the clouds).

Old Town Scene; 4th and Bury Sts.; downtown scene with horse and buggy.

TOPEKA

American Legion Mural, Steve O'Hare, 2001; American Legion Post 400, 3029 Hwy 24; patriotic mural dedicated to veterans.

Aspects of Negro Life: Slavery through Reconstruction (after Aaron Douglas), **directed by Dave Loewenstein, assisted by Stan Herd and high school volunteers, 2005 (No. 30).**

Aztec Murals (two murals), Tavo, 1998; Salon de Baile El "Azteca," 1201 SE 6th St.; Aztec imagery.

Century of Service, **Anthony Benton Gude, 1999 (No. 31).**

Church Murals (8 murals), 1889; St. Joseph Catholic Church, corner of SW 3rd and SW Van Buren, inside; Christian religious themes, four of the eight murals were original to the 1889 building, and four were repainted following water damage.

Courtyard Mural, Ed Navone and students, c. 2003; Washburn University, Student Union, 1700 College, inside, courtyard; education and graduation metaphors.

Dinosaurs, Dino Jim Boydston, 1993; 1019 W. 6th, back of building, view from the 600 block of SW Clay; dinosaurs.

Early Topeka, John William Bashor, 1965; Kaw Valley State Bank, 1110 N. Kansas Ave., inside; scenes of early Topeka.

Garden, Steve O'Hare; 1401 6th St.; fountain and garden.

Harvest, Steve O'Hare, 2001; Rees Fruit Farm, 1476 K4 Hwy.; fruit, harvest.

KANSAS STATE CAPITOL MURALS, 10TH AND JACKSON STS., INSIDE

Dome Murals, a Chicago firm, 1902; dome; eleven figures represent Knowledge, Plenty, Peace, Power, Temperance, Religion, Agriculture, Art, Science, the Civil War, and the Spanish American War. (Dome murals were first painted by Jerome Fedeli in 1898. They depicted twelve partially nude Grecian women holding flowers

and vases. When Republicans regained control of the Legislature, they had Fedeli's murals replaced.)

First Floor Rotunda Murals, David Overmyer, 1953; first floor rotunda; Kansas historical themes.

Second Floor Rotunda Murals, Lumen M. Winter, 1978 (No. 33).

***The Tragic Prelude* and *Kansas Pastoral*, John Steuart Curry, 1937–1942 (No. 32).**

Kansas, The End of the Trail, David Overmyer, 1939; Topeka High School, 800 SW 10th St., inside; Kansas history.

Kansas: Four Directions from Topeka, Stan Herd, 2001; Topeka and Shawnee County Public Library, 1515 SW 10th St., inside; landscape and native plants in four general regions of Kansas; oil on canvas.

The Lord Is My Shepherd, Jean Haber, 2000; Town and Country Church, 4925 SW 29th St., inside; snowy hills with sheep.

Mediterranean Port, David Overmyer, 1937; Topeka High School, 800 SW 10th St., inside, teacher cafeteria; Mediterranean Port.

Our Lady—Altar Mural, Mexican artists, 1950s; Our Lady of Guadalupe Church, 1008 NE Atchison, inside, sanctuary; scene of Juan Diego with apparition of Our Lady of Guadalupe in glass mosaic, with religious symbols in tile beside the altar area.

Our Lady—Basement Mural, Joe Rocha, 1970s; Our Lady of Guadalupe Church, 1008 NE Atchison, inside, basement; Jesus with priests and nun offering a Bible to a family.

Our Lady—Entrance Mural, 1940s; Our Lady of Guadalupe Church, 1008 NE Atchison; religious and Hispanic cultural imagery; ceramic mosaic.

Santa Fe Trail Historical Mural (section), Stan Herd, first installed in Dodge City in 1986, repainted and installed in Topeka, 2002; Fairlawn Shopping Plaza, 21st and Fairlawn, inside; western Kansas history.

Sullivan's Chapel Mural, Warren Eteeyan, 1977; Sullivan's Chapel, 1937 NE Madison; Native American cultural imagery, mother and baby (life), fire, service, cross of Jesus, the creator.

Swims and Sweeps Mural, Steve O'Hare, 1999; Swims and Sweeps, 422 SW 6th St.; whimsical ad mural that carries on tradition of murals at that location.

Timberline Murals, Mike Fallier, 1999; 1425 SW Wanamaker, inside, main and private dining rooms; mountains, farm scene, white buffalo.

Train Stop, Stan Herd, 1989; Kansas History Center and Museum, 6425 SW 6th St., inside; steam engine exhibit, train stopping point.

Unicorn; Swims and Sweeps, 422 SW 6th St., east side; unicorn (remnant from first large-scale mural at this site facing 6th St.).

Williams Magnet School Murals, Jim Boydston, 2001–2006; Williams Science and Fine Arts Magnet School, 13th and Monroe, inside; themes include sea life, dinosaurs, wildlife from around the world, and Kansas heritage.

VERMILLION

Vermillion Murals, JoAnn Dannels with children, 1981, 2000 (No. 34).

WAMEGO

Alcove Murals, Cynthia Martin, 2004; Oz Museum, 511 Lincoln St., inside; Wizard of Oz themes.

Columbian Exposition Murals, Theodore Behr, 1893 (No. 35).

WATERVILLE

1870s Waterville (2000), *Waterville Depot 1912* (2003), and *The Lost Cow Town* (1996), Kenny Winkenwader; Depot, on Kansas St. between Front and Commercial Sts., inside; scenes of early Waterville.

Historical Waterville (mural 1), *Historical Waterville* (mural 2), and *Waterville, The Lost Cow Town* (mural 3), Kenny Winkenwader, 1995; S. Nebraska St. between Commercial and Front Sts.; early 1900s Waterville; Indians herding buffalo off the cliff for slaughter and cowboys driving cattle into Waterville from Texas.

History of the Bible (1998), *What God Created* (1999), and *Jesus and the Children* (2003), Kenny Winkenwader; Waterville United Methodist Church, Main and Nebraska Sts., inside (basement, basement nursery, steps to basement); Christian scenes.

SOUTHEAST REGION

AMERICUS

Cowboy Mural, Marilyn Dailey, 1980s; Coyotes, 608 Main St.; cowboy in the Flint Hills.

BAXTER SPRINGS

Quantrill's Raid on Baxter Springs, Edmund Ness, 1968; Baxter Heritage Center and Museum, 8th St. and East Ave., inside; massacre of Ft. Blair troops by proslave guerrillas; oil on masonite.

The Story of Baxter Springs, Paula Blincoe Collins, 1995 (No. 36).

Trail Drive, John Gibbins, 1991; 11th and Military Sts. on 11th St.; longhorn Texas cattle drives into Baxter Springs, first cow town in Kansas from 1867–1872.

BLUE MOUND

Patriotic Mural, Jim Stucky, 1996; downtown on Main St.; woman with flag.

BRONSON

Farm Landscape, Charles Wood, Chris and Lael Wood, 1995; Bronson Locker, 508 Clay St.; farm landscape.

BURLINGAME

Where Rail Meets Trail, eighth-graders directed by Marj Day, c. 1994, repainted 2004; parking garage, 100 block of W. Topeka; Oregon Trail and Santa Fe Railroad.

BURLINGTON

* *Boy and Colt*, Robert Kittredge, 1942; Post Office, 118 S. 4th, inside; boy and colt; stone sculpture.

CANEY

Caney: The Big Gas Town, Marion Bryant, 1996; Caney Valley Historical Society Museum, 314 W. 4th St., inside; collage of Caney history including the discovery of oil fields in 1900.

CARBONDALE

Church Murals, Phillip Evarts, 1993; Berry Creek Wesleyan Church, just north of Carbondale on old Hwy 75 (Berry Creek Rd.), inside; Noah's Ark, Moses and children of Israel, nativity story, Christ's passion.

CHANUTE

Chapman Library Mural, Marjorie Hall Bicker, 1998; Neosho County Community College, Chapman Library, 800 W. 14th St., inside; historical events, people, and architecture of Neosho County.

CHETOPA

Chetopa Schools Murals, Joan Allen, 1995; Chetopa high school and grade school, 430 Elm St., inside, hall, cafeteria, and other locations; cartoon Koala bears demonstrate quality education.

Historic Scene of Downtown Chetopa, Joan Allen assisted by Larry Allen and Jerg Frogley, from original painting by Marie Horner, 2000; 406 Maple St.; downtown Chetopa with old depot and Neosho River Bridge.

COFFEYVILLE

Attractions Map, Don Sprague, 1989; 811 Union; locations of Coffeyville attractions.

Aviation History, Don Sprague, 1991 (No. 37).

Baptismal Scene, Don Sprague, 1992; Union Baptist Church, Lake and Delaware Sts., inside; baptismal scene.

CASA—A Child's Voice in Court, Daniel Villela, Sherry Gilfillan, and Native American Art Class; downtown on building east of the post office, faces west; abstracted image of circle of children near road leading to a house.

Chief Black Dog, Don Sprague, 1989; portable murals sometimes shown in vacant downtown windows; Chief Black Dog and his band of Osage Indians made a trail through Coffeyville.

Coffeyville Community College Mural, student artists under direction of Michael DeRosa, 2004; 500 block of W. 8th St.; the human condition, based on photo references.

Collage of Coffeyville History, Don Sprague, 1988; 127 W. 8th St., inside; collage of Coffeyville's past and present.

Colonel Coffey's Trading Post, Don Sprague, 1989; portable mural sometimes shown in vacant downtown buildings; Colonel Coffey had a trading post that became the town of Coffeyville in 1869.

Daltons as They Were "Laid Out," 1992, repainted by Don Sprague in 1997; 807 Walnut St., sidewalk and wall mural; after four Dalton Gang members were killed following a bank robbery attempt in 1892, their bodies were laid out in the jail for a day before burial.

Defenders, Tommy Thompson, 1993; Dalton Defenders Museum, 113 E. 8th St., inside; honors four citizens who died defending two banks against the Dalton Gang in 1892.

Defenders on Wall, Don Sprague, 1991; back entrance to Downtown Mall, 114–118 W. 9th St.; depicts those who shot Dalton Gang members during the 1892 bank robbery attempt.

Downtown Coffeyville in 1892, Don Sprague, 1988; 807 Walnut St.; depicts Coffeyville as it looked when the Dalton Gang rode into town.

First Baptist Church Murals, Peppi Mendez, 1969; 300 W. 9th St., outside and inside sanctuary; Christian symbolism; concrete carved relief.

Interurban, Don Sprague, 1989; 109 W. 7th St.; celebrates Coffeyville's interurban transportation system that began in 1905.

Kansas Wholesale, Don Sprague, 1990; 809 Elm St., north wall; depicts 1909 building with business that carried wholesale groceries.

Natatorium, Don Sprague, 1989; 9th and Elm Sts.; the Silurian Springs Bath House built by W. P. Brown in 1906.

Old Grocery Store Interior, Don Sprague, 1989; 111 W. 9th St., inside; an early-day grocery store.

Pardners West, Michael DeRosa, 1998; alley between 9th and 10th Sts., east side of Maple St.; western landscape with cowboy and covered wagons with rattlesnake in foreground.

Walter Johnson, Don Sprague, 1991; 222 W. 9th St.; celebrates Walter Johnson, the famous pitcher for the Washington Senators who lived in Coffeyville on the off season, as well as the local Little League.

COLUMBUS

Achievement of Our Forefathers, Duke Wellington, 1987; Columbus Community Building, 320 E. Maple, inside, large meeting room; history of Columbus; oil paint.

* *R. F. D.*, Waylande Gregory, 1938, restored 1976; Columbus Community Building, 320 E. Maple St., inside, small meeting room; mounted postman delivering the mail (originally commissioned for Columbus post office); terra cotta relief.

EMPORIA

Celebration of Kansas, Norma Kluthe, 2000; walkway of the 700 block of Commercial St.; contains the official version of the state song *Home on the Range*.

The Flag, Norma Kluthe, 2000; back side of 714 Commercial St.; antique American flag.

Jazz Players, John Finley, 2003; 700 block of Merchant St. on the back wall of Flint Hills Music; images of jazz players.

Our Flag Was Still There, Marilyn Dailey, 2003 (No. 38).

Sports Mural, K. Kohler; Josie's Tavern, 6th and Mechanic Sts., west wall; celebrates Emporia State University sports.

Spring in the Flint Hills, Stan Herd and Louis Copt, 2003; JavaCat–5, 6th and Merchant Sts.; spring Flint Hills landscape.

EUREKA

* *Cattle Roundup*, Vance Kirkland, 1938; Post Office, 301 N. Oak St., inside; cattle roundup, oil on canvas.

FORT SCOTT

* *Border Gateways*, Oscar E. Berninghaus, 1937; Post Office and Courthouse, 120 S. National St., inside, room 206; pioneers and Native Americans; oil on canvas (the only Section of Fine Arts mural not on the Historic Register).

Justice Enthroned, David Overmyer, 1929; Bourbon County Court House, 210 S. National St., inside; allegorical justice image.

Liberty Theater Murals, George W. Kieffer, 1951; Liberty Theater, 113 Main St., inside (view by appointment, call Dallas Smith at 1-800-530-5038); old-time town scenes.

Robert the Bruce's Castle, *The King's Chamber*, and others (theater drops), painted in 1904, repainted and changed in 1924 by Thomas G.

Moses of Armstrong Studio, Inc.; Fort Scott Scottish Rite Temple, 110 S. Main St., inside; Scottish Rite themes.

FREDONIA

* *Delivery of the Mail to the Farm*, Lenore Thomas, 1939; Post Office, 428 Madison St., inside; rural mail; glazed terra cotta.

Flag Mural, Jordan Johnson, 2002; southeast corner of 7th and Monroe Sts.; U.S. flag with military jet.

Mill Dam, Trish Manion, 1989; Harlan's True Value Hardware, 700 Madison St.; commemorates the history of the mill, built in 1872.

FRONTENAC

Community Trees, Jim Reed with students and senior citizens, 1999 (No. 39).

GARNETT

Abstract Murals (two murals), Inge Balch, 1993; 3rd and Oak Sts., view from back alley, faces west; brightly colored abstract geometric forms.

Crazy Quilt, Jannelle Adams and Robert Logan, 1993; energetic abstract mural.

Garnett Public Library Mural, Conrad Snider, 2001; Garnett Public Library, 125 W. 4th St.; the arc within the mural reflects the patterns traced by the shadows from the large trees in the area; ceramic tile.

Jacob's Ladder, Robert Logan, 1993; southwest corner of 5th and Oak Sts., faces north; colorful zigzag pattern.

Kittens on the Prairie, Robert Cugno and Robert Logan, 1993 (No. 40).

GRENOLA

The Longhorn Cattle Drive, Eddy Poindexter, 1993; Community Building, Main St., north wall; cattle drive and train depot.

HUMBOLDT

Civil War Monument, Bob Cross, 2001; City Square, northwest corner; history of the 1861 raid on and burning of Humboldt; freestanding mural, carved stone.

INDEPENDENCE

The Rail Splitter, Honest Abe the Learner, The Stump Speaker, and *President Abraham Lincoln* (four murals), Fredda Wright, 1939; Lincoln School, 701 W. Laurel St.; based on Carl Sandburg's biography (WPA murals).

LONGTON

The Ten Commandments, Linda South, 2003; 400 block of Kansas St.; image of the Ten Commandments, intended to express support for viewing Ten Commandments in public buildings.

LYNDON

Lyndon Elementary Middle School Every Kid Counts, Shirley Akers, 2000; Lyndon Elementary Middle School, 420 E. 6th St.; past to present scenes, a covered wagon, old and new school, school bus, space shuttle.

MOUND CITY

Father DeSmet at Sugar Creek Mission and *Arrival of Mother Duchesne at Sugar Creek Mission* (two murals), Sister Regina and other Ursuline nuns, 1941; Sacred Heart Church, 729 W. Main St., inside; scenes of

Father DeSmet and Mother Duchesne among Potawatomi people at Sugar Creek Mission, 1841.

NEODESHA

* *Neodesha's First Inhabitants*, Bernard J. Steffen, 1938; Post Office, 123 N. 5th St., inside; Chief Little Bear and his wife and daughter greeting Dr. Blakeslee atop Little Bear's Mound; oil on wood.

OSWEGO

A. Gessellhart Barber Shop, Joan Allen, 2000; 418 Commercial St.; depicts the barbershop that was the original occupant of the building in 1870.

American Flag, Joan Allen, 2001; 303 Commercial St., south wall; American flag.

Spirit of '76, Mark Switlik, 1975; 800 4th St.; patriotic drummers with flag.

End of the Trail, Joan Allen assisted by Larry Allen, 1998; 307 Commercial St., upper story north wall; silhouette of an Indian on a horse.

* *Farm Life*, Robert Larter, 1940, restored mid-1990; Post Office, 819 W. 4th St., inside lobby; barnyard scene; oil on canvas.

Hobart and Taylor Bank, Joan Allen, 2000; 418 Commercial St., on glass windows; commemorates the location of the old Hobart and Taylor Bank.

The Jail House Mural, T. J. Fuller, 2000; 709 5th St., front windows; the artist chose to paint jail scene because the police station is next door, the sheriff's office and jail are across the street, and the last business in the building was a bail bond business.

Mural for Jane—Mountain Scene and Little Boy, Joan Allen, 2002; Infinia Healthcare, 1212 S. Ohio St., inside; in honor of all Alzheimer patients.

Mural of Oswego Activities, Mary Casey Inman Dugger and David Dugger, 1992; Commercial and 6th Sts.; historic places in Oswego; freestanding mural.

Old Country Bank, Ted Watts, 1976; Commercial Bank, 501 Commercial St., inside, behind tellers' station; country scene featuring old bank building.

Oswego Public Library Murals for Children, Angela Vail, A. J. Wood, Jason Kellogg, 1995; Oswego Carnegie Library, 704 4th St., inside, basement; children's book themes.

Village of White Hair, E. Marie Horner and Joan Allen with Jerg Frogley and Larry Allen, 1998 (No. 41).

OVERBROOK

Don't Overlook Jesus, Phillip Evarts, 1995; Grace Community Church, 310 E. 8th St., inside; Jesus in wheat field during harvest with sky filled with balloons.

Don't Overlook Overbrook, original mural painted for 1986 town centennial, later revised and repainted by Julie Gibbs; corner of Locust and Hwy 56; town mural.

PITTSBURG

Egyptian Murals (two murals), Bob Blunk; Memorial Auditorium and Convention Center, 503 N. Pine St., inside, lobby and hallway; Egyptian themes.

French Cafe, Jim Reed, 2005; Stella's, on Broadway St. between 5th and 6th Sts.; French Cafe scene.

Pittsburg State Centennial Mural, Mark Switlik, 2004 (No. 42).

Solidarity . . . , Wayne Wildcat with students and community members, 2000 (No. 43).

SCRANTON
Western Scene, Sally Rayles, 2005; Scranton Bar and Grill, 301 Brownie; western scene with girl and cowboy.

SEDAN
Buffalo, Stan Herd, 2002; 165 E. Main St.; abstract buffalo.

Wild Horses, Alena Patterson, 2002; Ranch Cafe, 115 S. School; wild horses in southwest landscape.

NORTH CENTRAL REGION

ABILENE
Patriotic Silo, Karen Lewis, 2005 (No. 44).

AGENDA
Historic Agenda, Glen Lojka, 2002; downtown city park; Rock Island steam train going through Agenda in its heyday, frontier.

BELLEVILLE
And You Shall Have Dominion, Marion Walker, 1989; Belleville Public Library, 1327 19th St., inside; Kansas heritage.

Belleville, Kansas, Charting History, Advantage Sign and Graphic, designed by Pat Mikesell, painted by Pat Mikesell and Denise Dove, 1995; corner of M and 19th Sts.; Kansas map as landscape with highlighted towns, landmarks, and emblems.

Kansas Hillbilly Life—The Good Old Days, Candy Sanford, 1997; Boyer Gallery, 1205 M St.; humorous Kansas Hillbilly farm scene.

* **Kansas Stream, Birger Sandzén, 1939 (No. 45).**

CAWKER CITY
Window Murals; in downtown storefronts on Wisconsin St.; reproductions of famous paintings.

CONCORDIA
The Napoleon Curtain, Twin City Scenic Company, 1907 and 1979 (No. 46).

COURTLAND
Pictorial View of Courtland, Tim Leaf and students, 1984 (repainted by Pat Mikesell, 1996) (No. 47).

COVERT (A GHOST TOWN BETWEEN OSBORNE AND WALDO)
Covert Kansas 1895, Jim Nelson, 2003; Covert Creek Lodge, 1982 County Rd. 671, inside dining room; depicts the main business street of Covert in 1895, with notable buildings and people from other eras of Covert's history.

DOWNS
Ise Historical Marker; U.S. 24; illustration of plowing from John Ise's book Sod and Stubble; freestanding mural.

Theater Drop, c. 1924; Memorial Hall, inside; Liberty Island, the Statue of Liberty, and the New York City skyline.

GLASCO

Conversation and Community, Lora Jost with community volunteers, 1998; recycling center downtown; one of the remaining silhouette figures from a larger project about the Glasco community.

Immigrant Journey to the Solomon Valley, Diana Werts with fourth–eighth graders from Glasco Grade School, 2004; The Corner Store, 129 E. Main St., inside, above produce counter; traces the Hillhouse family's journey from Scotland to the Solomon Valley, 1856–1866.

HANOVER

Oregon Trail at Hollenberg Station, Charles Goslin, 1998; Hollenberg Pony Express Station, 2307 Big Bear Rd., inside; Oregon Trail scene.

Pony Express Station, Ina Fike, 1989; junction of Hwy 36 and 138; Pony Express; freestanding mural.

HERINGTON

* *Arrival of the First Train in Herington—1885*, H. Louis Freund, 1937 (No. 48).

Railing Wall, Verda and Milt Fleming, 1996; 9 S. Broadway St.; Rock Island No. 652 and Old Rock Island Depot.

HOLYROOD

H & B Communications Mural, Pat Potucek, 1999; H & B Communications, 108 N. Main St., inside; president's office, history of the Koch family communications business.

Holyrood Area Landscape, Michelle Petermann, 1985; Bank of Holyrood, inside; area landscape.

LONGFORD

The Old Depot, Clarissa Kramer, 2003; Post Office on Weda, faces west; historic train depot.

LUCAS

Lucas, forty community volunteers; intersection of Hwy 232 and Hwy 18; welcome sign created in the manor of Ed Root, an outsider artist featured in Lucas' Grassroots Art Center; concrete freestanding mural with embedded found objects.

Old World, New World (two murals), T. M. Swift, late 1920s; Brant's Meat Market, 125 S. Main St., inside; farm scenes depicting old and new world of the immigrant.

MILTONVALE

Church Murals, N. A. Stafford with Phil Burns, 1954–1955; St. Anthony's Catholic Church, 612 W. 4th St.; scenes include holy spirit, women at the tomb on Easter Sunday, holy family at home in Nazareth, the transfiguration of the Lord.

Pioneer Kansas on a Quilt, Diana Werts with third–sixth graders, 2004; Miltonvale Grade School, 520 Oak St., inside, library; quilt patterns are used to set off settlement themes of food, shelter, transportation, and recreation.

MINNEAPOLIS

Pastoral Scene, Scott Robins and Lori Campbell, 2003; Good Samaritan Center, 815 N. Rothsay St., inside; fall pastoral scene with farm, church, covered bridge, and covered wagon.

The Thirties Era, Phyllis Brown, 2003; Golden Wheel Senior Center, 114 S. Concord, inside; steam engine, agriculture, Rock City.

NATOMA

Western Mural, Stan Herd, 1985; United National Bank, 702 N. 2nd St., inside; western imagery.

RUSSELL

Comin Soon, E. E. F., 1980; 901 Main St.; psychedelic Jesus.

Historical Murals, Rick Rupp; Fossil Station Restaurant, 1410 S. Fossil; Russell history.

Oil Mural, E. E. F., 1980; 809 Main St. and Bricker Park; landscape with oil wells, oil industry, and 1930s Gorham Field.

* *Wheat Harvest*, Martyl Schweig, 1940; Post Office, 135 W. 6th St., inside; wheat harvesters and oil drilling; oil on canvas.

SALINA

Alleyway Mural, Gear, 2004; north of Iron in alley between Santa Fe and 7th Sts.; flowers and bees; spray paint.

The Arts, Nicolette Mitchell, 2002; South High School, 730 N. Magnolia; abstract mural symbolizing the arts.

Bugs Series Mural, Gear, 2002; Caper's, 109 S. Santa Fe, in back; bugs; spray paint.

Comic Strip Mural, Steve Britt, late 1990s; Oakdale Park (between Santa Fe and Ohio), tennis court; the Lone Ranger and Tonto.

The Coming of the Pioneers, Robert W. Grafton, 1928; Kansas Wesleyan University, Hall of the Pioneers, 100 E. Claflin, inside; pioneers and Native Americans (see photo, page 7).

Cottonwood School Mural, Ruth Moritz with students, 2002; Cottonwood School, 215 S. Phillips, inside; incorporates children's art; multimedia.

Floral Mural, Joey Pohl; Gutierrez Restaurant, 1935 S. Ohio St., inside, entry and interior; decorative flowers.

Kansas Heritage Murals (two murals); Salina Bicentennial Center, 800 The Midway, inside, lobby; Kansas heritage.

* *Land* and *Communication* (two sculptures), Carl C. Mose, 1940; Smoky Hill Museum, 211 W. Iron; sculpture.

Meadowlark School Mural, Ruth Moritz with students; Meadowlark Elementary School, 2200 Glen, inside, connecting hall; incorporates children's art, multimedia.

Points of Contact, Conrad Snider assisted by Hanna Eastin, 2002 (No. 49).

Procession, Ernest Bruce Haswell, 1953 (No. 50).

Schilling Mural, Katy England; Schilling Elementary School, 3121 Canterberry, inside; climbing wall, mountain scene.

Stations of the Cross, Randal Julian, 2006; Elizabeth Ann Seton Church, 1000 Burr Oak Ln., inside; stations of the cross; bas-relief.

Sunset School Mural, Tony Ortega with students, 2004; Sunset School, 1510 Republic, inside; landscape incorporates neighborhood and students.

Ten Acres Garden Mural, Deon Smally, 2000; Ten Acres Garden, 8853 E. Cloud, inside (open in the spring and fall); garden scene.

What Do You Love about This Place, Jane Beatrice Wegscheider with others, 1999 (No. 51).

SCANDIA

Transportation Mosaic, Carl Hepp Jr., 1972; Reece Construction, 402 4th St.; forms of transportation; ceramic mosaic.

TESCOTT

Tescott at the Turn of the Century, Amy Christenson, 1998; 120 S. Main St.; scene of Tescott at the turn of the century with picture of Thomas Eugene Scott (T. S. Scott), the founder of Tescott.

WASHINGTON

Don't Tread on Me; Hwy 36 entering Washington, north side of street; American flag design with "Don't tread on me, three that keep us free, God guns guts."

Roots and Creatures under Water, Jack Curran, 1985; First National Bank, 101 C. St., behind bank; an extension of the bank's garden with tree roots and animals; carved brick.

WILSON

From Homeland to Bosland, Alva and Arita Wallert, 1974; Opera House, 41 S. 29th St., inside; Czech Festival Pageant Play backdrop moved to Opera House.

SOUTH CENTRAL REGION

ANDOVER

Murals at the Middle School (two murals), Steve Murillo, 1996; Andover Middle School, 1628 N. Andover, inside; children sitting on floor making a classical-looking chalk drawing of an MTV image.

Welcome to Timbuktu, Mark Pendergrass, 2005; Timbuktu Grill and Bar, 1251 N. Andover; animals of Timbuktu; three-dimensional elements.

ANTHONY

1940s Farmstead, Anson Sanford, 1984; Anthony Chiropractic Center, 216 Main St., inside; mural painted with dots of farmstead, house, and outbuildings.

Anthony Downs Centennial, Raintree Schneider, 2004; 800 N. Madison, bleachers; celebrates the centennial of the Anthony Downs historical racetrack built in 1904.

An Atoll Called Tarawa, Mike Fallier, 2004; 206 E. Main St.; tribute to World War II soldiers and the battle on the Betio Island of Tarawa Atoll.

Betty Boop, Raintree Schneider, 2004; 100 N. West St.; small mural of Betty Boop.

Destination Topolabampo, Mike Fallier, 2004; Memorial Park, 700 W. Main St.; train and station to celebrate the driving of the spike in Anthony, which was the beginning of the Kansas City–Mexico–Orient Railroad in the United States.

J. K. and Maxine, Raintree Schneider, 2005; J-Mac Flower & Gift, 117 E. Main, inside; tribute to the former owners of the flower shop.

Kanza Bank Mural, Zona Wheeler, 1962; Kanza Bank, 102 E. Main, faces west; agriculture; ceramic tile.

Kay Lane's Kloset, Karen Cather, 1990s, and *Thelma & Margurite*, Raintree Schneider, 2005; Kay Lane's Kloset, 118 W. Main St.; window murals and stairwell mural of people shopping.

Racing My Stallion, Raintree Schneider, 2004; Anthony Wellness Center, 117 W. Main, inside; the free spirit of exercising.

* *Turning a Corner*, Joe Jones, 1939; Post Office, corner of Steadman and N. Bluff, inside; farming scene, oil on canvas.

A Walk in the Park, Raintree Schneider, 2005; Anthony East Park, 300 S. Santa Fe; park scene with symbols of Anthony history.

Welcome to Anthony, Raintree Schneider, 2004; Chamber of Commerce, 227 W. Main; greeting visitors (on the wall next to the Chamber of Commerce).

ARGONIA

Argonia's Past and Present, Cristi McCaffrey-Jackson with community involvement, 2001 (No. 52).

ARKANSAS CITY

American Flag, Carina (McGowen) Taylor, 2002; Rakie's Oil Company, 302 N. Summit St., north wall; American flag.

Cherokee Strip, Shirley Bennett, 2004; Cherokee Strip Land Rush Museum, 31639 S. U.S. Hwy 77; Cherokee Strip land grab.

Cherokee Strip Land Rush, Stan Herd, 1984; 113 N. Summit St., faces north; depicts the Cherokee Strip land grab with Indians on horses watching.

Community Mural, Denise Irwin with painting participation from more than 400 Arkansas citizens, 2005; Jefferson and Summit Sts.; historical mural commemorating markets and food production.

Lotuses, designed by Laura Foster and painted by sixteen community members (listed on mural), 1978; northeast corner of Summit and Washington Sts. on Washington St.; abstract lotus design.

Summit Street Windows, Cleo Graves, 1998 (No. 53).

ARLINGTON

Buffalo Landscape, Larry Caldwell and AvNell Mayfield, 1997; Crazy Horse Dining Hall, Hwy 61 and Main St.; buffalo herds on the Kansas prairie.

AUGUSTA

* *A Kansas Gusher*, Donald Silks, 1940; Post Office, 119 E. 5th St., inside; oil "gusher" within rural scene; oil on canvas.

The Reluctant Dragon, Mark Pendergrass, 2002; Augusta Public Library, 1609 State St., inside; children's area, fantasy castles, dragon, knight, with three-dimensional elements.

Theater Murals (two murals), Kansas City Theatrical Company artisans, 1949; Augusta Historic Theater, 523–25 State St., inside; north and south walls of theater, oil on canvas.

BELLE PLAINE

Historical Plaque, Randal Jullian, 1995; Belle Plaine Tourist Center, I-35 at Belle Plaine; area history; small bas-relief.

BENTON

Chisholm Trail, Rick Regan, 2000; Prairie Rose Chuckwagon Supper, 15231 SW Parallel St., inside; Chisholm Trail.

BURNS

Storefront Treasure Hunt, Barbara Anderson and Brenda Koehn, 2003; corner of Washington and Broadway Sts., faces north; storefronts with hidden objects in the mural.

CALDWELL

Box Turtle—State Reptile, Marty Capron, 1989 (No. 54).

Cherokee Strip, Brenda Lebeda Almond, 1993; Heritage Park, corner of 1st and Main Sts.; Caldwell history and the Cherokee strip land grab.

* *Cowboys Driving Cattle*, Kenneth Evett, 1941; Post Office, 14 Main St., inside; driving cattle; tempera.

CAMBRIDGE

The Count, Melvin Redburn, 1996, repainted c. 2003; Stockman's Cafe, 506 Pearl St.; cowboy looking over hills counting cattle.

CLEARWATER

Clearwater Historical Mural, Yancy Lough, 2004; Clearwater Historical Museum, 149 N. 4th St.; early Clearwater history.

CUNNINGHAM

City of Cunningham, Gene Wineland, 2004; northwest corner of Main St. and Hwy 54; town history including 1880s settlers, 1920s Main St., and twenty-first century.

DERBY

Derby History, Gerard Wellemeyer, 2001; Atwood's, Red Powell and K-15; historical mural with train, old bank building, McConnell plane, stagecoach, and contemporary water tower.

Derby Middle School Mosaics, Sue Jean Covacevich with students, 1960–1970; Derby Middle School, 801 E. Madison St.; 126 mosaics illuminating famous inspirational quotes.

DEXTER

History of Dexter, Elizabeth Boyd Vaughan, early 2000s; Central and Main Sts.; Dexter history.

EL DORADO

Country Club Murals (two murals), Omer Wilson, 2001; Prairie Trails Golf and Country Club, 1100 Country Club Ln., inside, dining room; train in landscape and horse-drawn carriage in landscape.

El Dorado Scenes, Julie Boman; on Main St. between Locus and Olive Sts.; contemporary community scenes and Kansas imagery.

The Glory of the Hills (Flint Hills Landscape), Phil Epp with Terry Corbett, 1998 (No. 55).

Old Downtown, Julie Boman and D. L. Sailer, 1996; Silverado's Restaurant, 151 N. Main St., behind restaurant; old downtown scene.

ELLINWOOD

Ellinwood Grade School Mural, Jimalene Haddon, 2000; Ellinwood Grade School, 310 E. 6th St.; elementary education and community themes.

FLORENCE

Patriotic Mural, Barbara Chavez, 2003; 400 block of Main St. by Veterans' Park; eagle with flag background.

GALVA

Honor Role Memorial, the Priscilla Club, 1944. Repainted for town centennial by Daphne (Anderson) Flasschoen, 1987; 202 S. Main St., faces north; bears the names of more than 160 men and women from the Galva community who served in the armed services in World War II.

GEUDA SPRINGS

The Old Gray Mule and *Where in the World but Kansas*, Stan Herd, 1985; Post Musical Homestead, 1679 E. 160th St. South, inside house and barn (view by appointment, contact Bill Post at 1-620-442-4336); mural imagery is based on songs.

GOESSEL

Mennonite Centennial Mural, 1874–1974, Peter H. Friesen, 1974; Mennonite Heritage Museum, 200 N. Poplar St., inside; Turkey Red Wheat Palace; five glimpses into the life of Mennonite immigrants to Kansas.

Small Town Big Heart, Goessel High School art students coordinated by Brian Stucky, 1979, repainted 1995; 300 block of E. Main St.; sunrise.

GREAT BEND

El Baile (The Dance), Dave Loewenstein with Clay Bailey, 1998; between 10th and 11th Sts. on Main St.; community dance.

Central American Village, Christina Lamoreaux, 1999; Dr. John Harrell's Office, 1701 Hwy K-96, inside; Central American village scene where Dr. and Mrs. Harrell do medical mission work.

Clara Barton, Dave Loewenstein, 1998; 16th and William Sts.; Clara Barton.

Farm Scene, Tommy Thompson and Jana Erwin, c. 1990s; corner of Williams and Forest Sts.; farm scene.

The First Fifty Years of Barton County, Pat Potucek, 1974 (No. 56).

Happy Trails, Dave Loewenstein with Clay Bailey, 1999; 10th and Washington Sts.; Santa Fe Trail at the millennium.

The Holy Family, Anne Zerger, 2001; Holy Family School, 4200 Broadway St., inside, entryway; Mary looking on as Joseph teaches the child Jesus carpentry skills.

Holy Family School Mural, Parker Zerger with students, 2001; Holy Family School, 4200 Broadway St., inside; celebrates union of St. Patrick's Parochial and St. Rose Parochial Schools into Holy Family School; ceramic tile.

Hopi Rain Clouds, Yancy Young, 2001; Medicine Bear Trading Company, 1704 Hwy K-96, northwest wall; Hopi rain clouds.

The Lion's Mural (1998, Lion House) and *The Tiger Mural* (2001, Lion House), designed by Diann Henderson and Paul Martin, painted by children enrolled in mural program through the Great Bend Recre-

ation Center; Brit Spaugh Park and Zoo, 2000 block of Main St.; animals and their cultural connections and habitat.

Migration, Dave Loewenstein with Great Bend High School students, 1997; 16th and Main Sts.; birds, wheat, quilts.

Page Bistro, Dave Loewenstein, 2004; 2920 10th St., behind Perkins; restaurant themes.

Panthers, Sally Cox and Jay Tschehe, 2001; Great Bend High School, 2027 Morton St., inside, commons area; native area for panthers (the school mascot); carved brick.

The Santa Fe Trail Mural, designed by Paul Martin and Diann Henderson, painted by Hutchinson seniors and elementary school children, 1999; Senior Center, 2005 Kansas St.; covered wagons on the Santa Fe Trail.

A Sign of the Times, AvNell Mayfield and Larry Caldwell, 1998; southwest corner of 7th and Main Sts.; depicts old west scene and the reaction of people and animals to the first automobile that drives down Main St.

Something for Everyone, AvNell Mayfield and Larry Caldwell, assisted by Dana Carson and more than seventy volunteers, 1998; 1616 Williams St.; celebrates the Barton County Fair.

Southwest Scene, Mary Alice Skelton and Deena Dent; 918 Adams; southwest mountain scene.

HALSTEAD

Back to the Future, AvNell Mayfield and Larry Caldwell, 1998; Halstead Antique Mall, 225 Main St., inside; 1880s girl looking out the window at Halstead's Main Street of the period.

Halstead High School Murals, AvNell Mayfield and Larry Caldwell, 2000; Halstead High School, inside, throughout school; school themes and activities.

Halstead Montage, Gene Marsh, c. 1998; Gatz Office Complex, 309 Main St., inside; significant places in Halstead.

Horse and Buggy Doctor, AvNell Mayfield, 1995; Heritage Inn Lodging, 300 Main St., inside; landscape with river and doctor in buggy.

* *Where Kit Carson Camped*, Birger Sandzén, 1941; Post Office, 319 Main St., inside; junction of the Little Arkansas River and Black Kettle Creek; oil on canvas.

Wizard of Oz Mural, AvNell Mayfield and Larry Caldwell with students, 1999; Halstead Middle School, 221 W. 6th St., inside, cafeteria; the Wizard of Oz.

HARDTNER

Hardtner Scenes, Julia Bland, 1983; Peoples State Bank, 100 E. Central St., inside; three panels represent the Hardtner economy including the cattle rancher, wheat farmer, and oil industry.

Mountain Splendor, Christie McNett and Geneva Fox, 1982; bathrooms at Hardtner City Park, 501 N. Main St.; mountain scenes.

HARPER

American Legion Park Mural, Mike Fallier, 1997; American Legion Park, 117 Main St.; Iwo Jima soldiers, Buffalo, Civil War sentinel.

Come Swing with Us, junior high students coordinated by Karen Dunkelberger, 2001; Heritage Estates Assisted Living, 1212 Hickory St., inner courtyard; garden scene with swings.

Grow with Us, junior high students coordinated by Karen Dunkel-berger, 1999 (No. 57).

Harper History, junior high students coordinated by Karen Dunkel-berger, 1992, repainted 1999; corner of Central and Main Sts., faces south; historical buildings of Harper.

HAYSVILLE

Haysville Mural, Joetta Branch with first through sixth graders, 2000; backside of 200 W. Grand St.; township history through the tornado of 1999.

HESSTON

Dyck Arboretum Commemorative Mural, Conrad Snider, 2004; Dyck Arboretum Visitors Center, 177 W. Hickory St., inside, near entryway; relief mural incorporates textures from native grasses and other primary plants; ceramic tile.

Flint Hills Landscape; Dyck Arboretum, 177 W. Hickory St., inside; fabric mural.

Generations, Hand in Hand, Paul Friesen, 2005; Hesston Childcare Center, 200 W. Cedar St. then to Neufeld Dr., inside; intergenerational imagery with animals, children, insects, and texture; clay.

Hesston College Mural, Conrad Snider, 2003; Hesston College, Mary Miller Library, 301 S. Main St., inside; abstract, the patches of white can be viewed as one might view clouds—seeing images in each random shape; ceramic tile.

Parable of the Ten Virgins, Paul Friesen, 1986; Hesston Mennonite Church, 309 S. Main St., inside; based on Christian parable; clay.

Prairie Bloom, Paul Friesen, mid-1970s; Hesston College, Mary Miller Library, 301 S. Main St., inside; bloom, wood.

Prairie Rose, Paul Friesen, 1980; Hesston College, Kropf Education Center, inside; flower, wood.

HOISINGTON

The Generation, Bob Booth, 1990 (No. 59).

* ***Wheat Center***, Dorothea Tomlinson, 1938 (No. 58).

HUTCHINSON AND SOUTH HUTCHINSON

Ad Astra, Dave Loewenstein assisted by Trey Morgan, 2002; Main St. and Avenue A; Kansas constellations.

Angels We Have Seen on High, Pat Potucek, 2000; St. Teresa Catholic Church, E. 5th St., inside, sanctuary; heralding angels (artist used her eleven granddaughters as models).

Children's Activity Room Mural, Jeanne M. Drew, 1965; Hutchinson Public Library, 901 N. Main St., inside children's activity room; fanciful landscape with book characters.

Children's Library Murals, Larry Caldwell with children, 1990s; Hutchinson Public Library, 901 N. Main St., inside children's area; colorful scenes of the ocean, jungle, and other environments.

Courthouse Mural; Reno County Courthouse, inside, third floor; wagon trains and Indians.

Dream, Robert McCall, 2002 (No. 60).

Flag Theater Murals, Larry Caldwell and AvNell Mayfield, 1993; Flag Theater, 310 N. Main St., inside, auditorium; depicts an audience of

more than 300 theatrical, historical, and political characters and local patrons for the restoration of the Family Children's Theater.

Frontiers, Pat Potucek, 1983 and 1985; Hutchinson Middle School 7, 210 E. Ave. A, inside; frontiers from Davie Crockett to the space shuttle.

The Good Earth (1987) and *Candy Making and History of Richard Scheble Candy Co.* (1997), Pat Potucek; Smith's Market, 211 S. Main St., inside; Amish people planting and preserving vegetables; candy being made in the 1940s candy company housed at that location, and a woman making candy at home.

History of Dentistry from 1900 to 1930, Pat Potucek, 1977; Dental Center, 200–210 E. 30th St., inside; history of dentistry.

Jesus with Children, AvNell Mayfield and Larry Caldwell, 2000; First Southern Baptist Church, 1201 E. 23rd St., inside; Jesus with children.

Middle School Mosaic, Teddy Gingerich with Hutchinson Community College assistants and students; Hutchinson Middle School 7, 210 E. A; school-related theme.

Motor Sport Mural; 119 W. 5th St.; a drag-racing rat; spray paint.

Nature Center Murals, AvNell Mayfield and Larry Caldwell, 2000; Dillon Nature Center, 3002 E. 30th St., inside; Kansas landscape with animals in their natural habitat.

Our Lady of Guadalupe Church Murals, Caesar Ramirez, 2001 and 2004; Our Lady of Guadalupe Church, 612 S. Maple St. (S. Hutchinson), inside, sanctuary and chapel; Juan Diego story and religious themes.

Our Lady of Guadalupe Shrine, Edward Curiel, Fred Henze, and

Migdonio Seidler with the Shrine Committee, 1982, in South Hutchinson (No. 62).

***Pioneer Center Mural*, Larry Caldwell and AvNell Mayfield, 2001 (No. 61).**

Recreation Center Murals, Larry Caldwell and AvNell Mayfield; Hutchinson Recreation Commission Wellness Center, 400 East Ave. E, inside; hall, lobby, and dressing rooms.

The Story of Hutchinson, Paula Blincoe Collins, 1984; Hutchinson Public Library, 901 N. Main St.; courthouse, Amish buggy, grain elevator, salt mines, state fair, sports arena, and Cosmosphere; carved brick.

* *Threshing in Kansas*, Lumen Winter, 1942; Post Office, 128 E. First St., inside; threshing scene; egg tempera and oil (the only Section Program mural in Kansas painted directly on the wall).

Victorian Scenes, Larry Caldwell and AvNell Mayfield, 2001; 319 N. Main St., window murals; Victorian scenes.

INMAN

Inman's Mural, Stan Herd, 1986; on Main St. one-half block south of E. Central St., faces north; depicts Inman c. 1910 and early farm life.

KINGMAN

American Flag, c. 2001; corner of Main and B; American flag.

County History Mural, Kingman Art Club artists directed by Clara Furry, 1982; Kingman County Museum, 400 N. Main St., inside; history of county including Osage Indian life, discovery of oil, and the formation of the "Cattleman's Picnic."

In the Days of Cattlemen's Picnic, Jessie S. Wilbur, 1942; Post Office, 45 N. Main St., inside; cattleman's picnic; tempera.

Silver Wings and *Cannonball Stage Line*, Stan Herd, 1998; Kingman County Museum, 400 N. Main St., north wall; Clyde Cessna's first airplane flying over Kingman and D. R. "Cannonball" Green driving a stagecoach run from Kingman to Greensburg.

We Make Auto Loans, Julie Hegeman and Gail Ewy, late 1980s; corner of Main and B, bank drive-through; 1956 Corvette.

LINDSBORG

Bank Mural, Robert Walker and Rita Sharpe, 1981; Bank of America, 118 N. Main St., inside; bank buildings and local people in Swedish folk art style.

Carousel, Eldon Swensson, 1997; Swensson Park, Swensson Memorial Band Shell; carousel.

Coronado Heights, Rita Sharpe with children, early 1990s; Public Library, 100 block of S. Main St.; Coronado Heights.

Kansas Stream, Birger Sandzén; Sandzén Memorial Gallery, 401 N. 1st St., inside; Kansas stream (a second version of the mural in Belleville).

Old Mill, middle school students, early 1990s; Lindsborg Middle School, 401 S. Cedar, inside; old mill in Lindsborg.

Our Founders in Architectural Heaven, Eldon B. Swensson, 2001 (No. 63).

Scandinavian Dragon, John Whitfield, 1999; corner of Main and Lincoln Sts.; dragon; painted relief.

Smoky River, Birger Sandzén, 1938; Post Office, 2 Lincoln, inside; river landscape; oil on canvas.

Soderstrom Elementary School Mural, Robert Walker with sixth graders, 1983; Soderstrom Elementary School, 227 N. Washington, inside; school scenes in Swedish folk style.

View from Gazebo, Maleta Forsberg, 1986; Courtyard Gallery, 125 N. Main, inside; Swedish landscape.

LITTLE RIVER

Kansas Scene, Beth Myers with high-school art class, 1995; Little Ol' Cookie House, 305 Main St.; early Kansas scene.

Psalm 23rd Memorial, Paula Blincoe Collins, 2005; Congregational Church, 410 Clinton St.; imagery based on Psalm 23.

LYONS

Change a Comin', Carolyn Loutzenhiser, 1983; Rice County Courthouse, 101 W. Commercial St., inside, 1st floor; Native Americans sitting on ground with wagon trains in the distance.

Industries of Rice County, Pat Potucek, 1982; Rice County Courthouse, 101 W. Commercial St., inside, second floor; Rice County industries.

Rice County America 1902 (outside, 1986) and Wichita Indian Life (inside, 1992), Stan Herd; Coronado Quivira Museum, 105 W. Lyon; images of daily life in 1902 Lyons (outside), a scene of Wichita Indian village life (inside).

MARION

Patriotic Mural, Barbara Chavez, c. 2002; 211 E. Main St.; American flag and clouds with "In God We Trust."

Marquette

Civic Mural of Marquette, Allan Lindfors and others, 1983 (No. 64).

Historic Panorama of the Marquette Area, Allan Lindfors, Janis Larson, Vivian Lueckfield, Barbara Rose, 1982, repainted 2005; 120 N. Washington St.; Marquette area history.

Noah's Ark Mural, Allan and Laurie Lindfors with Sunday School children, 1991; Elim Lutheran Church, 403 N. Lincoln, inside, basement; cartoon-style Noah's Ark.

McPherson

Historical Views of the First McPherson Opera House, Matthew Richter, 2002; First McPherson Opera House, 119 N. Main St.; five window murals depict copies and interpretations of opera house tickets, posters, and playbills.

Medicine Lodge

Church Mural; Restoration Church, corner of Fowler and Cherry Sts.; Christian cross making shadow on the world.

Moundridge

Goebel's Drug Store, Prairie Design, Brian Stucky assisted by Robert Van Arsdale, 1982; interior of old-fashioned drugstore once at this location.

Newton and North Newton

Blue Sky Project, Phil Epp, Terry Corbett, and Conrad Snider; Centennial Park; glorifies the open spaces of Kansas and provides a context for how humanity relates to this expanse; freestanding sculptural mural.

Carousel, Steve Murillo, 1996; Newton Factory Outlet, 601 S. 36th St., inside; carousel.

Children's Library Mural, Stephanie Ash, 1998; Newton Public Library, 720 N. Oak St., inside, children's area; Newton historical development through railroads, agriculture, and industry.

Landscape with Train, Phil Epp, 2002; 504 N. Main St.; sky landscape with Santa Fe Chief train.

Harvest Daughter, James Jerde, 2003; The Spartan, 301 N. Main St., inside; woman holding basket of food as symbol of bounty.

***La Vida Buena, La Vida Mexicana (The Good Life, Mexican Life)*, Patrice Olais and Raymond Olais, 1978 (No. 65).**

Patriotic Mural, Barbara and Jose Chavez, 2003; 119 W. 5th St.; American flag with soldier.

Pony Express, Stephanie Ash; Post Office, 400 N. Poplar St., north side; Pony Express rider through the Great Plains.

Rotunda Mural, Phil Epp, 2003; Medical Office Plaza, 600 Medical Center Dr., inside, rotunda; weather-related landscape.

Spartan Mural, James Jerde, 2000; Main and Broadway Sts. on Broadway St.; small mural of citrus fruit on table, influenced by the artist Henri Matisse.

View over Caleb's Hill, Paul Friesen, 2001; Bethel College (North Newton), Mantz Library, 300 E. 27th St., inside; aerial landscape, wood.

We Are the Church Together, summer Sunday School (K–8 graders) directed by LaDonna Unruh Voth and Kathy Schroeder with Conrad Snider as artistic and technical coordinator, 1997; Bethel College

Mennonite Church (North Newton), E. 25th and College Sts., inside, 1st floor; commemorates 100th anniversary of the church; clay.

NICKERSON

Exotic Animal Murals (nine rooms with murals), Marjie Barron, Bob Kelly, D. Miller, Jack Stout, Pat Potucek, Mitchell, Ginny Hornbeck, 1993; Hedrick's Exotic Animal Farm and Bed and Breakfast, 7910 N. Roy L. Smith, inside, bed and breakfast suites; exotic animals and habitat.

Guardian Angel Prayer, Pat Potucek, 2002; Nickerson United Methodist Church, Riverton and 82nd Sts., women's restroom; angels.

OXFORD

Box Turtle, Marty Capron, 1987; 100 block of S. Sumner, walkway between police station and city building; box turtle.

Catfish, Marty Capron, 1984; 113 E. Main St.; catfish.

The River (1991), *Kansas Nighttime Thunder Storm* (1991), and *Mating Buffalo* (1992), Marty Capron; The Rendezvous, downtown Oxford, inside; nature scenes.

PRATT

B-29 Mural, Kerry Conn, 2002; Skaggs Ace Hardware, 107 S. Main St.; commemorates the Pratt Army Air Field and the B-29s of World War II.

Osage Indian Village, Betty Kenworthy, 1999; Pratt County Historical Museum, 208 Ninnescah, inside; Osage Indian Village of southwestern Pratt County.

The Pioneers, *The Development*, *The Dark Dusty Days*, *World War II*, and *Achievement* (five mural scenes), Agnes Borden, 2002; Pratt County Historical Museum, 208 Ninnescah, inside; Pratt County History.

Prairie Life, Joan Lee, 2002; Pratt County Historical Museum, 208 Ninnescah, inside; early-day farm.

Pratt, Gene Wineland, 1984, repainted 1999; 317 S. Main St., faces south; commissioned for the 1984 centennial, a look at Pratt from a hill south of town.

UDALL

Early Udall, Elizabeth Boyd Vaughan, c. 2000; Two Rivers Co-op, 112 S. East St.; train and early Udall.

WALTON

Country Mural, Connie Rhodes, 2003; 200 E. Main St.; train, windmill, sunflowers.

WELLINGTON

American Flags, c. 2001; on garage on 8th St. between Poplar and Olive Sts.; two American flags.

Transportation Crossroads, Marjorie Hall Bicker, 2000; 7th and Washington Sts.; Wellington and transportation, including covered wagons, steam engine, jet, and the space shuttle.

We Shall Meet at the River, Elizabeth Boyd Vaughan; First Christian Church, 123 W. 9th St., inside; baptismal font mural.

WICHITA

1 in 6 Hungry, Ryan Bell and others, 2002 (No. 66).

11th St. Bridge Mural, Randal Julian, 1996; West River Blvd. and 11th St.; local fauna and fish; bas-relief.

42nd Street, Rick Regan, 2005; NY Cafe, Central and St. Paul Sts., inside; New York skyscraper scene.

Along the Garden Path, Vicky Terry, 2000; Art 'n Attick, 124 S. Emporia St., inside; garden scene.

American Flag, c. 2002; Graham Central Station, 10001 E. Kellogg St.; American flag waving.

Bacchanal di Pompeii and *Helen*, Sarah Scott, 2003; Art 'n Attick, 124 S. Emporia St., inside; inspired by "Old Master" painters.

Baseball Mural, Randal Julian, 1997; Lawrence Dumont Stadium, Maple and Sycamore Sts.; baseball; freestanding bas-relief.

Basketball Mural, students from Northeast Magnet School; Lynette Woodard Recreation Center, 2750 E. 18th St. N., inside; crowd with famous basketball players.

Bayou Mural No. 1, Steve Murillo, 1995; Red Beans Bayou Grill, 306 N. Rock, inside; outdoor life on the bayou.

Bayou Mural No. 2, Steve Murillo, 1999; Red Beans Bayou Grill, 7447 W. 21st St., inside; outdoor life on the bayou.

Be Still and Know That I Am God, Bernard Frazier with others, 1964 (No. 67).

Bison, Jonathan Clark, 2004; 2900 E. Central; bison grazing in field.

A Brighter Future for Children: Building on Our Heritage, Charles Shoemaker, 1998; Heartspring Conference Center, 8700 E. 29th. St. N., inside; collage of butterflies, clowns, and things children would enjoy; three-dimensional elements.

Cafe Bel Ami, Rick Regan, 1994; Cafe Bel Ami, 229 E. William St., inside; tribute to artist Auguste Renoir.

Cafe La Vie Mural, Rick Regan, 2004; Cafe La Vie, 6249 E. 21st St., inside; Riviera street scene.

Carry-out or Dine-in, Rick Regan, 2000; Beacon Restaurant, 909 E. Douglas St.; diner scene.

Chisholm Trail Mural, Steve Murillo, 2000; Chisholm Trail State Bank, 6160 N. Broadway St., inside; tells epic story of the Chisholm Trail with contemporary and archaeological imagery.

College Hill Swimming Pool Mural, Steve Murillo, 1998–2000; 304 S. Circle Dr.; decorative 1920s; ceramic tile.

Colonel James Jabara Memorial Plaque, Randal Julian, 1985; Colonel James Jabara Airport, 31st and Webb Sts.; commemorates Colonel Jabara, a World War II and Korean War pilot; freestanding bas-relief.

Crystal Ballroom Mosaic, Blackbear Bosin, early 1960s (No. 68).

Eaton Place Mural, Steve Murillo, 2001; Eaton Place, 517 E. Douglas St., inside, lobby (call on exterior phone for admittance during regular office hours); nineteenth-century realism shows Eaton building with street scene at 1886.

Emprise Bank Mural, Conrad Snider, 2001; Emprise Bank Main Offices, 257 N. Broadway St., inside, lobby; abstract pattern and color suggests chaos within order; ceramic tile.

Epic Center Mural, Steve Murillo, 2001; Epic Center, 301 N. Main St., inside, lobby; abstract mural with architectural theme.

The Evergreen Mural No. 1, **Ryan Drake and Cody Handlin with youth apprentices, 1995 (No. 69).**

The Evergreen Mural No. 2, Ryan Drake and Cody Handlin with youth apprentices, 1995; Evergreen Recreation Center, 2700 Woodland, inside; tribute to Diego Rivera.

Evergreen Park Library Mural and Sculpture, Albert Martinez, Raymond Olais, and Conrad Snider, 2003; Evergreen Park Library, 2601 N. Arkansas; the artwork incorporates local cultures and early American themes.

La Familia Murals, Susie Cunningham with community youth, 1996; La Familia Multicultural Community Center, 841 W. 21st St., both sides of patio wall; southwest landscape and world flags.

Field of Dreams, Rick Regan, 2005; Neighbors Restaurant and Bar, 2150 N. Amidon, inside; tribute to baseball.

Fiesta, Rick Regan, 1999; Margarita's Restaurant, 3109 E. Douglas; Mexican dancers.

Flight for Freedom (1994) and *To the Boys* (2002), Rick Regan; Roosevelt and Ross Pkwy.; salute to American West and 9/11 military salute to all veterans.

From Whence All Life, Blackbear Bosin, 1972; Farm Credit Bank Building, 245 N. Waco, inside, lower level; Native American cultural imagery (page 8).

Graffiti Mural, anonymous artists, 2005 (No. 70).

A Heritage of Faithfulness . . . A Future of Faith, Mark Pendergrass, 2004; Grace Baptist Church, 1414 W. Pawnee, inside; Jesus ascending/descending in clouds, Bible heroes, modern church.

Historical Collage Murals (two murals), Felix Jones, 1936; will be installed at the Kansas Aviation Museum, 3350 George Washington Blvd., inside; historical, transportation, and postal theme mural was originally painted for the Wichita post office but was instead installed in the Administration Building of the old airport.

The Journey Is the Reward; Hwy 54/E. Kellogg and Oliver Sts., underpass; illustrated poem; bas-relief.

KAKE-TV Mural, Steve Murillo, 1980; KAKE-TV, 1500 N. West, inside; history of local KAKE-TV station.

Kansas Daydreaming, Peggy Whitney and Terry Corbett, 1993 (No. 71).

* *Kansas Farming* (Richard Haines, 1936) and *Pioneers in Kansas* (Ward Lockwood, c. 1930s); U.S. District Court Building, 401 N. Market St., inside; agriculture, pioneer and Indian shooting, train, settlement.

Keep'n Kute Mural; Keep'n Kute, 17th and Spruce Sts.; graffiti-style sign for hair salon.

The Land of Oz, Mark Pendergrass, 2003; Vatterott College, 3639 N. Comotara, inside; themes include knowledge, opportunity, integrity, diversity, courage, and Wizard of Oz imagery.

Larkspur Mural, Steve Murillo, 1992 (No. 72).

Larkspur Mural, Steve Murillo (designer), Richie Bergen, Jonathan Clark, Kent Wilkenson; 904 E. Douglas, inside, Phyllis Diller Room; card game in architectural space.

The Lindbergh Panel, Lewis W. Clapp, 1935 (No. 73).

Lunch Hour 1943, Rick Regan, 1998; McClellan Hotel, 229 E. William, in back of building; bricked-in windows are painted with 1940s-era scenes.

Mamadeaux Murals, Rick Regan, 2003; Mamadeaux Seafood House, 606 N. Winterset, inside; Florida seascape.

John Marshall Middle School Mural, Denise Davis with students, 2005; John Marshall Middle School, 1510 N. Payne; children's imagery; tile mural.

Medicine Man, Rick Regan, 1976; Hunter Health Clinic, 2318 E. Central, inside; medicine man.

Medicine Songs, Rick Regan, 1986 (No. 74).

Medieval Fantasy, Jim Butler, 2001; Exploration Place, 300 N. McLean Blvd., inside, Once Upon a Castle Pavilion; medieval fantasy outside a troll's hideout.

Mediterranean Gardens, Rick Regan; Brownstone Grill, Harry and Hillside, inside; Mediterranean garden scene.

Moonlit, Jonathan Clark, 2003; Whiskey Creek Steakhouse, 233 N. Mosley, inside; coyote howling at the moon.

Murals for Fun and Faith, Mark Pendergrass, 2004; Living Word Outreach, 3033 S. Hillside, inside, three rooms and a stairwell; religious and wildlife themes.

New York, New York, Rick Regan, 2003; Fingers Piano Bar, 2120 S. Woodlawn, inside; New York City skyline, jazz singers.

Noah's Ark Mural, Susan Fellows, 2004; East Evangelical Free Church, 14725 East Harry, inside, children's education hall; biblical story of Noah's Ark.

O. G.'s Murals, 2000; O. G.'s Barber and Beauty Salon, 3121 13th St.; graffiti-style ad sign.

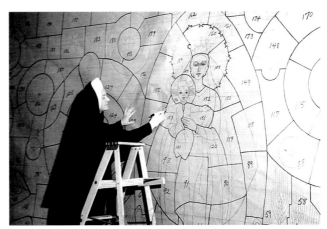

Sister Mary Fleurette working on her mosaic mural, early 1960s.

Olive Tree Murals (three murals), Steve Murillo, 1998, 1995, 1986; Olive Tree Restaurant, 2949 N. Rock Rd., inside; art historical references.

Our Lady of Kansas, Sister Mary Fleurette Blameuser, 1965 (No. 75).

Panera Mural, Steve Murillo, 1995; 1605 N. Rock Rd., inside; people on the floor making chalk drawings.

Personnages Oiseaux, Joan Miró, 1977 (No. 76).

Poppies, Jonathan Clark, 2003; Sunflower Shop, 607 W. Douglas, inside; Wizard of Oz themes.

River City Brewery—Bathroom Mural, Nathan Lambert; River City Brewery, 150 N. Mosley, inside, men's bathroom; three women who used to work at the brewery.

River City Brewery—Exterior Mural, Steve Murillo, 1993–1994; River City Brewery, 150 N. Mosley; turn-of-the-century images; trompe l'oeil painting.

River City Brewery—McHenry Mural; River City Brewery, 150 N. Mosley, inside, stairwell; prohibitionist Myra McHenry holding a beer.

Santa Fe Southwestern Chief, Rick Regan, 2000; Engine House Hobbies, 2745 Boulevard Plz.; train.

Solar Calendar, Steve Murillo, 2003–2004; Central Riverside Park, Nims and Murdock; Solar Calendar with stone and ceramic mural designs.

The Spirit of the Prairies, Arthur Sinclair Covey, 1915 (No. 77).

Sunflower Mural, Steve Murillo, 1999; Sunflower Bank, 21st and Tyler Sts., inside; abstract sunflower themes.

Timberline Mural, Mike Fallier, 1999; Timberline Steak House, 2243 N. Tyler, inside; Colorado mountain scenes.

Two Feathers, Rick Regan, 1989; El Torero Restaurant, 108 E. 2nd N., inside; Pueblo Indian scene.

Water Birds (two murals), Rick Regan, 1978; Mid-America All Indian Center, 650 N. Seneca, inside; Kiva area, waterbirds that come out of the fire to take messages to God (based on Native American Church spirituality).

Wheat Fields, Jonathan Clark, 2005; Whole Foods, 21st and Amidon Sts.; wheat fields.

Whiskey Creek Series, Steve Murillo, 1998; Whiskey Creek Steakhouse, 233 N. Mosley, inside; Wichita history.

Wichita High School North Murals, Bruce Moore with Terra Cotta Ornamental Works, c. 1928; Wichita High School North, 1437 Rochester (WPA funded the building); terra-cotta relief sculptures.

Wichita High School North Student Murals, high-school students; Wichita High School North, 1437 Rochester, inside building and on outside portable classroom; Native American and other themes.

Wichita History Murals (three murals), Steve Murillo, 1999; Hotel at Old Town, 830 E. 1st St., inside; Wichita history with a 1906 focus.

With Love to Diego Rivera, Rick Regan, 2005; Marco's Restaurant, 6600 W. Central, inside, dining areas and garden; tribute murals to the famous Mexican muralist Diego Rivera.

Wooden Heart, Rick Regan, 2000; Wooden Heart Antiques, Mosley and Douglas Sts.; turn-of-the-century street scene.

WINFIELD

American Legion Post 10 Eagles, Elizabeth Boyd Vaughan, 1997; 15 W. 10th St., faces north; eagle.

The Barn, Eddy Poindexter; Lumbert's Auto Sales and Salvage, three miles east from 9th and Main Sts., inside; barn and agriculture.

Comet Coca Cola, Marjorie Hall Bicker, 1998; 221 E. 9th St., faces east; cola ad with people watching comet with Coke sign in the center; bas-relief and acrylic.

Counties Map, Cowley County Courthouse; 9th St. between Loomis and Fuller Sts.; Kansas counties map.

English Cottage, Marjorie Hall Bicker, 1999; Island Park on N. Main St., exterior of restroom; painted to look like an English cottage with people in the doors and windows.

Hard at Work (two murals), Marjorie Hall Bicker, 1999; Webber Land Company, 810 Loomis; old-time depictions of people who work in the business.

Jumpin Juke Box, Marjorie Hall Bicker, 1998; 1017 Main St.; 1950s Juke Joint with three-dimensional figures.

Off the Beaten Path, Janice Krebbs; 208-A E. 9th St.; garden path.

Rural Scene, Eddy Poindexter; 1002 Main St.; agriculture.

Searching for Magic, Marjorie Hall Bicker, 2001 (No. 78).

The Story of Winfield, Sue Jean Covacevich, 1951 (No. 79).

Toto's, Elizabeth Boyd Vaughan assisted by Megan Bender, 1995; 314 W. 8th St.; *Wizard of Oz* characters.

Western Mural, Eddy Poindexter; Carma's Chuckwagon Cafe, 2862 85th Rd., inside; western imagery.

Wrap around Winfield, Marjorie Hall Bicker assisted by Claudia Lawson, 1998; Joe's Carpet Warehouse; Winfield heritage murals on three walls and roof.

NORTHWEST REGION

AGRA
The Rocket, Joel McCormack, 1987; Main St., faces northeast; 1950s Rock Island train "the Rocket" with local depot.

ATWOOD
Atwood Covered by Ocean, Atwood High School art class, 1992; Dunkers Radio and TV, 423 State St.; images include the courthouse and when Atwood was covered by ocean.

Garden Scene, K. J. H., 2001; Atwood Floral Shop, 204 S. 4th St., faces south; garden scene.

History of Rawlins County, Rudolph Wendelin, 1976 (No. 80).

Picnic after Harvest, Ryan Drake and Cody Handlin, 1997; 404 State St.; picnic in harvest landscape.

COLBY
Education in Thomas County, Kenneth Mitchell and others, 2001 (No. 81).

Nellie Kuska Mural, Cathy Gordon, late 1970s; Prairie Museum of Art and History, 1905 S. Franklin St., inside; portrait of Nellie Kuska who donated 30,000 artifacts to the museum.

Schroeder Family Mural, Kenneth Mitchell, late 1970s; Prairie Museum of Art and History, 1905 S. Franklin St., inside Cooper Barn; Schroeder family early settlement.

Stove Seller, Kenneth Mitchell, 1989; Colby Plaza, 505 N. Franklin St., inside, end of main hallway; 1908–1910 street scene with stove seller.

Wheat Mural, Bruce Bandy, late 1970s; Prairie Museum of Art and History, 1905 S. Franklin St., inside Cooper Barn; wheat field.

ELLIS
American Flag, Bill and Kathy Desaire, Wayne and Vera Haver, Anne Buchholz, 2001; Railroader Lanes and Dining Car, 203 E. 2nd St.; American flag and "God Bless America."

Ellis Economy, Blaine O'Dell, 1997; 815 Jefferson St.; Ellis economy, elevator, and oil.

Ellis Train Station, Shawn Beuchat, 1991; Railroader Lanes and Dining Car, 203 E. 2nd St.; old Ellis train and station.

Historical Murals, Rick Rupp; Kansas Granite Industries, 819 Dorrance St.; Ellis history.

Signal Lanterns, Lee Smith, 2000; Railroader Lanes and Dining Car, 203 E. 2nd St., inside; train signal lanterns.

GOODLAND

Chance, Choice, and Change, Dave Loewenstein with high school students, 1996; Goodland High School, 1209 Cherry, inside, second floor; what to do after high school.

Historical Plaque, Randal Julian, 2000; Goodland Tourist Center, eastbound Hwy 70 near Goodland; area history; small bas-relief.

* Rural Free Delivery, Kenneth M. Adams, 1937; Post Office, 124 E. 11th St., inside; mail carrier in horse-drawn carriage delivers mail to expectant rural family; oil on canvas.

Sunflowers after Vincent van Gogh, Cameron Cross, 2001 (No. 82).

HAYS

Hays Recreation Murals, Rick Rupp, 2000; Hays Recreation Commission, 1105 Canterbury St., inside and outside; recreation themes.

Historical Mural, Rick Rupp; Professor's Steak House, 521 E. 11th St., inside; Hays history.

Justice and Equality: An Evolving Legacy, Kris Kuksi, 2002; Ellis County District Court, 1204 Fort St., inside, courtroom; justice themes.

Presidential Mural, Tom Moorhous, ongoing from 1976; Fort Hays State University, Wiest Hall, Building 1 on 600 Park St.; caricatures of presidents.

Protect Our Water Quality, Rick Rupp and volunteers, 2001–2003 (No. 83). (Additional project murals on bridge supports at 27th and Donald Sts., 13th and General Custer Sts., and 22nd and General Custer Sts. in 2001; 21st and Anthony Sts., 17th and Harvest Sts. on Indian Trail between 26th and 27th, and 27th and Lincoln Sts. in 2003.)

Saloon, Chad Haas, 2000; Horseshoe Bar and Grill, 8th and Vine Sts.; Old West saloon poker game.

Summer, Chad Haas, 2001 (No. 84).

HOXIE

Roller Coaster Mural, John Scott with other high-school student assistants, late 1970s; Utah and Main Sts.; agriculture, tornado, hog, and bull on roller coaster.

MORLAND

The Lady's Name Discovers Morland's Past, Jack Curran, 1993; Citizen's State Bank, 511 W. Main St.; depicts plants and animals found from an archaeological dig in the area.

NORTON

Justice Enthroned, David Overmyer, 1929; Norton County Court House, 105 S. Kansas, inside; allegorical justice figure.

OAKLEY

Processions of the Prairie, Dan Burgevin; Fick Fossil Museum, 700 W. 3rd St., inside; Kansas inland sea and current Kansas prairie.

Pioneer and Native American, Phyllis Hooker; Fick Fossil Museum, 700 W. 3rd St., inside; prairie landscape with pioneer and Native American encounter.

PHILLIPSBURG

Activities Mural, Sherry Gillihan, c. 1998; Horseshoe Bar and Grill, 667 4th St.; area sports and activities.

STOCKTON

First Train, Kevin Thayer, c. 1995; Main and Walnut Sts.; the first train into Stockton.

Places in Rooks County, Artist Unknown, 1920s (No. 85).

WAKEENEY

North Pole Park Mural, Edna Mae Deines; 204 Hazel St.; snow and pine trees as part of North Pole Park.

North Pole Village, Laurie Albin, 1997; 124 N. Main St.; a Charles Dickens Victorian neighborhood.

SOUTHWEST REGION

BUCKLIN

Centennial, Charlene Kirkpatrick and Don Bolinger, 1987; 115 N. Main St., faces north; 1887 view of Main St. looking north toward railroad.

COLDWATER

Museum Mural, Stan Herd, 1986; Comanche County Museum, 100 block of Main St.; design is based on Herd's 1980 cover for a book about the county's history.

COPELAND

Prairie Learning, Allan Bailey and Travis Bailey, 1992; Copeland Public Library, Santa Fe, faces north; schoolchildren walking in Kansas landscape with train.

DIGHTON

First House of Lane County, **Mary Alice Bosley, 1961 (No. 86).**

DODGE CITY

Area Landscape, Ted Carlson, 1974; Ace Hardware, 401 W. Trail, inside; agricultural landscape.

Dusk on the Santa Fe Trail, Stan Herd, 1982; Dodge City Public Library, 1001 2nd St.; covered wagon and campfire.

Harvest through the Twentieth Century, Ted Carlson, 1957 (No. 87).

Kansas Harvest, Stan Herd, 1986 or 1987; Dodge House Convention Center, 2408 W. Wyatt Earp Blvd., inside; threshing scene.

The Old Stagecoach of the Plains, Stan Herd, 1979, restored 2001; Bank of America, 2nd and W. Spruce Sts., faces south; modeled after Frederic Remington's *The Old Stagecoach of the Plains.*

Our Lady, Lucille Hopkins, 1986; Our Lady of Guadalupe Church, on I between Ash and Hickory Sts.; small freestanding mural of Our Lady painted on tiles.

ELKHART

Santa Fe Trail, Charles Goslin; Morton County Historical Museum, U.S. 56 and Ave. A, inside; the Santa Fe Trail, Rock Creek crossing.

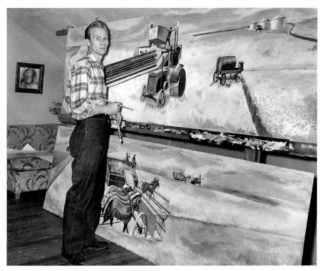

Ted Carlson working on his mural for the Dodge City Co-op, 1957.

GARDEN CITY

An Oasis on the Plains, Dave Loewenstein with community volunteers, 2005; 112 Grant; cultural influences (among them Hispanic, Vietnamese, and European) are symbolized through kites aloft over the high plains.

Rural Landscape, Stan Herd; Area Mental Health Center, 111 E. Spruce St., inside; conference room (by appointment, call 1-620-276-6470); rural landscape.

Tornado, Mallory Dignor, 2003; Bonnie's Kitchen, 1265 Solar Ave., west wall; agriculture, tornado, airplane.

Train, Chrissell Ricard, 2005; Bonnie's Kitchen, 1265 Solar Ave., west wall; train, agriculture.

United We Stand, Holcomb Kansas school children, 2002; St. Catherine Medical Building, 310 E. Walnut, inside, lobby; agriculture, Kansas, children.

GREENSBURG

Dinosaurs, Amy Christenson; Delmer Day Elementary School, 600 S. Main St.; dinosaurs.

Farm Scene; Greensburg Tractor and Implement, 721 W. Kansas (U.S. Hwy 54); farm scene; carved brick.

Garden Scene; Main St. beside Kiowa County Library; windmill, garden.

HUGOTON

Fishing, Roger Lynch; 1012 S. Main St.; fishing theme.

Southwest Kansas, Roger Lynch, c. 1980s; Dominoes Bar and Grill, 506 S. Main St.; cowboys.

JETMORE

The Home Place, Jan (Cambell) Schaffer with high-school students, 1982; Jetmore Lumber Yard, Main St.; the home place of lumber yard owner Junior Steinbring.

KINSLEY

Kinsley Carnival Mural, Jessica White-Saddler, 1999 (No. 88).

Window Murals, Larry Caldwell with high-school students; 111 and 113 E. 6th St., window murals; imagery is based on former tenants and includes a lawyer, birdcage, father and daughter, mother sewing, doctor, and insurance business.

LARNED

A section from *The First Fifty Years of Barton County*, Pat Potucek, 1974; Santa Fe Trail Center, two miles west of Larned on Hwy 156, inside (call ahead as the mural section may be in storage or on view); depicts Barton County history.

Bertha's Backyard, Deena Dent with assistants Loretta Mathis, Mary Alice Skelton, Terri Adams, Kathy Smith, Jessica Smith, Courtney Cormack, Marcheta Jacobson, Glenda Eye, Afton Eye, Russell Linderer, Sarah Taylor, Sally Byer, Lindsay Sooby, and Larissa Spare, 2003; 501 Broadway; garden scene.

Boy Scout Mural, Mike Pivonka and Mike Debusk with community help; 815 Broadway; Boy Scout overlooking mountain scene and scout patches.

LEWIS

Casey Claire Memorial Mural, Dennis Burghart, 1999; Lewis School, 502 Sunnyside, inside, main entrance; waiting for the school bus.

LIBERAL

Entrada, Stan Herd, 1979, 1986 (No. 89).

Pancake Race (outside) and Early Liberal (inside), Stan Herd, 1983; First National Bank, 324 N. Kansas, outside and inside lobby; commemorates Liberal's Pancake Day; scene of early Liberal and how the town got its name.

MEADE

Landscape, Pat Denison, Sue Copeland, Kathy Schafer, Liz Roush, 1985; 138 W. Carthridge; area landscape.

MINNEOLA

American Flag, c. 2001; barn, Hwy 54 just outside of Minneola; American flag.

Farm Landscape, Pat Denison, Sue Copeland, Kathy Schafer, Liz Roush, c. 1984; southwest corner of Main St. and Hwy 54, faces north; landscape, farm.

Historic Landscape, Pat Denison, Sue Copeland, Kathy Schafer, Liz Roush, 1984; southeast corner of Main St. and Hwy 54, faces north; landscape, teepees, wagon wheel.

NESS CITY

Rural Landscape, Catherine McIntosh, 2005; Pennsylvania and Chestnut Sts.; rural landscape.

OFFERLE

The Saga of the Santa Fe, Dennis Burghart, 1991 (No. 90).

PLAINS

Meade County Farm, Stan Herd, 1980; Plains State Bank, 411 Grand, bank drive-through; early southwest Kansas agriculture.

PROTECTION

Rural Protection, Stan Herd, 1984; 226 Main St., faces south; landscape, farming, and Protection (also see the Stan Herd museum in Protection's public library).

SPEARVILLE

Main St. Scene; next to 407 Main St.; old train station and Main St.

SYRACUSE

Syracuse Murals (four murals), Mike Fallier, 1990s; all visible from downtown stoplight; western scenes and wagon trains, Cavalry Honor Guard, settler on horseback with Indian woman.

ULYSSES

Old Downtown, Jill Clinesmith, 1991; Grant and Main Sts.; old downtown.

Ulysses Industries, Armando Minarez, 2005; Patterson Ave.; gas, oil, cattle, and agriculture.

WILMORE

Naming Wilmore, Stan Herd, 1987; grain elevator, corner of Taft and Railroad Sts., faces south; two men on horseback who flipped a coin to see who got to name the town (see photo, page 9).

Welcome to Wilmore, Jill Metzer, Trish Snyder, Betty Yost, Wanda Booth, Barbara Delaney; corner of Taft and Railroad; welcome sign with hotel and garden.

Sources

Introduction

Cockcroft, Eva, John Pitman Weber, and James Cockcroft, *Toward a People's Art: The Contemporary Mural Movement* (Albuquerque: University of New Mexico Press, 1988).

Marling, Karal Ann, *Wall-to-Wall America: A Cultural History of Post-Office Murals in the Great Depression* (Minneapolis: University of Minnesota Press, 1982).

Imagery and Identity in Kansas Murals

Brundage, Alan (mayor of Argonia), telephone interview with Lora Jost, 15 October 2005.

Eikleberry, Leslie (director of public relations, Kansas Wesleyan University, Salina), telephone interview with Lora Jost, 12 August 2005.

From Whence All Life (Wichita, Kans.: Farm Credit Bank Building). Pamphlet.

"Go Home: Trends Affecting Our Towns," Public Broadcasting System, www.pbs.org/livelyhood/ourtowns/trends.html (accessed 15 October 2005).

Jost, Jerry (of the Kansas Rural Center), email correspondence with Lora Jost, 14 October 2005.

Kendall, M. Sue, *Rethinking Regionalism: John Steuart Curry and the Kansas Mural Controversy* (Washington, D.C.: Smithsonian Institution Press, 1986).

Resolution in memory of John Steuart Curry, Kansas Senate Resolution 1809, 1992.

Swann, Marjorie, and William M. Tsutsui, "John Steuart Curry: A Portrait of the Artist as a Kansan," in Virgil W. Dean, ed., *John Brown to Bob Dole: Movers and Shakers in Kansas History* (Lawrence: University Press of Kansas, 2006), 241–252.

Wright, Barbara (tourism advocate in Anthony), email correspondence with Lora Jost, 25 August 2005.

Kansas Murals: Northeast

Abbot's Chapel Mural

"Brother's Art in New Chapel," *Abbey News*, December 1938, p. 38.

Hellman, John Steele, "Portrait of a Liturgical Artist," *St. Louis Review*, 28 November 1958.

Hickey, Regis F., O.S.B., "Wagner, Art and Crafts," *Kansas Monks*, Vol. 5, No. 8 (1996).

Schultz, Father Blaine, O.S.B., interview with Dave Loewenstein, 6 March 2002.

Trinity and *Episodes of Benedictine Life*

Hickey, Regis F., O.S.B., "Charlot: Loved Man of Art," *Kansas Monks*, February 1995.

Schultz, Father Blaine, O.S.B., interview with Dave Loewenstein, 6 March 2002.

Thompson, Karen, "Jean Charlot: Artist and Scholar," *Jean Charlot Collection*, http://libweb.hawaii.edu/libdept/charlotcoll/charlot.html (accessed 25 June 2005).

Oregon Bound, Fall Hunt, and *Kansas Wildlife*

Martin, Cynthia, telephone interview with Dave Loewenstein, 16 April 2004.

Oregon Trail Nature Park (brochure), published by Westar Energy.

Stratton, Lori, "Oregon Trail Nature Park," *Kansas! Magazine*, 2nd issue, 1997, pp. 25–27.

Gypsum on the Blue

"Alcove Springs and the Oregon Trail," *Blue Skyways*, Kansas State Library, http://skyways.lib.ks.us/history/alcove.html (accessed 23 June 2005).

"Alcove Spring Today," Alcove Spring Preservation Association, www.angelfire.com/in/lassie/alcovespring.html (accessed 23 June 2005).

"Blue Rapids, Kansas," Blue Rapids Chamber of Commerce, www.lasr.net/pages/city.php?City_ID=KS0705009 (accessed 23 June 2005).

"The Gypsum Industry in Blue Rapids," *Blue Skyways*, Kansas State Library, http://skyways.lib.ks.us/towns/BlueRapids/gypsum.htm (accessed 23 June 2005).

Ruetti, Oretha. "Not One, but Two, Steamboats Operated at 'Gem City,'"
Marysville Advocate, www.mvleadvocate.com/web/isite.dll?1050521860880
(accessed 23 June 2005).
Winkenwader, Kenny, telephone interview with Lora Jost, 2 May 2004.

Farmland Mural
The Farmland Mural and *Farmland Industries' World Headquarters Mural* (information handouts), 2004 (Bonner Springs, Kans.: National Agriculture Center and Hall of Fame Archives).
Frederic James, a Painter from Kansas (Kansas City, Mo.: Nelson-Atkins Museum of Art, 1986).
"Howard A. Cowden," Cooperative Hall of Fame, www.cooperoes.org/inductees/cowden.html (accessed 23 June 2005).
Script used for visitors to Farmland Industries (Bonner Springs, Kans.: National Agriculture Center and Hall of Fame Archives).
Twiddy, David, "Farmland Transplants Mural to New Home at Ag Center," *Business Journal*, www.kansascity.bizjournals.com/kansascity/stories/2004/04/26/story6.html (accessed 24 June 2005).

History of Brown County
Allerton, Ron, "Biographical Sketch" (Hiawatha, Kans.: Brown County Historical Museum Archives).
Descriptive plaque mounted next to mural.
Kansas Farm Facts 2004. www.nass.usda.gov/ks/ffacts/2004/ffacts.htm#start (accessed 4 September 2005).

Changing Horses for the Pony Express and Picnic in Kansas
McManigal, John W., U.S. postmaster, descriptive panel at Horton, Kansas, post office, 2 February 1957.
Perry Huston & Associates, Inc., descriptive panel at the post office, Center for the Conservation of Art, Fort Worth, Texas.
St. Joseph Museums, Inc. *The Pony Express Museum*. www.stjosephmuseum.org/PonyExpress/history.html (accessed 23 June 2005).

Anthology of Argentine
Argentine Mural. www.arthes.com/community/research/mural/ (accessed 18 August 2005).

Sanchez, Mary, "Argentine's History to Get Colorful Tribute," *Kansas City Star*, 2 June 1998.
Sanchez, Mary, "Colorful Look at Part of KCK 'Anthology of Argentine' Mural by Team of Artists Is to Be Dedicated Today," *Kansas City Star*, 15 August 1998.

Crossroads
Toombs, Michael, interview with Lora Jost, 18 September 2004.

Justice and The Prairie
Descriptive plaques next to murals.
Haas, Richard, *The City Is My Canvas* (New York: Prestel, 2001).

Pillars of Hope and Struggle
Clevenger, Christal, telephone interview with Lora Jost, 24 January 2005.
Loewenstein, Dave, interview with Lora Jost, Lawrence, 19 January 2005.

A Thousand Miles Away
Cordley, Richard, "Lizzie and the Underground Railroad," in *Freedom's Crucible: The Underground Railroad in Lawrence and Douglas County, Kansas, 1854–1865: A Reader*, ed. Richard B. Sheridan (Lawrence, Kans.: University of Kansas, 1998), pp. 67–75.
Loewenstein, Dave, interview with Lora Jost, 19 January 2005.

Auditorium Mural
Ayers, Geraldine, telephone interview with Lora Jost, 8 November 2004.
Combest, Hannes, telephone interview with Lora Jost, 19 February 2005 and 28 July 2005.
Franklin Gritts (Oou-nah-ju-sah) (three-page biography), O. B. Jacobson Collection, Western History Collections, University of Oklahoma Library.
Gritts, Galen, telephone interview with Lora Jost, 6 November 2004.
Gritts, Galen, email correspondence with Lora Jost, 19 July and 26 July 2005.
Heil, Mike, "Overland Man Garners Overdue Acclaim for 53-Year-Old Mural," *County Star Journal*, 7 September 1994.
"Murals to Adorn Auditorium Walls," *Indian Leader*, Vol. 44, No. 9 (24 January 1941), p. 1.
Stillman, Dara Beth, telephone interview with Lora Jost, 2 November 2004.
Wyckoff, Lydia L., ed., *Visions and Voices: Native American Painting from the*

Philbrook Museum of Art (Tulsa, Okla.: Philbrook Museum of Art, Inc., 1996), pp. 19–49.

Berkosaurus and Out Standing in His Field

Baker, Jim, "The Big Picture," *Lawrence Journal-World*, 13 March 2000.

McCoy, Missy, interview with Dave Loewenstein, 23 May 2004.

Ranney, Mick, essays from Footprints mail order catalogs, Fall 2000, Spring 2001, and Summer/Fall 2001.

Cranes

Hope, Jack, telephone interview with Dave Loewenstein, 24 March 2005.

Jost, Lora, interview with Dave Loewenstein, 26 January 2005.

Make Your Life in Harmony

Carlson, Amy, interview with Lora Jost, 24 March 2004.

Life Changes

Faus, Joe, Cathy Ledeker, and apprentice artists. *Life Changes* descriptive statement on the wall beside the mural.

Ledeker, Cathy, interview with Lora Jost, 31 March 2004.

Lewis, Jim, telephone interview with Lora Jost, 2 April 2004.

Starry Way

Dary, David, *Pictorial History of Lawrence, Douglas County, Kansas* (Lawrence, Kans.: Allen Books, 1992).

Helm, Dennis, "Sea Above, Sea Below: Lawrence Artists and the Archetype of the Central Region," *Kansas Quarterly*, Vol. 24, No. 1 (1993), p. 53.

Kellas, Judi Geer, interview with Dave Loewenstein, 7 April 2004.

LeComte, Richard, "Powerful Paintings Are Legacy Left by Artist," *Lawrence Journal-World*, 5 June 1992, p. 6.

First City Mural

Bates-Lamborn, Debbie, telephone interview with Dave Loewenstein, 21 July 2005.

Federal Writers' Project of the Work Projects Administration, *The WPA Guide to 1930s Kansas,* new edition, 1984, University Press of Kansas, Lawrence.

Johnston, J. H., III, *Early Leavenworth and Fort Leavenworth: A Photographic History* (Leavenworth, Kans., 1977).

"Preserving the Past through Art," *Leavenworth Times*, 5 October 2003.

Young, Michael, telephone interview with Dave Loewenstein, 19 July 2005.

We Are the Dream

Kreps, Matt, "Mural behind Hale Move," *Kansas State Collegian*, 9 October 1997.

Minorities Resource and Research Center Newsletter (Farrell Library, Kansas State University, Manhattan), January 1980.

The Industries, Agriculture, The Arts, and The Home

Hahn, Rick, "David Hicks Overmyer: A Kansas Muralist," *Topeka Performing Arts Center Playbill*, 1991.

"Library Murals for College Accepted by President," *Kansas Industrialist*, 31 October 1934.

Sodders, Lisa M. "Larger Than Life," *Topeka Capital-Journal*, 8 September 1996.

Sottosanti, Karen, "New Life for Old Art," *Manhattan Mercury*, 23 July 1996.

Student Achievement

Bransby, Eric, telephone interview with Dave Loewenstein, 30 June 2005.

Computing and Information Sciences, Kansas State University, "The History of Nichols Hall," www.cis.ksu.edu/Misc/Tour/about.nichols.shtml (accessed 5 September 2005).

Eiland, William Underwood, "Eric Bransby: Draftsman and Muralist," in *Figurative Connections: Selected Works by Eric Bransby* (Athens: Georgia Museum of Art, 2004).

D. O. Bacon's Art Gallery

Cole, Wes, telephone interview with Lora Jost, 19 July 2004.

"Saving D. O. Bacon's Gallery," article accompanying mural, author and publication information unknown.

Stephens, Norma, telephone interview with Lora Jost, 20 July 2004.

Cottonwood Falls Monarch Mural

Henriksen, Alicia, "Developer Takes Charge of Abandoned Ottawa School," *Lawrence Journal-World*, 18 November 2004.

Howe, William, interview with Dave Loewenstein, 15 December 2004.

Potawatomi Children

Prairie Band Potawatomi Nation, "History," www.pbpindiantribe.com/
history.htm (accessed 23 June 2005).
White Hawk, Laurie H., telephone interview with Lora Jost, 11 December 2003.
White Hawk, Laurie H., www.whitehawkgallery.com/bio.php (accessed
25 November 2003).

Sabetha Bank Murals

"Bank Celebrates Saturday," *Sabetha Herald*, 13 May 1965.
Mishler, Jarry, telephone interview with Lora Jost, 30 March 2005.

Men of Wheat

Carlisle, John C., *A Simple and Vital Design: The Story of the Indiana Post Office
Murals* (Bloomington: Indiana University Press, 1995).
Hiltgen, Ken, Seneca postmaster, interview with Dave Loewenstein, 7 March 2002.
Jones, Joe to Seneca postmaster W. S. Kauffman (letter), 20 November 1939.
Marling, Karal Ann, *Wall to Wall America: A Cultural History of Post Office Murals
in the Great Depression* (Minneapolis: University of Minnesota Press, 1982).

A Look Back

Goslin, Charles, interview with Dave Loewenstein, 29 December 2004.
Ladesich, Jim Edward, "Charles Goslin: Painting Historian," *Kansas Magazine*, 1st
issue (1974), pp. 7–9.
Mural brochure (Shawnee, Kans.: City Hall Archives).

St. Mary's Church Murals

Information brochure, St. Mary's Church (available at the church).
St. Mary's Church website. www.stmarysbenedict.org (accessed 7 August 2005).

Aspects of Negro Life: Slavery through Reconstruction (after Aaron Douglas)

Hiller, Karen, interview with Dave Loewenstein, 22 April 2005.
Kirschke, Amy Helene, *Aaron Douglas: Art, Race, and the Harlem Renaissance* (Oxford: University of Mississippi Press, 1995).

Century of Service

"Anthony Benton Gude: An Artistic Legacy," www.anthonybentongude.com
(accessed 23 June 2005).
Gude, Anthony Benton, telephone interview with Dave Loewenstein,
21 November 2003.
Kendall, Dave (producer), "Muralists," *Sunflower Journeys* (television program),
KTWU Channel 11 (Kansas), 2003.

The Tragic Prelude

Kendall, M. Sue, *Rethinking Regionalism: John Steuart Curry and the Kansas Mural
Controversy* (Washington, D.C.: Smithsonian Institution Press, 1986).
Lambert, Don, "Men of Controversy: John Brown and John Steuart Curry," *American Artist* (March 2004), www.myamericanartist.com (accessed 23 June 2005).
Lambert, Don, "Remembering John Steuart Curry," *Kansas Magazine*, 4 (1992),
pp. 4–7.

Kansas State Capitol Second Floor Rotunda Murals

Hinnen, Dean, "Mural Plan Born Here," *Hutchinson News*.
Marshall, John, "Curry Mural Completion Call," *Hutchinson News*.
Potucek, Pat, interview with Dave Loewenstein, 21 February 2004.
Richardson, Jim, "For as Long as There Is a Kansas: Lumen Winter Paints the
Statehouse Murals," *Kansas! Magazine*, 1st issue (1978), pp. 2–6.

Vermillion Murals

Dannels, JoAnn, telephone interview with Dave Loewenstein, 8 August 2005.
Schober, Daisy L., telephone interview with Dave Loewenstein, 8 August 2005.
Vermillion Public Library website, http://skyways.lib.ks.us/library/vermillion
(accessed 7 August 2005).

Columbian Exposition Murals

The Columbian Theater website, www.columbiantheatre.com (accessed 23 June
2005).
Morris, Raymond, Colonel USAF (Ret.), interview with Dave Loewenstein, 26
February 2004.
Morris, Raymond, Colonel USAF (Ret.), "The History of the Rodgers Building,
Columbian Theater and Columbian Murals," *Classic Movie Theaters of Kansas*,
http://moviehousehistory.tripod.com/wamego.htm (accessed 23 June 2005).

Kansas Murals: Southeast

The Story of Baxter Springs
Abbott, Phyllis, email correspondence with Lora Jost, 3 April 2004.
Collins, Paula Blincoe, telephone interview with Lora Jost, 10 March 2004.
Smith, J. C., "Brick Sculpture Depicts Baxter Springs Heritage," *Baxter Springs News*, 24 September 2004.

Aviation History
Coffeyville Convention and Visitors Bureau. *Coffeyville, Kansas, Historical Murals* (Coffeyville, Kans.: Chamber of Commerce). Pamphlet.
Sprague, Susie, telephone interview with Lora Jost, 10 July 2004.
Turner, Ursula, "People in Focus." *Coffeyville Journal*, 20 June 2002.
Wade, Bernard, telephone interview with Lora Jost, 8 September 2004.

Our Flag Was Still There
Dailey, Marilyn, telephone interview with Dave Loewenstein, 31 December 2004.
Emporia Area Chamber of Commerce and Convention and Visitors Bureau, www.emporiakschamber.org/veterans (accessed 30 December 2004).
Larson, Gwendolynne, "Signed and Sealed," *Emporia Gazette*, 7 November 2003.

Community Trees
Reed, Jim, telephone interview with Lora Jost, 29 January 2005.

Kittens on the Prairie
Logan, Robert, telephone interview with Lora Jost, 1 May 2004.
Olson, Marty, telephone interview with Lora Jost, 23 August 2004.

Village of White Hair
Allen, Joan, telephone interview with Lora Jost, 3 April 2004.
Description of mural (Oswego, Kans.: Oswego Historical Society Archives).
Graves, W. W. *History of Neosho County* (St. Paul, Kans.: Journal Press, 1949), pp. 2–27.
Horner, E. Marie, telephone interview with Lora Jost, 3 April 2004.
"Labette County," http://skyways.lib.ks.us/genweb/archives/1912/l/labette_county.html (accessed 3 September 2005).

"The Osage Nation," www.osagetribe.com (accessed 25 June 2005).

Pittsburg State Centennial Mural
Cleland, Joan, telephone interview with Lora Jost, 26 April 2005.
Smoot, Joseph Grady, "Pittsburg State University Centennial Mural 1903–2003."
Sullivan, Olive L., "Local Artist Braves Elements to Finish PSU Mural," *Morning Sun*, www.morningsun.net/stories/080804/loc_20040808055.shtml (accessed 25 April 2005).
Switlik, Mark, telephone interview with Lora Jost, 23 April 2005.

Solidarity, March of the Amazon Army—The Women Who Marched on Behalf of Alexander Howat, the Kansas Coal Miners, and the Labor Struggle, 1921
Knoll, Linda, telephone interview with Lora Jost, 24 April 2004.
Wildcat, Tolly Smith, "Mining History for Art: The Story of Wayne Wildcat's *Solidarity*," *Journal of the West*, Vol. 43, No. 1 (Winter 2004).
Wildcat, Wayne, and Tolly Smith Wildcat, interview with Lora Jost, 21 April 2004.
Wildcat, Wayne, website, www.waynewildcat.com (accessed March 2004).

Kansas Murals: North Central

Patriotic Silo
Lewis, Karen, telephone interview with Lora Jost, 12 December 2004.
Lewis, Karen, "Patriotic Silo," *www.patrioticsilo.com* (accessed 24 June 2005).
Sullivan, Amy, "Special Silo: Patriotism Spurs Abilene Woman to Finish Project," *Salina Journal*, 5 September 2002.

Kansas Stream
Lindquist, Emory, *Birger Sandzén: An Illustrated Biography* (Lawrence: University Press of Kansas, 1993).
Michael, Ronald, Curator of the Birger Sandzén Memorial Gallery, telephone interview with Dave Loewenstein, 23 October 2004.
Registration Form for Belleville Post Office to be placed on the National Register of Historic Places, 8 December 1988.

The Napoleon Curtain

Brockman, Lance, University of Minnesota, email correspondence with Lora Jost, 25 October 2004.
King, Lyndel, and C. Lance Brockman, *Twin City Scenic Collection Exhibit Catalog* (Minneapolis: University Art Museum, University of Minnesota, 1987).
Lowell, Rita, ed., *The Brown Grand Theatre: Commemorative Program Book* (Concordia, Kans.: Blade-Empire Publishing Company, 1980).
Sutton, Susan L., telephone interview with Lora Jost, 25 April 2004.
Sutton, Susan L., *The Brown Grand Theatre.* Pamphlet.
Sutton, Susan L., "Napoleon Featured on Grand Drape: Painted Scenery and Turn-of-the-Century Theatre," *Brown Grand Gazette*, October 1992, p. 2.

Pictorial View of Courtland

Johnson, Herb, telephone interview with Dave Loewenstein, 12 February 2004.
Mikesell, Pat, telephone interview with Dave Loewenstein, 12 February 2004.
"Welcome to Courtland," www.courtland.net (accessed 25 June 2005).

Arrival of the First Train in Herington—1885

National Register of Historic Places—Nominating Form, Louis and Elsie Freund Papers, University of Arkansas Libraries, 1989. http://libinfo.uark.edu/SpecialCollections/findingaids/freund.html (accessed 23 June 2005).

Points of Contact

Points of Contact (Salina, Kans.: First Presbyterian Church). Flyer.
Rhea, Martha, telephone interview with Lora Jost, 25 January 2004.
Snider, Conrad, telephone interview with Lora Jost, 14 January 2004.

Procession

Coady, Frank, telephone interview with Lora Jost, 28 September 2004.
Hake, James E., "The History of the Cathedral Parish" (Salina, Kans.: Catholic Diocese).

What Do You Love about This Place

Wegscheider, Jane Beatrice, telephone interview with Lora Jost, 7 July 2004.

Kansas Murals: South Central

Argonia's Past and Present

Billington, Monroe, "Susanna Madora Salter—First Woman Mayor," *Kansas Collection: Kansas Historical Quarterlies*, Vol. 21, No. 3 (1954), www.kancoll.org/khq/1954/54_3_billington.htm (accessed 2 July 2005).
McCaffrey-Jackson, Cristi, telephone interview with Lora Jost, 10 March 2004.

Summit Street Windows

"Biography of Cleo Graves," Art-for-U, www.art-for-u.com (accessed 15 December 2004).
Graves, Cleo, telephone interview with Dave Loewenstein, 8 February 2005.

Box Turtle—State Reptile

Capron, Marty, telephone interview with Lora Jost, 3 July 2004.
Miller, Larry, "An Album of Science Related Photos by Larry L. Miller of Wakarusa, Kansas," http://members.tripod.com/tcslacerta/tcsphotos (accessed 15 June 2005).
Miller, Larry, "Getting an Official State Reptile for Kansas: The Ornate Box Turtle Story," unpublished paper (14 April 1987).
Miller, Larry, telephone interview with Lora Jost, 2 July 2004.

The Glory of the Hills (Flint Hills Landscape)

Epp, Phil, phone interview with Dave Loewenstein, 10 February 2005.
Epp, Phil, website, www.philepp.com (accessed 7 February 2005).
Koch, Nicole, "Flint Hills Come Alive with El Dorado Mural," *Wichita Eagle*, 2 January 1999.
Thiesen, John D., and Ami Regier, "An Interview with Artist Phil Epp," *Mennonite Life*, December 2003.

The First Fifty Years of Barton County

Berry, Mike, "Bartering Art a Way of Life," *Wichita Eagle*, 17 April 2000.
First National Bank in Great Bend: 1974 Annual Report.
Melland, Dorothy, "Story of Big County Told in Great Bend Murals," *Hutchinson News*, 8 December 1974, p. 11.
Potucek, Pat, telephone interview with Lora Jost, 21 February 2004.

Grow with Us
Dunkelberger, Karen, telephone interview with Lora Jost, 12 November 2003.

Wheat Center and The Generation
"Application for National Register of Historic Places," date and author unknown (Hoisington, Kans.: Post Office Archives).
Booth, Bob, telephone interview with Lora Jost, 13 November 2003.
Glynn, Robert, telephone interview with Lora Jost, 8 September 2004.
Park, Marlene, and Gerald E. Markowitz, *Democratic Vistas: Post Offices and Public Art in the New Deal* (Philadelphia, Pa.: Temple University Press, 1984).
"Sketch When Idea Strikes," date and author unknown (Hoisington, Kans.: Post Office Archives).
"The Stone City Art Colony and School 1932–1933: Dorothy Tomlinson Marquis," www.mtmercy.edu/stone/marquis.htm (accessed 7 July 2005).

Dream
Bova, Ben, *Vision of the Future: The Art of Robert McCall* (New York: Harry N. Abrams, 1982).
Kansas Cosmosphere and Space Center. www.cosmo.org/news/archives.html (accessed 28 July 2005).
McCall, Robert, telephone interview with Lora Jost, 23 July 2005.
McCall, Robert, one-page biography unpublished, provided by McCall.
Moran, Jerry, *Tribute to Mrs. Patricia Brooks Carey of Hutchinson*. www.house.gov/moranks01/speech2003/sp010803PattyCarey.html (accessed 28 July 2005).
"Robert McCall: Celebrating 100 Years of Powered Flight." University of Richmond Museums, Joel and Lila Harnett Museum of Art. http://oncampus.richmond.edu/cultural/museums/hmaexhibitions/mccall.html (accessed 28 July 2005).

Pioneer Center Mural
Mayfield, AvNell, telephone interview with Lora Jost, 8 January 2005.

Our Lady of Guadalupe Shrine
Boor, Colin, Rev., telephone interview with Lora Jost, 8 November 2004.
Curiel, Edward, telephone interview with Lora Jost, 10 December 2004.
"Juan Diego Cuauhtlatoatzin," Fact Index, www.fact-index.com/j/ju/juan_diego_cuauhtlatoatzin.html (accessed 23 June 2005).

"The Story of Juan Diego," St. Juan Diego Specialty Page, Discount Catholic Store, Inc. www.discountcatholicstore.com/juan_diego.htm (accessed 23 June 2005).

Our Founders in Architectural Heaven
Swensson, Eldon B., informational plaque next to mural.
Swensson, Eldon B., telephone interview with Dave Loewenstein, 28 March 2005.

Civic Mural of Marquette
Lindfors, Allan, telephone interview with Lora Jost, 29 April 2005.

La Vida Buena, La Vida Mexicana (The Good Life, Mexican Life)
Olais, Patrice, and Raymond Olais, interview with Lora Jost, 13 March 2004.
Reeves, Betty, "Mural Illustrates Local Mexican Heritage," *Newton Kansan*, 1 August 1978.
"Viva Cesar E. Chavez!" Cesar E. Chavez Institute, www.sfsu.edu/~cecipp/cesar_chavez/chavezhome.htm (accessed 23 June 2005).

1 in 6 Hungry
Adair, Connie Pace, telephone interview with Lora Jost, 21 March 2004.
Bell, Ryan, telephone interview with Lora Jost, 8 April 2004.
Slusser, Chris, telephone interview with Lora Jost, 21 March 2004.

Be Still and Know That I Am God
Bernard Frazier, Sculptor (resume) (Tulsa, Okla.: Philbrook Museum of Art).
First United Methodist Church website. www.1stumcwichita.org/around_the_church/Church_Symbolism/symbolism.html (accessed 15 June 2005).
Frazier, Malcolm, telephone interview with Lora Jost, 11 September 2004.
Hankins, B. Lester, *Ten Adventurous Decades* (Wichita, Kans.: First United Methodist Church, 1970).

Crystal Ballroom Mosaic
Allen, Bill Dwayne, telephone interview with Lora Jost, 17 July 2005.
Allen, Bill Dwayne (Wichita, Kans.: Wichita Art Museum Library Archives, c. 1979), description of mural.
"Artist Honored at Unveiling," *Wichita Beacon*, 28 September 1972.
From Whence All Life (Wichita, Kans.: Farm Credit Bank Building). Pamphlet.
King, Jeanne Snodgrass, "Blackbear Bosin," *American Indian Art Magazine*, Vol. 21, No. 1 (Winter 1995), p. 52.

Norton, Margaret (author of forthcoming book on Blackbear Bosin), email correspondence with Lora Jost, 14 and 15 July 2005.
"Profile: Blackbear Bosin," *Wichita* (March–April 1977), pp. 12–13, 21.
Wyckoff, Lydia L., ed., *Vision and Voices: Native American Painting from the Philbrook Museum of Art* (Tulsa, Okla.: Philbrook Museum of Art, 1996), pp. 39–40.

The Evergreen Mural No. 1
Drake, Ryan, and Cody Handlin, telephone interview with Lora Jost, 5 December 2004.

Graffiti Mural
Anonymous, Wichita graffiti artist, interview with Lora Jost, 26 July 2005.
Art Crimes. "Graffiti Definition: The Dictionary of Art." www.artcrimes.org/faq/graf.def.html (accessed 10 August 2005).
Art Crimes. "The Writing on the Wall." www. graffiti.org (accessed 31 July 2005).
Deaf (Lawrence graffiti artist), interview with Lora Jost, 31 July 2005.
Dunitz, Robin J., and James Prigoff, *Painting the Town: Murals of California* (Los Angeles: RJD Enterprises, 1997), p. 21.
"Graffiti Art." *Wikipedia.* http://en.wikipedia.org/wiki/Hip_hop#Graffiti_art (accessed 31 July 2005).
"Hip Hop." *Wikipedia.* http://en.wikipedia.org/wiki/hip-hop (accessed 31 July 2005).

Kansas Daydreaming
Holman, Rhonda, "Mural Will Share Random Reflections," *Wichita Eagle,* 18 April 1994.
Whitney, Peggy, interview with Dave Loewenstein, 9 January 2004.

Larkspur Mural
Murillo, Steve, telephone interview with Lora Jost, 21 March 2005.

The Lindbergh Panel
"Aerodrome," Kansas Aviation Museum, www.kansasaviationmuseum.org/aero.htm (accessed 24 June 2005).
"Death Ends Career of L. W. Clapp," 17 December 1934 (Wichita, Kans.: Wichita-Sedgwick County Historical Museum Archives).

House, Walt, telephone interview with Lora Jost, 19 March 2005.
"Lindbergh Panel over Entrance to Airport, Building Memorial to the Late L. W. Clapp," *Wichita Sunday Eagle,* 31 March 1935.

Medicine Songs
Regan, Rick, interview with Lora Jost, 29 December 2004.

Our Lady of Kansas
Blameuser, Sister Mary Fleurette, B.V.M., *A Mosaic Mural at Kapaun Mount Carmel, Wichita, Kansas, Our Lady of Kansas.* Unpublished artist's statement.
Cattell, Jaques, ed., *Who's Who in American Art* (London: H. R. Bowler, 1978).
Gilbert, Sister Kathleen, letter to Lora Jost, 2004.
Gragert, Andrea, telephone interview with Lora Jost, 6 October 2004.
Simoni, John, "Nun Exhibits Sensitivity," *Wichita Eagle and Beacon,* 9 May 1965.
Wescott, Michael W., letter to the Catholic Diocese of Wichita, "Nomination of Sister Mary Fleurette, B.V.M.," October 2003.

Personnages Oiseaux
Centaur Galleries. "Joan Miro." www.centaurgalleries.com/Artists/Miro.htm (accessed 5 September 2005).
Wichita State University. "*Personnages Oiseaux.*" http://webs.wichita.edu/?u=mark2&p=/personnages (accessed 5 September 2005).

The Spirit of the Prairies
The Carnegie Legacy in Kansas. "Wichita: Early Library History." http://skyways.lib.ks.us/carnegie/page155.html (accessed 22 July 2005).
Lensky, Lois, *Southwestern College Collection of Art by Arthur Covey* (Winfield, Kans.: Southwestern College, c. 1960). Exhibit catalog.
Statement about *The Spirit of the Prairies* (Wichita, Kans.: Southwest National Bank Archives, 1985).
Wichita Photo Archives. "1940s." www.wichitaphotos.org/searchresults.asp?yr=1940s&offset=−1 (accessed 22 July 2005).

Searching for Magic
Bicker, Marjorie Hall, telephone interview with Lora Jost, 13 April 2004.

The Story of Winfield

Foster, Mary Sue, telephone interview with Dave Loewenstein, 10 February 2005.
Grana, Teresa, telephone interview with Dave Loewenstein, 13 April 2005.
Southwest National Bank. Pamphlet describing the mural.

KANSAS MURALS: NORTHWEST

History of Rawlins County

Crabb, Marjorie M., "Historical Panorama of Rawlins County," *Kansas! Magazine* 2 (1976), p. 26.
Pearson, Richard, "Obituary for Rudolph Wendelin," *Washington Post*, 3 September 2000, p. C06.
Wendelin, Rudolph, audiotape describing the mural, 17 October 1976.

Education in Thomas County

It's Time to Celebrate! (Colby, Kans.: Colby Community College). Pamphlet.
Mitchell, Kenneth, telephone interview with Lora Jost, 16 June 2004.

Sunflowers after Vincent van Gogh

Berry, Mike, "A Huge Vincent van Gogh Reproduction," *Wichita Eagle*, 20 June 2001.
The Big Easel website. www.thebigeasel.com (accessed 7 August 2005).
Lokema, Rhonda Chriss, "Great Gallery on the Plains," *Kansas City Star*, 17 August 2003.

Protect Our Water Quality

Newcomb, Matt, "What a Difference Day Makes," *Fort Hays State University Leader*, 30 October 2001.
Reeves, Megan, "Artistic Skills Are Used to Promote Earth Day," *Fort Hays State University Leader*, 25 April 2003.
Rupp, Rick, telephone interview with Dave Loewenstein, 13 January 2005.

Summer

Haas, Chad, telephone interview with Dave Loewenstein, 18 March 2005.
Haas, Chad, biography submitted by the artist.

Places in Rooks County

Strutt, Clara (Rooks County clerk), telephone interview with Dave Loewenstein, 24 January 2005.

KANSAS MURALS: SOUTHWEST

First House of Lane County

Bosley, Mary Alice, telephone interview with Lora Jost, 18 December 2004.
"Good Show," *Dighton Herald*, July 1961.
Mosbacker, Linda, "Vernacular Architecture," *Utah Education Network*, www.uen.org/utahlink/activities/view_activity.cgi?activity_id=6091 (accessed 22 June 2005).
Wortman, Julie A., and David V. Johnson, *Legacies of Kansas' Older County Courthouses* (Topeka: Kansas State Historical Society, 1981).

Harvest through the Twentieth Century

Carlson, Ted, telephone interview with Lora Jost, 17 April 2004.
Gurtner, Gene, telephone interview with Lora Jost, 27 April 2004.
Planet Wheat, Wheat History, www.cyberspaceag.com/wheathistory.html (accessed 4 April 2004).
"Wheat History," Kansas State Historical Society, www.kshs.org/exhibits/wheat/wheat1.htm (accessed 23 June 2005).

Kinsley Carnival Mural

Brodbeck, Buford, *On the Road with the Carnival* (Kinsley, Kans.: National Foundation for Carnival Heritage, 1973).
"Midway USA: Kinsley Kansas," *Kansas: Local Legacies*, www.loc.gov/bicentennial/propage/KS/ks–1_h_moran2.html (accessed 25 June 2005).
White-Saddler, Jessica, telephone interview with Dave Loewenstein, 10 December 2003.

Entrada

Herd, Stan, *Crop Art and Other Earthworks* (New York: Harry N. Abrams, 1994).
Herd, Stan, interview with Lora Jost, 22 June 2005.
A Historical Mural of Dodge City Kansas (Dodge City, Kans.: Hyplains Dressed Beef, Inc.). Pamphlet.

The Saga of the Santa Fe

Burghart, Dennis, telephone interview with Lora Jost, 8 August 2004.
Cockcroft, Eva, John Pitman Weber, and James Cockcroft, *Toward a People's Art: The Contemporary Mural Movement* (Albuquerque: University of New Mexico Press, 1988).

FURTHER READING ABOUT MURALS

Cockcroft, Eva, John Pitman Weber, and James Cockcroft, *Toward a People's Art: The Contemporary Mural Movement* (Albuquerque: University of New Mexico Press, 1988).

Dunitz, Robin, *Painting the Towns: Murals of California* (Los Angeles: RJD Enterprises, 1997).

Federal Writers' Project of the Work Projects Administration, *The WPA Guide to 1930s Kansas* (1939; new edition, Lawrence: University Press of Kansas, 1984).

Golden, Jane, Robin Rice, and Monica Yant Kinney, *Philadelphia Murals and the Stories They Tell* (Philadelphia, Pa.: Temple University Press, 2002).

Gray, Mary Lackritz, *A Guide to Chicago's Murals* (Chicago: University of Chicago Press, 2001).

Gude, Olivia, and Jeff Huebner, *Urban Art Chicago: A Guide to Community Murals, Mosaics, and Sculptures* (Chicago: Ivan R. Dee Press, 2000).

Kendall, M. Sue, *Rethinking Regionalism: John Steuart Curry and the Kansas Mural Controversy* (Washington, D.C.: Smithsonian Institution Press, 1986).

Marling, Karal Ann, *Wall-to-Wall America: A Cultural History of Post-Office Murals in the Great Depression* (Minneapolis: University of Minnesota Press, 1982).

Park, Marlene, and Gerald E. Markowitz, *Democratic Vistas: Post Offices and Public Art in the New Deal* (Philadelphia, Pa.: Temple University Press, 1984).

Prigoff, James, and Robin J. Dunitz, *Walls of Heritage, Walls of Pride: African American Murals* (San Francisco: Pomegranate Communications, 2000).

Rochfort, Desmond, *Mexican Muralists* (San Francisco: Chronicle Books, 1998).

WEB SITES

Art Crimes, www.artcrimes.org (worldwide graffiti art)

Chicago Public Art Group, www.cpag.net

Cowichan, "Chemainus Murals," www.northcowichan.bc.ca/murals.htm (murals of Chemainus, British Columbia)

Groundswell, www.groundswellmural.org (community murals in Brooklyn)

Mural Arts, www.muralarts.org (murals of Philadelphia)

Precita Eyes Mural Arts and Visitors Center, www.precitaeyes.org (San Francisco community murals)

SPARC (Social and Public Art Resource Center), www.sparcmurals.org (community murals in California)

WPA Murals, www.wpamurals.com (New Deal murals)

INDEX

Page numbers in bold refer to pictured murals.